Everything You
Didn't Need To
Know About

AUSTRALiA

Printed and bound in Great Britain by Butler & Tanner Ltd, Frome, Somerset

Distributed in the US by Publishers Group West

Published by Sanctuary Publishing Limited, Sanctuary House,
45–53 Sinclair Road, London W14 0NS, United Kingdom

www.sanctuarypublishing.com

Cover concept: Splashdown
Cover illustration: Peter Quinnell
Illustrations: Axos

'Advance Australia Fair'
Words by Peter Dodds McCormick
© Copyright Control

'Slip, Slop, Slap'
Words by Peter Best
© Copyright Control

'Waltzing Matilda'
Words by Banjo Paterson
© Copyright Control

ISBN: 1-86074-598-9

Everything You
Didn't Need To
Know About

AUSTRALIA

Adam Ward

Sanctuary

ACKNOWLEDGEMENTS

This book would not have been possible without the foresight of Iain MacGregor, sometime publishing genius and erstwhile veteran of wounded knee and many a long campaign in the saddle. A good bloke and no mistake. Thanks also go to the following (in no particular order): the Right Honourable Richard Dubouis Scott, who remains undoubtedly the nicest Australian I've met, and his dear lady wife Anna; to the Kells, Elizabeth, Sandra and Russ, for their practical and emotional support; to editors Chris Harvey and Nikky Twyman for their patience and kind words in response to the sometimes erratic words I supplied them with; to Magic G, my ever reliable support; and finally, to my boys Joe and Tommy for the priceless gift of perspective.

PREFACE

Trivia does not play a big part in Australian culture. Sure, the quirky facts and figures are all out there, it's simply that Aussies don't care that much for pointless intellectual ephemera. They like things straight, no frills, no fuss and no unnecessary details. The bloke in the pub is not interested in the origins of his vernacular or in amusing facts about his country's flora and fauna. He just knows what's fair dinkum and what's daggy.

The English, by contrast, are a nation obsessed with minutiae; priding themselves in a smug, self-satisfied way at their ability to recount nuggets of useless data. So, you're thinking, where does this book fit in? Essentially, it is written from a foreign perspective – an English one – and it takes a look at the details that most Aussies couldn't really care less about. To be pompous, it is a kind of anthropology of the pointless aspects of Australian culture and society.

Having said that, the title of the book may be somewhat misleading, as alongside the daft stuff, I've included the important, serious events in Australian history…the attempted genocide of the Tasmanian aboriginal people, the Gallipoli campaign and whale hunting, to name but three. You simply can't ignore these events and even trivia needs a context. However, wherever possible I have tried to tell the stories in the most light-hearted way.

The book is, of course, not exhaustive, how could it be in under 200 pages? But if things are missing or mistakes made, it does at least give some clever soul the opportunity to write to the publisher and point out his (it's bound to be a bloke) superior knowledge of the Antipodes. And I bet my royalties that the first clever letter is written by a Pom…

BLIND FREDDY

You will often hear Australians – usually men – talking about a character called Blind Freddy. Phrases like 'Even Blind Freddy could see that your red car was a death trap' or 'Even Blind Freddy could have told you that the Poms would lose the Ashes' are commonplace. Don't be alarmed, for Freddy does not exist; he is merely a fictional dullard who inhabits the murky world of Aussie vernacular. Freddy, it seems, cannot appreciate or understand anything unless it is painfully obvious and has been made clear with words of only one syllable. Other characters you may want to watch out for are Jacky (as in 'Sit up like Jacky' – children are told to do this at the dinner table), Hughie (God), Buckley (as in 'Buckley's chance', which means you have no chance) and Alf (a fool).

DOWN AND OUT, DOWN UNDER

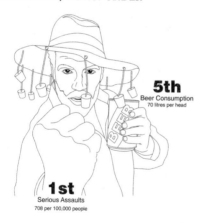

5th
Beer Consumption
70 litres per head

1st
Serious Assaults
708 per 100,000 people

According to recently published statistics, the stereotype of the Aussie male as an 'all-drinking, all-fighting, bloke's bloke' is not too far from the truth. In the beer consumption global league table, Australians sit in a respectable fifth place, with retail sales of 70 litres/154 pints per head. However, when it comes to scrapping, the Aussies can truly take on all comers. Nowhere in the world has a higher incidence of reported serious assault than Australia: in 1999, there were 708 crimes of this kind recorded per 100,000 people. To put that in context, Lebanon clocked up 209 per 100,000, Zimbabwe had 198 and Rwanda a mere 114.

SHARK ATTACK

To English visitors brought up on beaches filled with nothing more violent than dried-up starfish and sewage, Australian seas can seem a little scary. Sharks, jellyfish, seasnakes… It's enough to make a paranoid Pom stick to the sand. The daddy of beach paranoia is unquestionably the great white shark (GWS), the biggest and baddest of sharks and the one we fear most, thanks to *Jaws* (not to mention those interminable documentaries starring divers in cages and overly earnest voiceover actors). Hopefully, our quick guide to the GWS will help put your fears at rest and help you avoid an uncomfortable and unnecessary attack.

- GWSs are solitary creatures, which is obviously a good thing, as you'd struggle to fight off more than one.

- Not all sharks off Australia are GWSs.

- You can identify a GWS by the fact that it will be scary and massive.

- GWSs live on a diet of flesh. You will not be able to distract one with a chocolate treat or biscuit.

- Female GWSs are bigger than males – is this a good thing?

- The GWS can have up to 3,000 triangular saw-like teeth located in rows, so you won't knock its teeth out even if you're really hard and have got 'backup'.

- 'Bite and swallow' is the GWS modus operandi when it comes to eating, so at least you won't be chewed up. Every cloud…etc.

- GWSs attack from below, so if you're nervous, try swimming along the bottom of the ocean. (For legal reasons, we must advise you to do this only if you are wearing breathing apparatus and have undergone a proper period of training.)

- GWSs have an acute sense of smell and are particularly good at sniffing out blood. For this reason, it is inadvisable to carry calves' liver or other offal in your swimming costume.

- Fun can be had swimming in very shallow water.

HORSERACING

Australians like nothing better than a day at the races. A picnic, a few beers and, for some at least, an excuse to get dressed up, makes race day a special occasion. All big towns and many smaller ones have a racetrack;

others get by with a Totalising Agency Board (TAB) betting office, which is frequently found in the local pub. The Melbourne Cup is the biggest event in the horseracing calendar, attracting not only local but also international interest. In fact, it is so big that the city gives its inhabitants a public holiday on the day of the race, which is held at Flemington on the first Tuesday in November. Adelaide also hosts another big racing meet, while the Birdsville Races in Queensland, the Alice Springs Cup and the Kalgoorlie Cup provide entertainment off the beaten track.

CONVICT CONCUBINES

Australia's 18th-century convict settlements were not a good place for women of high moral values. Not least of the problems for such ladies was prostitution, which was endemic, though this is hardly surprising when you consider that there were few other career options open to female convicts trying to save enough money to buy their passage back home.

Only 10 per cent or so of convicts were female, with fewer than 25,000 women deported to Australia in total. This sexual imbalance made prostitution inevitable and the Molesworth Committee of 1838 commented that convict women were 'all of them, with scarcely an exception, drunken and abandoned prostitutes'. A senior chaplain, the Rev Samuel Marsden, described Australia as 'a dreadful society for whoredom and all kinds of crimes'. However, he also noted that many of the country's problems came from the top downwards, with bureaucrats and administrators often keeping convict mistresses or concubines.

CAPTAIN BLOOD

Jack Dyer was the greatest Aussie Rules footballer of the 1930s and 1940s. He was also one of the game's great hardmen, with his antics earning him the moniker 'Captain Blood'.

The Captain was an uncompromising character and a talented player. Standing at a muscular 1.83m (6ft), as a footballer he genuinely struck fear into the hearts of opponents and inspired the ire of all rival supporters. He once commented that, 'The wild men are not villains – they are the heroes. They are the men who do the wild thing… Sport is not a pastime for gentlemen to air their graces and turn the other cheek…if you turn the other cheek you deserve to get whacked – and you usually do.'

Jack Dyer was admitted to Australia's Sporting Hall of Fame in 1992.

THE PRICE IS RIGHT IN PERTH

The Consumer Price Index of September 2003 revealed that Adelaide (with an index score of 145.4) was the most expensive of eight Australian cities to live in, while Darwin (at 137.8) was the cheapest. Sydney's index was 142.4.

TASMANIAN DEVILS

It may be a surprise to learn that the Tasmanian devil is more than just a fictitious Warner Brothers creation. Yes, the cartoon character that spins round in a rage and runs headlong into disaster is based on a real Antipodean mammal.

As the name suggests, you'll have to go to Tasmania to see one of these critters in the wild and, though there is something menacing about their appearance, there is no firm evidence that they are actually devils. The whole devil thing probably comes from their sharply pricked-up ears, which can look a little like satanic horns, and their piercing shrieks. Tasmanian devils are also Australia's largest carnivorous marsupials, growing to the size of an average dog, and with teeth strong enough to consume every morsel of their prey, down to the last scrap of bone.

Tasmanian devils live in dense bush habitat and hunt at night, feeding on birds and mammals, including chickens, lambs and wallabies. They also have a neat trick of consuming larger prey from the inside out. This practice may also explain their name, as to see a devil crawl into the carcass of a dead animal, then forage about before emerging blood-stained and sated, is not a pretty sight.

WITCHETTY GRUBS, THE ORIGINAL BUSH TUCKER

If you really want to sample the true experience of 'going bush', you must eat a witchetty grub. These famous larvae look like giant maggots, and… basically…that's what they are, but according to bush folk they're a delicacy that can be enjoyed hot or cold.

Witchetties are the larvae of a large moth and can be found in tree trunks and in the roots of trees. They tend to favour wattle, red gum and weeping willows, and their presence is usually given away by a small heap of sawdust at the foot of the tree.

According to *Going Bush*, you should hook the grubs out of their home with the hooked end of a piece of wire, before removing the head and guts (which apparently taste of wood pulp), then frying in butter or cooking in hot ashes.

EUROPEANS ARRIVE DOWN UNDER

The Dutch are acknowledged as the first Europeans to discover Australia, though it is clear that Spanish and Portuguese sailors had also come close to stumbling upon the Antipodes early in the 17th century. The Dutch, in common with their continental contemporaries, had been searching for the mythical islands of gold and the unknown southland. They were to be disappointed.

By the mid-17th century, and after two expeditions under the guidance of Commander Abel Tasman (who gives his name to Tasmania), the Dutch had charted the coast of Australia from Cape York Peninsula west to the end of the Great Australian Bight and southern Tasmania. But they had found neither gold nor silver.

It was not until the end of the 18th century that the English began to show an interest in establishing a colony in Australia. The English sailor and explorer James Cook landed at Botany Bay, near Sydney, in April 1770 and took possession of the country for George III at Possession Island, naming it New South Wales. He would return again four years later, after the Admiralty had dispatched him to continue his search for the mythical southland.

Cook never did find the islands of gold, but Sir Joseph Banks managed to find an imaginative solution to the question of what to do with Australia. Banks had travelled with Cook on his first trip to the Antipodes, and in 1779 told the House of Commons that the British government should found a penal colony at Botany Bay.

The British had previously deported many convicts to the southern colonies of America, but the revolt of 1776 meant this was no longer viable. Prisoners were now sent to overcrowded jails or set to work in the hulks (ships sat in dry dock). By 1786, America had won independence and, with riots and disease blighting the hulks and jails, the under-pressure Pitt government opted to instigate Banks's proposal. In August, the Home Office instructed the Admiralty to provide vessels, provisions and tools to transport 750 convicts to Botany Bay.

The Europeans had arrived.

COFFEE TAKES THE LEAD

Australian adults aged 45 years and over drink more tea than coffee, but for those aged 19 to 44 coffee is the hot drink of choice. Unsurprisingly, adults born in the UK and Ireland have the highest intake of tea.

BUSH CREEPY CRAWLIES

- **Mosquitoes** – Campfires, mosquito coils and insect repellent will help repel mozzies. Avoid swampy areas at dusk.

- **Sandflies** – These tiny flies leave painful, itchy bites, so cover up and use insect repellent. They are found in grassy areas around the coast or swamps.

- **Leeches** – Leeches look horrendous but these repugnant critters don't do as much damage as you might think. They are found in damp bush, swamp and billabong areas, and typically attack feet, ankles and legs. To remove them, you should apply salt, or, if you're feeling brave, hold a lit match near to the leech. Ripping them off is not a good idea, as it will just make bleeding worse. Once you've removed your unwanted passenger, apply antiseptic cream and a plaster.

- **Ticks** – These bloodsucking insects are not a huge concern for adults, but can make children ill. Watch for signs of lethargy and discourage youngsters from playing in areas of thick undergrowth. If you find a tick (they are usually brown) on your person, remove it quickly and cleanly. Specially designed tick extractors are best but, if not available, tweezers can be used. You must take care to remove the entire creature, including its head.

- **Scorpions** – A sting from a scorpion will hurt, but the good news is that these creatures would really rather be left alone, and – unlike mosquitoes – they will not come looking for you. Check your boots before you put them on, don't pick up timber without checking what's underneath, and don't leave your clothes lying around on the ground.

- **Flies** – The classic cork hat will keep flies from your face, but you'll probably end up walking into a gum tree before you get used to the dangling wine stoppers that keep appearing before your eyes. The main thing is to keep flies away from your food, so cover up all ingredients prior to cooking.

- **Spiders** – There are lots of spiders in the bush, but (in usual circumstances) there are only two that will kill you. The ones to watch for are the funnel-web and the redback. The most common way people are bitten by these deadly arachnids is by putting on shoes and clothing after they have been lying on the floor, but without checking them first. So don't leave stuff lying around, always avoid putting your hand under logs and rocks, and make sure you check under the toilet seat for redbacks.

FISHY STORY

If witchetty grubs aren't your thing, fish may be a realistic option when hunting for bush tucker. You should be safe with fish caught in fresh water, and even those taken from pools and billabongs will be OK, though they may taste a bit earthy. However, there are several saltwater varieties that are poisonous and should be avoided at all costs. Steer well clear of:

- boxfish
- pufferfish
- toadfish
- triggerfish.

THEY MIGHT BE GOOD AT CRICKET, BUT...

The Australian dollar is not as mighty as the good old English pound – a fact not lost on England's travelling cricket fans during the 2002–03 Ashes Tour. With little else to cheer about, the so-called 'Barmy Army' serenaded their Antipodean rivals with chants of 'You Get Three Aussie Dollars To The Pound' (sung to the tune of 'He's Got The Whole World In His Hands'). Just for the record, you also get around A$2 to US$1, but a mere A$1.75 to the Euro.

A TEAM OF AUSSIE SOCCER PLAYERS WHO MADE IT BIG IN BRITAIN

- Mark Bosnich (Chelsea, Manchester United, Aston Villa)
- Stan Lazaridis (Birmingham City, West Ham)
- Robbie Slater (Wolves, Southampton, West Ham, Blackburn Rovers)
- Danny Tiatto (Manchester City)
- Paul Okon (Leeds, Middlesbrough)
- Kevin Muscat (Millwall, Rangers, Wolves, Crystal Palace)
- Craig Moore (Rangers, Crystal Palace)
- Craig Johnstone (Liverpool)
- Brett Emerton (Blackburn Rovers)
- Harry Kewell (Liverpool, Leeds)
- Mark Viduka (Leeds, Celtic)

THE SOUND OF SOAP

Ten Australian soap stars who turned to pop:

- Gayle Blakeney (*Neighbours*)
- Gillian Blakeney (*Neighbours*)
- Stefan Dennis (*Neighbours*)
- Jason Donovan (*Neighbours*)
- Natalie Imbruglia (*Neighbours*)
- Craig McLachlan (*Neighbours*)
- Dannii Minogue (*Home And Away*)
- Kylie Minogue (*Neighbours*)
- Hayley Smith (*Home And Away*)
- Holly Valance (*Neighbours*).

TIPPING

The Australians, like the English, have a fairly miserly approach to tipping. It's not expected in bars and restaurants, although (of course) it's always welcome. If you're happy with the service, tip… If you're not, don't. Couldn't be simpler.

THE ECHIDNA

The echidna is one of numerous quirky Australian critters. But what sets this spiny anteater apart is that it is one of only two egg-laying mammals (monotremes) in the world. If you're unsure what it looks like, take a close look at the face of a 5 cent coin.

RANDOM ECONOMIC AND DEMOGRAPHIC STATISTICS

According to 'Country Profiles', published by *The Economist* in 2002, Australia can boast the following statistics.

Population: 19.1 million
Urban population: 84.7%
Life expectancy: 76.4 years (men); 82 years (women)
Structure of employment: 5% in agriculture; 21% in industry; 74% in services
Unemployment: 6.4% of workforce (in 2000)
Marriage rate: 0.69% of population

Divorce rate: 0.27% of population
Colour TVs: 91.4% of households
Telephone lines: 52% of population
Mobile phone subscribers: 57.8% of population

MUSCLE MEAT

The average Australian (let's call him Bruce, for the sake of stereotype) consumes 50g (2oz) of muscle meat a day. Bruce also eats (on average) around 10g (1/3oz) of sausages and saveloys and around 40g (1 1/2oz) of mixed beef and veal dishes. Bruces from Tasmania have the highest intake of muscle meats and the lowest intake of other meat.

SYDNEY OPERA HOUSE

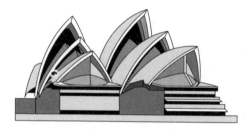

Australia's most famous piece of architecture rises dramatically from Bennelong Point next to Circular Quay and is the work of Dane Jørn Utzon. It may look like an impressionistic concrete yacht, but apparently its design was inspired by palm fronds.

It took 16 years to build and cost A$102 million (£42 million) prior to its opening in 1973. The Opera House has four main auditoriums, the largest of which is the concert hall, and plays host to classical music, ballet, theatre and, of course, opera. It also has a cinema and is the site of a craft market every Sunday. The newest addition to the Opera House is a contemporary arts venue called The Studio.

OLD NEWS DOWN UNDER

The *Sydney Morning Herald*, which was first published in 1831, is reputed to be the oldest newspaper in the southern hemisphere.

ANZAC

'Anzac' is a word that evokes images of Antipodean bravery and, in particular, memories of the young men who lost their lives during the infamous landing at Gallipoli in April 1915. The word comes from the initial letters of the Australian and New Zealand Army Corps, which was formed by Lord Kitchener during World War I. Today, of course, the 85,000 Australians who died at Gallipoli are remembered each year on Anzac Day (25 April). The story of the Gallipoli landings has been told in numerous films, books and dramas, but no medium can truly portray either the bravery or tragedy that unfolded on a somewhat obscure Turkish peninsula almost 90 years ago.

The objective was clear: the Anzacs were charged with taking control of the Dardanelles, the narrow strait that links the Aegean and Black Seas. However, the Gallipoli peninsula was a perilous and forbidding location, with its four beaches and mountainous landscape potted with ravines and gullies.

The situation was made even more challenging when the first assault force (the Australian 3rd Brigade) landed 1.5km (1 mile) too far north at what became known as Anzac Cove. A hail of bullets welcomed the Anzacs and confusion reigned. Boats were peppered with gunfire and some soldiers drowned after jumping into the seas out of their depth. Those that made it to the beach were faced with an imposing cliff-face and continued enemy fire.

Despite the terrifying odds, the Anzacs were soon formed into a rough line and began climbing the slopes. Some men got close to the operation's objective, the Narrows, while others embarked on a bayonet rush to take the hill at Baby 700. The fighting was intense and furious everywhere around Anzac Cove, with the Antipodeans burrowing into the slopes and ridges. For three long days after the landing, the Turks attacked the Anzac lines before reinforcements were called for from the Light Horse regiments in Egypt.

The fighting continued until December, with the Anzacs showing unprecedented stoicism in the face of repeated waves of Turkish assault. The Australian spirit remained unbroken, even after repelling a massive attack from 42,000 Turks on 18 and 19 May, during which General Birdwood's 12,500 men jockeyed for position on the front line. During later assaults, Anzacs are alleged to have paid compatriots as much as £5 for the honour of taking a position in a bayonet charge. Other contemporary reports tell of Anzacs who became expert at catching Turkish grenades and throwing them back at their foes.

Despite the heroism and dogged resistance of the Anzacs, it soon became clear that the Allies were on a hiding to nothing and that the peninsula would not be taken. The inevitable decision to evacuate came in December. Lieutenant-Colonel Brudenell White orchestrated the Anzac escape with great stealth, moving out 83,000 men in nine days and seeing only two of his soldiers wounded in the final stages of the withdrawal.

The writer Compton Mackenzie, who was working for the Australian headquarters staff in 1915, noted how the spirit and appearance of the Anzacs impressed all visitors to the peninsula during the fighting for Gallipoli: 'They were glorious young men. Their almost complete nudity, their tallness and majestic simplicity of line, their rose-brown flesh burnt by the sun and purged of all grossness by the ordeal through which they were passing, all these united to create something as near to absolute beauty as I shall hope to see in this world.'

THE ASHES

The most intense rivalry in international cricket is that between Australia and England. The two nations first played one another in 1861 but the Anglo-Aussie cricket clash did not come of age for another 21 years. After several tours – some official, others not – Australia shook Victorian England to its arrogant and self-assured core by beating the home team by seven runs at the Oval. It was a hugely embarrassing defeat for the English, who had fielded a full-strength team that included the legendary WG Grace. A famous mock-obituary appeared in the *Sporting Times,* reading:

'In Affectionate Remembrance of English Cricket

Which died at the Oval on 29th August 1882

Deeply lamented by a large circle of sorrowing

Friends and acquaintances.

RIP

NB: The body will be cremated and the ashes taken to Australia'

So was the idea of 'the Ashes' born. Prior to departing for the 1882–83 tour of Australia, the England captain (the Hon Ivo Bligh) promised to bring back the 'Ashes of English cricket'. Bligh proved as good as his word and, after his team defeated Australia, he was presented with the ashes of a burned cricket stump in an urn.

PERFECT COLOUR MATCH

For the benefit of pedants and anybody involved in the printing industry, Australia's official colours of green and gold correspond to Pantone Matching System numbers 116C and 348. If that means nothing to you, you have no reason to feel inferior.

THE AUSTRALIAN INSTITUTE OF SPORT

The AIS is widely regarded as the world's premier sports academy, and is credited with the development of a host of top-class athletes including the likes of Cathy Freeman, Shane Warne and Lleyton Hewitt. Its headquarters in Canberra accommodates 350 residents, and boasts state-of-the-art facilities staffed by leading coaches, sports scientists and physiotherapists. The result is an institution that is the envy of the rest of the world.

The *raison d'être* of the AIS is to create champions, and its stated aim of 'achieving supremacy in sport' is revealing. Mere excellence is not enough to satisfy the Aussies – nothing less than supremacy will do – and after the country's abject performance at the Montreal Olympic Games of 1976 it is easy to understand why the AIS was born and why it has been so determined to make its mark. Australia's medal haul at Montreal stood at one silver and four bronze – a paltry total for a country that takes great pride in its sporting prowess. The idea of establishing an academy had been mooted for several years, but now the plan began to gather momentum. However, as with all things political, it took time to come to fruition.

The AIS was officially opened on Australia Day (26 January) 1981, by Prime Minister Malcolm Fraser. Swimming coach Don Talbot was appointed as the Institute's first director and quickly set out to avert the downward trend that had begun to dominate Australian sport. With the AIS in place, athletes would be given the opportunity to train and hone their talent on home soil, rather than be forced overseas.

The results were soon evident, and at the 1984 Olympics in Los Angeles AIS athletes dominated Australian successes, winning 7 of the 12 swimming medals collected, and making progress in both track and field events. It was enough to prompt Sports Minister John Brown to increase the Institute's funding, and led to an expansion of the sports covered. Today, scholarships are offered to elite athletes in 35 sporting disciplines, with a team of more than 75 coaches at sites across Australia.

The Institute has become such a success, in fact, that it is now something of a tourist attraction in its own right. Its campus is now open to visitors, who can enjoy an insight into 'a day in the life of an elite athlete' via 'athlete-guided tours' and the interactive exhibition, Sportex.

Ten famous AIS graduates:

- Lleyton Hewitt
- Mark Viduka
- Craig Moore
- Robbie McEwan
- Cathy Freeman
- Shane Warne
- Adam Gilchrist
- Brett Lee
- Brett Emerton
- Lucas Neill.

THE OTHER GAMES

When Sydney was still a second-rate city, Melbourne flew the flag for Australia when it held the 1956 Olympic Games. If you need a reminder, this was the year of Elvis singing 'Heartbreak Hotel', of President Nasser of Egypt seizing control of the Suez Canal and of an uprising in Hungary against Soviet domination. In the first Olympics held south of the Equator the Soviet Union was at the top of the medal table. Its athletes took home 37 golds, 29 silvers and 31 bronzes, a total of 97 medals. Australia carved out a triumph or two, with sprinter Betty Cuthbert winning gold at 100 metres and 200 metres, and hurdler Shirley de la Hunty coming in first at 80 metres. But most Australian medals came, typically, from pool events where Dawn Fraser and Lorraine Crapp were the fast-moving water babes.

FIRST THE GOOD NEWS...

Australia's Northern Territory boasts the highest fertility rate in the country – an average 2.2 babies per woman compared with the national figure of 1.7. This is attributed to the state's relatively large Aboriginal and Torres Strait Islander population whose women average 2.3 babies. Unfortunately, the Northern Territory also has the highest death rate – 8.7 per thousand people per year – according to the Australian Bureau of Statistics.

'WALTZING MATILDA'

Australian rugby fans were left incensed when they learned that the International Rugby Board (IRB) had banned the hosts from singing 'Waltzing Matilda' prior to their games at the 2003 World Cup. It was a move that sparked an explosion of diplomatic interest, with Prime Minister John Howard leading the protests to the IRB and (eventually) getting his way.

The IRB had made a decision that only national anthems were allowed, with special exceptions made for performances of 'cultural significance'. No concession was to be made to what has become a tradition at Test matches involving Australia. However, pressure soon began to mount against rugby's governing body, with Australia's regular 'Waltzing Matilda' singer, John Williamson, claiming that the song is now Australia's national song, adding that, 'It will be a great shame for the fans.'

The IRB attempted to stand firm, with a spokesman declaring, 'We make concessions for culturally important things but we don't think it ["Waltzing Matilda"] applies.' It seemed that the All Blacks could have their haka and the South Africans were free to war-dance away their pre-match nerves, but the Aussies would not be permitted to give Matilda a good waltzing.

However, just when all seemed lost, the IRB relented, permitting 'Waltzing Matilda' to be sung before Wallabies matches at the World Cup. In a surprising about-turn, an IRB statement said, '[We] recognise the importance and significance of "Waltzing Matilda" to the Australian nation… [We] are pleased to confirm that it may be both formally played and sung at any nominated time before the teams take the field." Once the players were on the pitch, only national anthems and performances of cultural significance (such as the haka) were permitted.

AUSTRALIA'S PRIME MINISTERS

Name	Held office
Sir Edmund Barton	1 January 1901 to 24 September 1903
Alfred Deakin	24 September 1903 to 27 April 1904
John Christian Watson	27 April 1904 to 18 August 1904
George Reid	18 August 1904 to 5 July 1905
Alfred Deakin	5 July 1905 to 13 November 1908
Andrew Fisher	13 November 1908 to 2 June 1909
Alfred Deakin	2 June 1909 to 29 April 1910
Andrew Fisher	29 April 1910 to 24 June 1913
Sir Joseph Cook	24 June 1913 to 17 September 1914

Andrew Fisher	17 September 1914 to 27 October 1915
William Morris Hughes	27 October 1915 to 9 February 1922
Stanley Melbourne Bruce	9 February 1922 to 22 October 1929
James Henry Scullin	22 October 1929 to 6 January 1932
Joseph Aloysius Lyons	6 January 1932 to 7 April 1939
Sir Earle Page	7 April 1939 to 26 April 1939
Sir Robert Gordon Menzies	26 April 1939 to 29 August 1941
Sir Arthur W Fadden	29 August 1941 to 7 October 1941
John Curtin	7 October 1941 to 5 July 1945
Francis Michael Forde	6 July 1945 to 13 July 1945
Joseph Benedict Chifley	13 July 1945 to 19 December 1949
Sir Robert Gordon Menzies	19 December 1949 to 26 January 1966
Harold Edward Holt	26 January 1966 to 19 December 1967
Sir John McEwen	19 December 1967 to 10 January 1968
Sir John Grey Gorton	10 January 1968 to 10 March 1971
Sir William McMahon	10 March 1971 to 8 December 1972
Edward Gough Whitlam	8 December 1972 to 11 November 1975
John Malcolm Fraser	11 November 1975 to 5 March 1983
Robert James Lee Hawke	5 March 1983 to 19 December 1991
Paul John Keating	19 December 1991 to 2 March 1996
John Howard	2 March 1996 to present

THE PLATYPUS

'So', you're thinking, 'if the echidna is one of only two monotremes what's the other?' Once more, we need only turn to our Aussie loose change to find the answer. And there, adorning the 20 cent coin, is the world's other egg-laying mammal, the platypus. Who needs books when you've got money in your pocket?

THE MELBOURNE CUP

In a country that loves horseracing, the Melbourne Cup is unquestionably Australia's most important racing event. It combines the glamour and festival of England's Royal Ascot with the drama and popular appeal of Aintree's Grand National. The result is a sporting spectacle that stops the nation in its tracks.

THE MELBOURNE CUP (CONT'D)

The Victoria Racing club oversees the event, which is held at Flemington Racecourse and draws prize money of more than A$4 million (£1.65 million). Just as at Ascot, ladies attending the race try to outdo one another with elaborate outfits and ostentatious millinery. For the rest of Australia, Melbourne Cup day means a trip to the bookies, with betting usually exceeding A$2 million (£800,000).

The race itself, which is held on the first Tuesday in November, is the climax of the spring horseracing festival. The first race was run in 1861 and was won by Archer (who also won the following year) in a time of 3 minutes 52 seconds. The current course record is 3 minutes 16.3 seconds, which was set by Kingston Rule in 1990. Kingston Rule was trained by J Cummings, who has trained Melbourne Cup winners on ten occasions.

NUDE FEATURE

According to most Australians, taboos were made to be broken. So it is no surprise to find out that the first woman to appear nude in a non-porn feature film was Australian Annette Kellerman (1888–1978). Former swimming star Annette had already scandalised society by wearing a one-piece bathing suit of her own design in 1911 – a time when women kept even their ankles under wraps. (If this wasn't enough excitement in one afternoon, some American cinema audiences were handed an envelope at the turnstile, containing a 36-inch tape measure with Ms Kellerman's vital statistics appropriately marked.)

Kellerman stripped off entirely for her role in the film *Daughter Of The Gods*, made in 1916 in Jamaica. She caused something of a stir and the moral code that governed Hollywood was swiftly tightened so few followed in her footsteps. However, she was sufficiently glorious and notorious to be the subject of the bio-pic made in the US in 1953 with Esther Williams in the leading role. With taboos firmly back in place, Ms Williams skipped the nude scene altogether.

AUSSIE SLANG

Back in the 1980s, Australian vernacular could seem bizarre, inpenetrable and extremely confusing. Thankfully, via the educational medium of the television soap opera, the British (and many other nationalities) have been able to acquire sufficient knowledge of Aussie slang to get by down under. From the early days of the acrylic-clad *Young Doctors*, to the heady 21st-

century mix of sun, surf and teenage angst served up by the casts of *Neighbours* and *Home And Away*, the Aussie soap has been providing a valuable service to Brits bound for the Antipodes. So, thanks to actors such as Stefan Dennis, Kylie Minogue and Mark Little, Brits are now au fait with words like 'grog' (alcohol), 'Sheila' (woman), 'dunny' (toilet) and a veritable lexicon of other Antipodean phrases. Of course, there are always a few that slip through the net, so here's a quick glossary of some useful Aussie slang.

Billabong

The name given to a watering hole in a semi-dry river. You will also see this word adorning the clothes of surf dudes and other style-conscious young Australians due to the fashion label of the same name.

Blowie

You may be relieved to learn that this word does not relate to anything lewd or illicit. It merely refers to an annoying insect – the humble blowfly.

Fossicking

This is one of those slang words you won't second-guess. It's used to describe the practice of seeking out precious stones, gold, etc.

Garbo

No, nothing to do with glamorous Hollywood stars of a bygone era. Instead, just the slang name for the garbage man.

Hoon

This is a derogatory word used to describe an annoying loudmouth. Typically heard in pubs – for example, 'That hoon [loudmouth] playing the pokie [fruit machine] is no cobber [friend] of mine. He looks like a swagman [tramp] and behaves like an ocker [idiot].'

Sandshoes

In Australia, just like everywhere else in the developed world, sports shoes are *de rigueur* for the cool and casual. Some Aussies call them sandshoes, others use the English ('trainers'), while some opt for the American influence and call them 'sneakers'.

LILLIPUTIANS IN THE NORTHERN TERRITORY

Lilliput, the fictional land inhabited by small people in Jonathan Swift's *Gulliver's Travels*, was located on the 30th parallel of south latitude, northwest of Van Diemen's Land…right in the middle of…Australia. Swift wrote his book 44 years before Captain Cook took possession of the country on behalf of England. Maybe somebody should have a close look for a colony of Lilliputians in the southern reaches of the Northern Territory?

PUBLIC LAND

Of Australia's 1,767,000 square km (682,000 square miles) of public land, only 10,000 square km (3,900 square miles) are designated as Aboriginal-freehold National Park. All of this land is located in the Northern Territory.

HIGHS AND LOWS

The highest recorded temperature in Australia came at Cloncurry (Queensland) in 1889, with the mercury rising to a blood-boiling 53°C (127.4°F). By contrast, Charlotte Pass (New South Wales) holds the record for the country's lowest recorded temperature, which came in 1994, at -23°C (-9.5°F).

BODYLINE

The most controversial of all cricket series came in 1932/33, when England contested the Ashes on Australian soil. The so-called 'Bodyline series' prompted a diplomatic storm, with the two nations' international cricket boards meeting at loggerheads prior to some behind-the-scenes negotiation at government level. The tour was eventually completed, with England winning the series as the Australian Board of Control continued its mutterings of dissatisfaction. The controversy centred around England's bowling tactics, which the Australians claimed were unsporting and dangerous, but which the tourists believed were legitimate and within the rules of the game.

England had travelled to the Antipodes with one major problem – Don Bradman. The Don was at the peak of his powers in 1932 and had averaged 139 during the previous Ashes tour of England in 1930. England captain Douglas Jardine knew he would have to stop the world's best batsman to have a chance of reclaiming the Ashes. The solution came with what was known as 'leg theory', which had been around for years but which had only ever enjoyed modest success in first-class cricket. Instead of bowling an offside line (to the left of the wicket as the bowler runs in to face a right-handed bat) – the orthodox mode of attack – the bowler targets the leg side, pitching the ball on leg stump or outside. The ball is dug in short, which means deliveries usually meet the batsman between waist and head, often arriving uncomfortably around the armpit. The tactic is completed by a field placing that sees a ring of fielders placed close in on the leg side around the bat, with only one or two men left on the offside to save runs should the ball be erroneously pitched on that side of the wicket.

Bodyline field placings

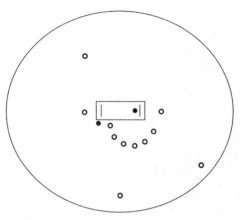

● Batsmen
○ Fielders

Traditional cricket field placings

BODYLINE (CONT'D)

The net effect is one of intimidation. The batsman knows that if he leaves the ball it is likely to hit him on the torso, but if he makes a shot he will be caught if unable to control the ball perfectly. Playing shots on the vacant offside is virtually impossible unless the ball is bowled poorly or the batsman makes room by backing away from the wicket, but this obviously makes him vulnerable to a straight ball bowled on a full length. It sounds simple enough, but requires a bowler who is both fast enough to hurry the batsman and accurate enough to hit a consistent leg-side line. Fortunately for Jardine, England had just the man in former Nottinghamshire coalminer Harold Larwood.

England won the first Test convincingly against an Australian side that was missing Bradman through ill-health. Bradman was back for the next Test, in Melbourne, scoring 103 not out to help the home side to victory by 111 runs. However, not even the Don could save the Aussies in the third Test in Adelaide, which exploded in controversy.

Australian batsmen Bertie Oldfield and Bill Woodfull were both struck, with the former suffering a fractured skull. When Woodfull was struck, the England field switched to the leg side, prompting the batsman to comment that only one side was playing cricket. The Australian Board of Control sent a cable to its counterpart at England's MCC, protesting about the tourists' tactics, which were described as 'unsportsmanlike'. The MCC's sensibilities were offended and it offered to cancel the tour. The cables continued, and after some diplomatic brinksmanship the tour was completed, with England winning the series 4–1. Ironically, Bradman still topped the batting averages, with a mean total of 56. Larwood, unsurprisingly, topped the bowling figures with 33 wickets, at an average of less than 20.

It would take years for Anglo-Australian cricketing relations to recover to the position of 'friendly animosity' that had characterised the situation prior to the events of 1932/33. In the years after the Bodyline tour, Jardine was left to defend his team's tactics: 'What is the body-line?' asked the England captain in an interview with the *London Evening News* in 1933. 'The term was coined by a sensational Press to explain or excuse defeat, and would have died a natural and speedy death had it not been adopted by the Australian Board of Control in its lamentable wire to the MCC.'

The Australians pointed the finger of blame squarely at Jardine for the perceived injustice of the bodyline tactics. Larwood was not held culpable and was even admired by many of his adversaries, with no lesser figure than Bradman declaring that, 'Larwood was outstanding. How he ever stood the strain of bowling at such terrific speed match after match I don't know.'

THE SAND ZONE

Australians may call their country the Godzone (as in 'God's own country'),
but perhaps it would be more accurate to describe it as the sand zone.
Australasia is the driest continent in the world (apart from Antarctica); 70 per
cent of Australia's mainland is considered arid or semi-arid (receiving less
than 500mm/20in of rain annually), while half that area is defined as desert.
The five largest deserts make up 14 per cent of Australia's landmass, totalling
more than 1,000,000 square km (390,000 square miles). But deserts aren't all
sand and dust...

Great Victoria Desert (South Australia/Western Australia)

The biggest desert in Australia spans around 350,000 square km (135 square
miles) and extends outside the boundary of Western Australia and into South
Australia and the Nullarbor Plain. This one's a classic sandy, sparsely
populated desert, with rainfall rarely rising above 250mm (10in) per annum.

Great Sandy Desert (Western Australia)

The clue's in the name... Yep, this is another sandy desert. It lies to the north
of the Great Victoria Desert and is a flat area between the Pilbara and
Kimberley rocky ranges. Western Australia is a large state and it certainly has
its fair share of desert. The Great Sandy – there is also a Little Sandy Desert,
which spans a modest 111,000 square km (43,000 square miles) – is 267,000
square km (100 square miles) and endures some of the most extreme
climatic conditions in the country. Temperatures in summer are as hot as
anywhere in Australia and much of the region's rainfall arrives during
monsoon thunderstorms and tropical cyclones.

Tanami (Northern Territory)

Hot and uninviting and situated to the northwest of Alice Springs, Tanami is
not a popular attraction with tourists. It extends into Western Australia and
takes up 2.4 per cent of the country's landmass.

Simpson Desert (Northern Territory/South Australia)

With temperatures often reaching 40˚C (104°F), the Simpson Desert is not an
inviting place in summer. However, some visitors like to explore the sand
dunes in winter, though they need a four-wheel drive to navigate its
rudimentary roads.

Gibson Desert (Western Australia)

With its Aboriginal reserves and rocky outcrops, the Gibson Desert provides a
relatively varied landscape...for a desert, anyway. Of course, it's still hot, with
rainfall almost exclusively provided by storms and cyclones.

SOAPLESS

Ten Australian musical acts that contain no soap actors:

- Counting Crows
- AC/DC
- Hoodoo Gurus
- INXS
- Men At Work
- Midnight Oil
- Nick Cave And The Bad Seeds
- Rick Springfield
- Savage Garden
- The Vines.

LIFE'S A BEACH

Australia has 7,000 beaches – which is more than any other country in the world.

THE DON ENDS WITH A DUCK

Don Bradman was unquestionably Australia's greatest ever batsman. For nearly 20 years he dominated the sport of cricket, monopolising back-page headlines and turning international bowlers into quivering wrecks.

Bradman's final Test appearance came on an emotional day against England at the Oval in 1948. Australia held an unassailable 3–0 lead in the five-match series going into the final Test, and the tourists were already well in control of the game when the Don strode out to the wicket for his last innings on the international stage. The England captain, Yardley, gathered his men around him and called for three cheers for Bradman. Much enthusiastic shaking of hands followed before the Australian skipper took guard.

There were rumoured to be tears in Bradman's eyes (though the player himself denied this) as Hollies ran in to bowl. The first ball was good and was resolutely blocked by Australia's veteran stroke player. The next drew Bradman forward but he missed the ball and it crashed into his stumps. It was not the ending that had been scripted. Having cheered him to the middle, the Oval crowd then cheered no less heartily at his dismissal.

What few people had failed to recognise was that Bradman needed just four runs to end his Test career with an average of 100 runs. Hence, his failure at the Oval became the most famous duck in cricket history. 'I'm very sorry I made a duck,' Bradman later explained. 'I'd have been glad if I'd made those four extra runs to have an average of 100. I didn't know it at the time and I don't think the Englishmen knew it, either. I think if they had known it they may have been generous enough to let me get four.'

IT'S NOT ALL DESERT AND BUSH

Australia may not be renowned for its water bodies, but there are nevertheless some notable lakes and reservoirs. Some are natural, others are man-made – constructed to meet power or water supply needs – but all are wet and welcome in the driest continent in the world (apart from Antarctica). The five biggest lakes in Australia are:

Lake	State/territory	Area in square km (square miles)
Lake Eyre (salt)	South Australia	9,500 (3,670)
Lake Mackay	Northern Territory/ Western Australia	3,494 (1,350)
Lake Amadeus (seasonal)	Northern Territory	1,032 (400)
Lake Garnpung (salt)	New South Wales	542 (210)
Lake Gordon	Tasmania	270 (104)

AUSSIES LOOK ON THE BRIGHT SIDE

'Australians have confidence, they are comfortable, positive, self assured, happy, believe that everything will turn out well.

'Ask someone in Australia how they are going and the automatic reply will be "good thanks".'

Jane Mulkerrins in *The Australian*, 26 July 2001

MOB ROOS

The correct term for a group of kangaroos is a mob.

SCHOOL TERM TIMES

No matter how much you like kids, most of us would rather take our vacations when other people's little smashers are still at school... otherwise it's time to queue, pay top whack and await the dulcet tones of teenage whingeing. So, if you're going on holiday to Australia, you may be glad of the following (though approximate) term dates for the country's education authorities.

Australian Capital Territory, Western Australia, New South Wales

Term 1	end of January to mid-April
Term 2	end of April to early July
Term 3	last week of July to end of September
Term 4	mid-October to mid-December

Northern Territory

Term 1	end of January to early April
Term 2	mid-April to last week of June
Term 3	last week of July to end September
Term 4	early October to mid-December

Queensland and Victoria

Term 1	end of January to mid-April
Term 2	end of April to end of June
Term 3	mid-July to last week of September
Term 4	early October to mid-December

Tasmania

Term 1	mid-February to end of May
Term 2	mid-June to early September
Term 3	last week of September to mid-December

SEA SNAKES

The Great Barrier Reef is home to a mere 16 species of sea snake.

SELECTED AUSTRALIAN PUBLIC HOLIDAYS

January
26 – Australia Day

March
1st Monday – Labor Day (Western Australia), Eight-Hour Day (Tasmania)
2nd Monday – Labor Day (Victoria)
3rd Monday – Labor Day (Australian Capital Territory)

April
25 – Anzac Day

May
1st Monday – Labor Day (Queensland), May Day (Northern Territory)

August
1 – Wattle Day (some states)
1st Monday – Bank Holiday (New South Wales)

September
1 – Wattle Day (some states)

October
1st Monday – Labor Day (New South Wales and Australian Capital Territory)
2nd Monday – Labor Day (South Australia)

November
1st Tuesday – Melbourne Cup Day (Melbourne metro only)
11 – Remembrance Day

December
28 – Proclamation Day (South Australia)

NO WHINGERS

Australians have a pathological hatred of whingers. There's nothing they loathe more than a persistent and pathetic complainer, particularly if the offending individual is English. One theory as to why they dislike them so much refers back to the convict settlers, who soon learned that they would suffer more if they complained about corporal punishment or moaned to their guards. Such behaviour was likely to invoke further punishment and would also give their tormentor a sense of satisfaction that they felt was unnecessary and unmerited. As JF Mortlock noted in *Experiences Of A Convict* in 1864, 'In Australia, silent composure under suffering is strictly prescribed by convict etiquette.'

PLASTIC NOTES AND X-RAYS

Australians are fundamentally modern, forward-looking folk. They are not people who respect tradition for tradition's sake, nor do they believe that the old ways are the best. Unsurprisingly, Australia has an impressive track record when it comes to inventions.

If there's a better, quicker or more economical way to do something, you can be sure that it won't be ignored down under. Take plastic banknotes – the rest of the world was satisfied with paper, but in 1988 the Aussies bucked the trend (if you'll forgive the pun) and issued plastic cash. It proved an instant success and was soon being copied (though not forged) in countries throughout the world.

Sure, you say, but the invention of plastic banknotes is hardly the stuff of the Lumière brothers or Mr Alexander Graham Bell. So, what else have the Aussie eggheads brought us?

How about X-rays? Adelaide-born Sir William Lawrence Bragg claimed the 1915 Nobel Prize for Physics for his work on X-ray diffraction crystals. Bragg, working with his father, is credited with taking the first diagnostic X-ray, which was performed on his younger brother's suspected broken arm.

Australia has also given medical science a vaccine to combat skin cancer. Patients who have melanomas detected early can now be treated with special human immune cells grown in a laboratory from the patient's own blood. The cells are then exposed to tumour cells, which apparently stimulate the immune system, making it more effective at fighting off tumours.

The list of Aussie medico-scientific breakthroughs is seemingly endless. The simpliRED HIV test has provided a straightforward two-minute diagnosis; Broncostat has eased the suffering of many bronchitis patients; and Aussie scientists have also been at the forefront of developments in the field of in-vitro fertilisation.

PRISONERS OF MOTHER ENGLAND

As is well documented, Australians hold the English in great affection and, as you might expect, they have their own term of endearment for their former colonial governors. The term 'POME' (or 'Pom'), usually used in close proximity to the word 'whingeing', is thought to be an acronym that stands for 'Prisoners Of Mother England'.

EVERYTHING YOU DIDN'T NEED TO KNOW ABOUT AUSTRALIA

AUSTRALIA GETS A NEW ANTHEM

Contrary to popular belief, Australia's national anthem is not – and has never been – 'Waltzing Matilda'. Up until the mid-1980s, Australians had to put up with 'God Save The Queen' (no, not The Sex Pistols' version!) as their official song, but in 1984 they finally got their own anthem in the shape of 'Advance Australia Fair'.

Sir Ninian Martin Stephen, Governor-General of the Commonwealth of Australia, was the man charged with announcing the adoption of the new song on 19 April 1984. However, he explained that the 'anthem "God Save The Queen" shall henceforth be known as the Royal Anthem and be used in the presence of Her Majesty The Queen or a member of the Royal Family'.

Advance Australia Fair
Australians all let us rejoice,
For we are young and free,
We've golden soil and wealth for toil;
Our home is girt by sea;
Our land abounds in nature's gifts
Of beauty rich and rare,
In history's page, let every stage
Advance Australia Fair.
In joyful strains then let us sing,
Advance Australia Fair.

Beneath our radiant Southern Cross
We'll toil with hearts and hands;
To make this Commonwealth of ours
Renowned of all the lands;
For those who've come across the seas
We've boundless plains to share;
With courage let us all combine
To Advance Australia Fair.
In joyful strains then let us sing,
Advance Australia Fair.

NED KELLY...AN AUSTRALIAN HERO

'[Ned] Kelly is a quintessentially Australian hero. He appeals to Australians' innate rebelliousness and distrust of authority.'
Kathy Marks in the *Canberra Sunday Times*, November 2000

AUSTRALIAN NOBEL PRIZE WINNERS

1915 Sir William Lawrence Bragg (Physics) for work on X-ray diffraction of crystals

1945 Sir Howard Walter Florey (Physiology or Medicine) for the development of penicillin into an anti-bacterial drug

1960 Sir Frank Macfarlane Burnet (Physiology or Medicine) for work on acquired immunological tolerance to tissue transplants

1963 Sir John Carew Eccles (Physiology or Medicine) for work on brain physiology and the nervous system

1975 Sir John Warcup Cornforth (Chemistry) for work on the structure of living matter

1996 Peter Charles Doherty (Physiology or Medicine) for work in immunology

LEGENDARY AUSTRALIANS: ERROL FLYNN

It would be fair to say that Errol Flynn is Tasmania's most famous son. Born on the island in 1909, he was something of a bad boy in his youth and, in truth, never lost his reputation for hedonistic excess throughout his career as a Hollywood heartthrob.

Errol's working life began as a shipping clerk before he got his big break in the Australian-made film, *In the Wake of the Bounty* in 1933. He then travelled to England where he gained experience in theatre work with the Northampton Repertory Company before winning a part in a film made by Warner Brothers in London.

A Hollywood contract duly followed, and Errol established himself as a dashing leading man with swordfighting and romantic roles a speciality. Off-screen his sexual appetite became legendary, spawning the somewhat graphic and less than salubrious saying 'in like Flynn', which is used when a person affects an action without hesitancy and with great speed. Errol died in 1959, shortly after he finished work on his last film, *Cuban Rebel Girls*.

FROM SURVIVOR TO PLAYMATE

The Australian bush is renowned for many things, but not usually as a scouting ground for *Playboy* magazine's legendary publisher Hugh Hefner. That is, until reality TV show *Survivor* filmed there in 2001, and Hefner caught sight of bikini-clad 30-year-old Jerri Manthey. In July 2001, *Playboy* carried a ten-page spread on Jerri, who was dubbed 'the Barramundi beauty' on the programme.

WIRE AND PANTYHOSE

According to an old Australian proverb,
'If it can't be fixed with pantyhose [tights]
and fence wire then it isn't worth fixing.'
This is not actually true.

WALTZING MATILDA

Once a jolly swagman camped by a billabong
Under the shade of a coolibah tree
And he sang as he watched and waited till his billy boiled
Who'll come a waltzing Matilda with me

Waltzing Matilda, waltzing Matilda, who'll come a waltzing Matilda with me
And he sang as he watched and waited till his billy boiled
Who'll come a waltzing Matilda with me

Down came a jumbuck to drink at that billabong
Up jumped the swagman and grabbed him with glee
And he sang as he shoved that jumbuck in his tucker bag
Who'll come a waltzing Matilda with me

Waltzing Matilda, waltzing Matilda, who'll come a waltzing Matilda with me
And he sang as he shoved that jumbuck in his tucker bag
Who'll come a waltzing Matilda with me

Up rode the squatter mounted on his thorough-bred
Down came the troopers, one two three
Who's that jolly jumbuck you've got in your tucker bag
Who'll come a waltzing Matilda with me

Waltzing Matilda, waltzing Matilda, who'll come a waltzing Matilda with me
Who's that jolly jumbuck you've got in your tucker-bag
Who'll come a waltzing Matilda with me.

Up jumped the swagman sprang in to the billabong
You'll never catch me alive said he
And his ghost may be heard as you pass by that billabong
Who'll come a waltzing Matilda with me

Waltzing Matilda, waltzing Matilda, who'll come a waltzing Matilda with me
And his ghost may be heard as you pass by that billabong
Who'll come a waltzing Matilda with me

10 RANDOM FACTS ABOUT TASMANIAN DEVILS

- Devils have extremely strong jaws – a 10kg (22lb) animal can bite as powerfully as a 40kg (88lb) dog.

- You will often see TDs with cuts on their faces. These have usually been acquired through fighting with other TDs. Alternatively, they might have been inflicted by a female fending off unwanted male attention at the end of the mating season.

- TDs are greedy...devils. They can eat up to 40 per cent of their body weight in half an hour.

- There is evidence that devils used to live in Papua New Guinea and the Australian mainland, but it seems they became extinct several thousand years ago, probably due to competition from other carnivores.

- TDs are not slow – they can outrun a human on rough terrain and will give you a good race on flat, smooth land.

- It's not only running that TDs are good at. They are also excellent swimmers, so if you could teach one to ride a bike, you'd have a compact and ferocious-looking triathlon competitor on your hands.

- There is no evidence that TDs have ever actively engaged in any satanic rituals or rites.

- There are fewer than 200,000 wild TDs in the world, but they are not an endangered species.

- Traffic is not a friend of the TD – they will often venture into the road to feed on a freshly mowed-down wallaby, only to suffer the same fate themselves.

- When stressed or excited, a TD's ears may turn red. It might also yawn, raise its tail or scream.

ALLAN BORDER

Australian cricket was not at its best when Allan Border took charge as captain of the national team in the 1980s, but the Sydney-born left-hander oversaw an unexpected and dramatic renaissance in fortunes. By the time of his Test retirement in 1994, the Australian team was back at the pinnacle of the international game.

As a batsman, Border was a skilful and powerful left-handed stroke player, but it was as a leader that he truly made his mark. Under his tutelage, Australia played as a team, where before they had relied on inspirational

performances from one or two gifted individuals in order to win matches. Border placed great stock in the virtues of solid fielding, disciplined batting and bowling and, most of all, a competitive, professional spirit. The results were impressive, taking in a host of Test victories and, most importantly, three successive Ashes triumphs.

HUGHES OUTSLEDGES ATHERS

'Athers could never really get through to me because he was far too intelligent. Most of what he said went clear over my head.'

Legendary Australian bowler Merv Hughes explaining how he dealt with verbals from England batsman Michael Atherton

THE BAD MEN OF THE BUSH

Bushrangers were bad men, but (like highwaymen and pirates) many became folk heroes, romanticised for their daring and apparent sense of social justice. In truth, of course, while many stole from the rich, few (if any) bushrangers gave to the poor. Most merely preyed upon the rich pickings of the gold rush era, ill-protected farmers and those who were unfortunate enough to cross their paths.

Some had turned to crime in preference to sweating out a miserable existence in the early penal settlements; others were seduced by greed or by the romantic image of the bushranger as portrayed in folklore. However, many men took the ranger route during the gold rush era of the mid-18th century. At this time, any Australian who could ride a horse and wield a spade headed for the gold fields looking for his or her fortune. This exodus left Australia short of policemen, with officers casting aside their uniforms to join the throng at the gold fields. Farmers were also left short-handed, giving bushrangers easy pickings of livestock and little fear of detection and punishment. Stealing sheep and horses could not compete with the rewards of robbing a cargo of bullion, though, and the roads to Melbourne and Sydney became particularly perilous.

However, despite their violence and criminality, many bushrangers became popular figures, gaining notoriety and enjoying the sympathies of the poorer classes, who identified with the rangers (whom they believed were striking a blow against authority and the middle classes). Some, like Ned Kelly, were smart enough to build on this goodwill and used their PR skills to gather support.

THE TASMANIAN TIGER

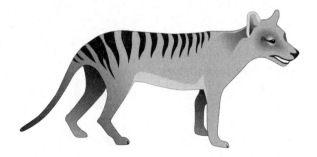

The coming of European settlement to the Antipodes had a devastating effect on not only human life but also the animal kingdom. In the last 200 years, 50 per cent of native mammal species have become extinct on mainland Australia. Tasmania's record is rather better – except, that is, for the sorry tale of the thylacine, also known as the Tasmanian tiger, which has been extinct since the 1930s.

The thylacine was the largest marsupial carnivore since the extinction of the thylacoleo (marsupial lion; see 'Megafauna', page 50). It was not a tiger at all, and its physical characteristics had more in common with a big dog with a large head. However, its fur, though predominantly brown, was decorated with dark stripes – hence the 'tiger' moniker.

Despite their size – typically about 60cm (2ft) tall and 1.80m (6ft) long – and their somewhat fearsome appearance, thylacines were shy, quiet and nervous creatures who bore no threat to humans. When caught by humans, they would usually give up without a fight and would sometimes die of shock.

They fed mainly on wallabies, though would also eat smaller mammals. Following European settlement on Tasmania in the early 19th century, tales of thylacines hunting livestock soon began to circulate. Stories quickly became embellished, and in 1830 a bounty was introduced to encourage hunters to kill these animals. By 1909, when the government withdrew the bounty scheme, the damage had already been done, and in 1936 the last captive Tasmanian tiger died. The species was declared extinct 50 years later.

JELLYFISH AND COMMON SENSE

The notorious box jellyfish is a super-toxic killer with a big reputation and venom to match. However, what few of us know is that Australia is also home to a smaller, but no less deadly, jellyfish. It is the Irukandji which is currently occupying the efforts of the Australian Venom Research Unit (AVRU), which is seeking to find an anti-venom for this troublesome invertebrate. The Irukandji is found in the northern waters of Australia and each year more than 60 people are hospitalised with 'Irukandji syndrome', most after coming into contact with jellyfish washed towards the shore from its preferred habitat in deep water.

The sting from an Irukandji is apparently not particularly painful, but, according to the AVRU, 'approximately 30 minutes later, some patients may develop a complex of systemic symptoms including severe abdominal pain, back, limb or joint pain, nausea and vomiting, profuse sweating and agitation. They may also experience numbness or paraesthesia'.

Thankfully the AVRU is working hard to find an anti-venom to help combat Irukandji syndrome. A team of scientists (the Unit's top boffins, in other words) are working on the project. In the meantime, it is a good idea to avoid all jellyfish and to seek medical advice if stung. It is also a good idea to look both ways before crossing the road, to resist the temptation to swim in crocodile-infested billabongs or to ask to see the vegan menu in an outback café. All this advice is provided freely and without prejudice.

LEECHES

'Slugs with teeth' would be a fair description of those most invidious of invertebrates – leeches. The bad news is that leeches down under can measure as much as 200mm (8in) when fully extended. The good news is that the Australian land leech has only two jaws (presumably some leeches have more!), which make a V-shaped incision in its victim. In truth, though leeches are vile, they are not particularly dangerous.

A hungry leech will lie in wait for a host to approach and will attach itself when its anterior sucker touches the animal or person. The leech's body will become rigid, to hold the sucker in place as its makes an incision in the skin, and once in place the leech secretes a special mucus into the wound. This acts as an anti-coagulant, keeping the blood flowing. Nice...

People have tried a variety of concoctions to repel leeches and keep them from getting on board. Soap, lemon juice, eucalyptus oil, insect repellent and physical barriers like stockings and socks have all been used with varying degrees of success.

THE KEG ON LEGS

Cricketer David Boon is more than a mere sporting legend in Australia. He's an icon, the very epitome of Aussie blokedom and a hero to larrikins (rowdy, hedonistic fellows) everywhere. So what was so special about the moustachioed Tasmanian?

First, and most important, Boon was a fantastic batsman (averaging 43.65 in Test matches and scoring 23,000 runs in first-class cricket). He was a buccaneering bat, bludgeoning opposing bowlers with his powerful stroke play and uncompromising nature.

But what endeared him most to Australia's sporting public was his all-round and unashamed blokiness. Powerfully built, straight talking and with a penchant for inflicting humiliating defeats upon the English, Boon was a kindred spirit for a certain section of Aussie cricket fans. His capacity to consume alcohol was also reputed to be immense.

Former team-mate Rodney Marsh called him the 'keg on legs', and in 1989 – en route to play an Ashes tour – he was alleged to have set a new record for the number of 'tinnies' consumed on a flight from Sydney to London, necking no fewer than 52 cans.

On the eve of his retirement in 1999, Boon was asked by an interviewer to comment on his legendary drinking spree: 'It's all a Merv Hughes fairytale. We had a few beers, but it wasn't anything dramatic,' said Boon.

AUSTRALIA'S NOTORIOUS BUSHRANGERS

Ned Kelly
See page 69.

'Mad Dan' Morgan
Notoriously violent and murderous, Mad Dan Morgan's head was removed from his corpse and sent to Melbourne for examination after his capture. Apparently the authorities wanted to try and discover what had made him so mad and bad.

Harry Powers
Harry was one of the Robin Hood guys. A PR expert, he was known as the 'Gentleman Bushranger', and is most famous for an early alliance with the 15-year-old Ned Kelly.

Ben Hall
Hall turned to crime after a wrongful arrest precipitated the complete collapse of his law-abiding life. He took up with the notorious Gardiner

gang and quickly embraced the life of a bushranger. He went on to form his own gang and took great pleasure in humiliating the police officers who tried to capture him. The press loved Hall and frequently lampooned the cops for their failure to put a halt to his antics. Along with Charlie Gilbert and Johnny Dunn, Ben Hall became the first Australian to receive outlaw status. He was betrayed by a friend who drew him into a police ambush which shot him dead, aged 27.

Martin Cash

Tasmania's most famous bushranger was born in Ireland. Martin Cash was another ranger who stole from the rich, even if the distribution to the poor failed to materialise. He was also one of the few notorious rangers who didn't meet a violent end. He spent much time in and out of jail, but died a free man at the age of 69, having written his memoirs some years earlier.

George Scott

George Scott earned his 'Captain Moonlite' nickname after turning to crime out of desperation, during a period of severe drought and unemployment. He was captured during a police siege and sentenced to death.

John Vane

Born to law-abiding settlers, Vane turned to crime out of boredom and in a quest to make easy money after meeting a kindred spirit in the shape of fellow bushranger Mickey Burke at the Turon Gold Diggings. He joined the notorious Ben Hall's gang and was involved in various robberies and assaults, but eventually turned himself in after Burke was killed in a shootout. Vane was sentenced to 15 years in jail, and on his release he returned to petty crime. He retired from wrongdoing in the 1890s and wrote his autobiography.

UTTERLY OPAL-LESS FACT

Australia is the only country on earth where 'opalised' fossils have been found. Most of these oddities have been uncovered around Lightning Ridge in New South Wales.

BEAUTIFUL LIES

'Australian history is almost always picturesque; indeed, it is also so curious and strange, that it is itself the chiefest novelty the country has to offer and so it pushes the other novelties into second and third place. It does not read like history, but like the most beautiful lies; and all of a fresh new sort, no mouldy old stale ones.' *Mark Twain, 1897*

SOCCER BABES BARE ALL

From muscle-bound firemen to the loose-fleshed ladies of the Women's Insitute, anybody short on modesty and eager for exposure seems to be making a nude calendar these days. In 1999, the Australian women's football team followed suit, posing for a fundraising and controversial calendar.

'There's full frontal, the whole business… It's very exciting,' claimed right-back and Miss June, Amy Taylor, at the calendar's launch. 'I wanted to prove we are not all big, butch lesbians. We are attractive, feminine girls.'

Apparently, 45,000 calendars were printed, each netting A$1 (40p) for the charity, but the calendar did not meet with universal approval, particularly as one revealing shot featured a girl of just 17. But 21-year-old Tracie McGovern made no apologies for the calendar, telling reporters, 'There's been a few people upset by it and we have to respect their opinion but they need to show us respect as well.'

SPIDERS

Whenever someone discusses a planned trip to Australia, at least one friend will bring up the topic of spiders or, to be more particular, big, hairy, poisonous spiders. Of course most of it is scaremongery, aimed to incite anxiety and paranoia. Fortunately, the Australian Venom Research Unit (AVRU) provides scientific advice and information on all of the country's toxic arachnids.

Apparently, the main four spiders to watch out for are:

- funnel-web spiders
- white-tailed spiders
- redback spiders
- mouse spiders.

BEACH BUMS

An estimated 80 per cent of Australians live on the coast…but if you consider that the interior of the country is dominated by desert, there's not exactly much choice on the matter!

ROUND THE WORLD

To circumnavigate the coastline of Australia, you would need to travel more than 19,000km (12,000 miles). This is the same distance as sailing from Sydney to London via the Suez Canal.

SLIP, SLOP, SLAP

There have been few more successful health initiatives than Australia's famous 'Slip, Slop, Slap' campaign of the 1980s. The aim of this alliterative campaign was to combat a rapidly rising melanoma rate and raise awareness of the preventative measures on offer.

'Slip, Slop, Slap' began in Queensland in 1981, but soon went national. The message was brought home by a singing seagull called Sid – totally resplendent in surf shorts and sunhat – who crowed out the following jingle:

Slip, Slop, Slap!
It sounds like a breeze when you say it like that
Slip, Slop, Slap!
In the sun we always say 'Slip Slop Slap!'

Slip, Slop, Slap!
Slip on a shirt, slop on sunscreen and slap on a hat,
Slip, Slop, Slap!
You can stop skin cancer – say: 'Slip Slop Slap!'

The jingle soon caught the imagination of the nation and coincided with a shift in attitude towards sunbathing. Sales of tanning oils fell as sunscreen, sunhats and protective sunglasses became de rigueur for the hordes flocking to Australia's beaches each summer.

The original ad has spawned further initiatives, like the SunSmart programme for schools and local communities, not to mention a succession of advertisements starring not only Sid the seagull but also his offspring…all singing, and all dancing.

On the 21st anniversary of the 'Slip, Slop, Slap' campaign, Dr Samantha Conias from the Australasian College of Dermatologists told the media that the campaign had been a huge success. 'While sun protection is important throughout life, it is particularly significant during childhood years and this hugely popular campaign got through to children and their parents,' she said. 'Has the campaign been a success in tackling skin cancer? Yes it has.'

EXCUSING ENGLAND

'When Australia lose, we look for reasons. When England lose, they look for excuses.' *Merv Hughes*

POISONOUS PLATYPUS

It would not be unfair to describe the duck-billed platypus (DBP) as a strange-looking creature. With its furry body, webbed feet, long flattened tail, and a snout shaped like – you guessed it – a duck's bill, the platypus looks like the animal God made with all the left-over bits. However, don't take this amphibious critter too lightly, as he packs a poisonous punch.

Male platypi have a hollow, sharp, horny spur on the inside of each hind leg, which connects to a venom gland. The platypus will use the spur to fend off potential predators and also to fight with rival males. A sting from a DBP will cause extreme pain in humans and is strong enough to kill a small dog.

THE EUREKA REBELLION

Rebellion is not the Australian way. Only once in the country's history have civilians challenged officialdom with a significant show of force. It came in 1854, when gold miners and prospectors rose up to fight for justice against a corrupt and inequitable colonial administration at Eureka in Victoria.

The tale of the Eureka rebellion makes for sorry reading, with the authorities burying their collective heads in the sand when an easily resolvable situation was allowed to spiral – albeit slowly – out of control.

The seeds of the uprising were sown by heavy-handed policing and duplicitous bureaucrats. Miners with genuine grievances about an unworkable and idiosyncratic system of licensing were ignored. The inevitable frustration caused by the system was intensified by the brutal exercise of police authority.

Heavy-handed and violent 'licence hunts', in which police stormed through the camps searching for unlicensed miners, became more frequent in September 1854, causing tensions to rise and an insurrection to seem ever more likely. October brought more evidence of corruption, with a dubious acquittal of an unpopular hotel owner and the conviction for assault of a 'crippled' and non-English-speaking aide to a local priest.

On 22 October, a group of around 10,000 miners met to share their grievances at Bakery Hill. A second meeting led to the formation of the Ballarat Reform League, but the organisation's attempts at negotiation and conciliation with the gold field's governor and commissioner were doomed.

The officials seemed hellbent on antagonising the miners, and the situation escalated still further.

A licence hunt at the end of November prompted the most militant of the miners to form a council of war, arming themselves and swearing allegiance to the blue Southern Cross flag. The miners dug in, building an impromptu stockade at Eureka and awaited a police attack. It duly came, in force, on 3 December. Outflanked and outgunned, the rebels were soon overpowered – 22 were killed, while many others were injured or taken prisoner.

Thirteen of the stockaders were tried, and – to great public acclaim – acquitted of treason. The miners had their actions further vindicated by a commission of inquiry, which roundly condemned the corrupt and nonsensical management of the gold fields.

The Eureka flag's five stars represent the Southern Cross, and the white cross joining the stars represents unity in defiance. It was designed by a Canadian gold miner by the name of 'Lieutenant' Ross.

TALL POPPY SYNDROME

If you read about Australian culture, you are sure to come across something called 'tall poppy syndrome'. Many commentators view the phenomenon as a plague to Aussie society, which serves only to undermine talent, while others regard it simply as an extension of the nation's intolerance of pretension and vanity.

So what is it? An old saying goes that, 'It is the tall poppy that is the first to be cut.' In the case of Australian society, the tall poppies are those who show signs of superiority or who are simply figures of authority. For this reason, some people argue that it is a legacy of Australia's past as a colony governed by a distant and insensitive imperial power.

The tall poppies, so the theory goes, are denigrated and cut down to size by fellow Australians, and it is this tendency that forms the basis of the syndrome. Those that have been cut down point blame at the syndrome, seeing it as a negative trait that serves only to stifle confidence and suppress talent. According to these people, the syndrome has variously been responsible for political, economic and social problems, as well as perceived shortcomings in the arts.

Defenders of the syndrome claim that it serves merely to stop people getting too big for their boots, and to encourage modesty and humility. They cite Australian celebrities – such as Don Bradman or John Farnham – who have excelled in their field, yet have avoided mass criticism, instead enjoying the affection of the nation.

MERVYN HUGHES

The rivalry between England and Australia in cricket is infamous, and when the two teams meet verbals fly as fast and as ferociously as a Dennis Lillee bouncer. In recent years, the Australians have dominated the war of words, with the men in green caps proving to be experts in the art of sledging (the practice of barracking an opponent, particularly a batsman standing at the wicket). The undoubted master of this offensive art was Mervyn Gregory Hughes.

As a cricketer, Merv was a decent enough player, but his talent as a bowler was exceeded by his competitive spirit and aggressive persona. He made his Test debut in 1985/86, but it was not until the early 1990s that he began to make his mark. With captain Allan Border looking to instil a new spirit of professionalism and determination into his men, Merv was the ideal standard-bearer. His appearance – crew cut, barrel chest and bushy moustache – was intimidating enough, but his colourful language and biting insults, spat out in a thick Victoria accent, were too much to bear for many batsmen.

Merv's contention that 'I only ever sledged batsmen that I respected' is small consolation for those he turned to quivering wrecks at the crease. On one occasion, Merv's insults toward England's Graeme Hick became so extreme that umpire Dickie Bird is reputed to have intervened, imploring Hughes to cease: 'Mervyn, Mervyn, those are terrible things to say. What has that nice Mr Hick done to you?'

DINGOES

Dingoes... We've all heard of them, and most of us have seen that film with Meryl Streep about the child snatched by these wild animals in the 1970s. But what's the real story behind these much-maligned and apparently dangerous dogs?

The scientists tell us that dingoes arrived in Australia about 4,000 years ago, coming along for the ride with adventurous Asian seafarers and apparently missing the boat home. The dingo's first crime, it seems, was effectively to wipe out thylacines (Tasmanian tigers) from mainland Australia, as it appears they competed for the same food.

Since then, the humble dingo has not always enjoyed the best press in the world. However, while some Australians regard them with disdain, others are determined to look after these much-maligned mutts. Chief among the dingo's allies is the Australian Dingo Conservation Association (ADCA), a

non-profit-making organisation that aims to 'protect the Australian Dingo and to lobby Governments, amend legislation, remove the dingo from the noxious list in all States and Territories and to promote scientific research on the dingo to maintain a pure gene pool of dingoes'.

The ADCA is involved in various initiatives intended to educate and inform the Australian public about dingoes. It also tries to raise awareness of the chief threats to both the animal and its habitat. Hybridisation with the domestic dog is the biggest peril to the dingo's gene pool, while poisoning, trapping and shooting offer a rather more obvious and direct source of danger. Erosion of habitat due to mankind's intrusion into bush and wilderness has forced the dingo into unsuitable areas and has also led to wider problems. First, there have been well-publicised instances of dingo attacks on humans, while, second, contact with mankind has brought with it increased contact with domestic dogs.

Although unquestionably wild animals, dingoes are kept by some people as pets. The term 'pets' is used advisedly, for although these animals can bond with humans and can even learn basic obedience they will never become entirely domesticated, nor will they lose their instinct to hunt.

WINE ON BEER

The Australian brewery Fosters is proud of its reputation as one of the world's premier beer manufacturers, but in 2002 the company made more money from sales of wine than from its 'amber nectar'.

SUNCREAM IS TAX-DEDUCTIBLE

In June 2002, the Federal Court of Australia ruled against the Tax Office in favour of a group of workers who had claimed that sun-protection products should be tax-deductible. Health and safety regulations in Australia state that outdoor workers must wear sunscreen and hats, but the Tax Office argued – somewhat curiously – that these products were no more than cosmetics and personal grooming items. Thankfully, common sense prevailed and the Federal Court ruled in favour of the workers.

PAY TV

Australians call cable and satellite TV (in all its guises) 'Pay TV'. And, what's more, they like it. The takeup rate has been significantly swifter than in England, and more than 1.5 million Aussies had signed up for subscriptions by the close of 2003.

10 DINGO FACTS

- Dingoes first came to Australia between 3,000 and 4,000 years ago, probably arriving on the continent from Asia with explorers and sailors from Asia.

- Dingoes cannot bark, although they can howl.

- Dingoes live in packs with defined hierarchies.

- Wombats, wallabies, kangaroos, lizards and rabbits make up their staple diet, but they have also been known to hunt sheep, birds and domestic dogs. Dingoes hunt collectively to tackle larger prey.

- The dingo breeds once a year (March to June), resulting in a litter of three to five pups.

- It is not a good idea to feed dingoes, as doing so has led to attacks on humans.

- Dingoes inhabit all of the Australian mainland, but not Tasmania.

- A typical dingo is reddish brown or yellow, stands the size of a medium dog and has an angular head with erect ears.

- Dingoes must drink water once a day.

- Dingoes reach sexual maturity at the age of one. They take a lifetime mate and raise their pups together.

MELANOMA STILL A PROBLEM

Despite the best efforts of Sid the seagull and his kids (see page 43), skin cancer remains a significant problem in Australia (as it does in much of the developed world). Statistics released in 2002 showed that incidence of melanoma continued to rise throughout the 1990s, with the rate increasing most significantly in men rather than women.

The statistics do not necessarily tell the whole story, however. The chief executive of the Cancer Council of Australia, Professor Alan Coates, explained that the lag in sun exposure and development of melanoma means that the impact of the 'Slip, Slop, Slap' campaign may not be felt for several years yet. Professor Coates added that, 'We have seen a 50 per cent reduction in sunburn between 1988 and 1998 and there is early evidence this is being carried through in a reduction in skin cancer rates among young people.'

OUTLAW MOVIES OUTLAWED

The early years of the 20th century were something of a golden era for the Australian film industry. In 1906, the Aussie-produced *The Story Of The Kelly Gang* became the world's first feature-length film, proving a huge success and netting receipts of A$64,000 (£26,000) after playing to full houses for several weeks.

The popularity of *The Story Of The Kelly Gang* spawned a succession of follow-ups, most of which centred on the antics of the country's infamous bushrangers. However, after six years at the pinnacle of moviemaking, government intervention brought the country's film industry to its knees by banning films about bushranging.

Home-grown movies could no longer compete with offerings from Hollywood. Films about cowboys and Indians brought all the drama of the Wild West to the Antipodes, and – while it wasn't Ned Kelly and it wasn't bushranging – any outlaw film is better than no outlaw film.

The Australian film industry has not been able to recover its position at the summit of moviemaking.

METAL MONEY

An Australian A$2 coin contains 2 per cent nickel. The other 98 per cent is made up of copper and aluminium.

REDBACKS GO INTERNATIONAL

Vegemite, Fosters lager, Crocodile Dundee… Australia's list of exports is long and impressive, but the people of Japan have not been quite so enamoured with the latest import from down under. The redback spider is one of the most venomous spiders in the world, and in 1995 it left its home in the Antipodes and headed for the Orient.

Redbacks have long been carted around Australia on trucks and amongst goods, but their arrival in the city of Osaka in Japan was something of a surprise. It seems likely that redback egg sacs or spiderlings found their way onto a cargo of timber and were insulated by the wood from the harsh extremes of Osaka's winter, surviving to reach maturity and to establish themselves in the city's drainage system.

To date, no incidents of redbacks biting humans have been reported in Japan. Other Australian spiders, most notably the brown widow, have been discovered at the Japanese ports of Yokohama, Tokyo, Nagoya and Okinawa.

HAT-TRICKS IN TEST CRICKET

If a bowler takes three wickets in consecutive balls, he is said to have completed a 'hat-trick'. Australian bowlers have done the 'trick' ten times in Test matches:

Spofforth – vs England at the Melbourne Cricket Ground (1878–9)

Trumble – vs England at the Melbourne Cricket Ground (1901–2)

Trumble – vs England at the Melbourne Cricket Ground (1903–4)

Matthews – vs South Africa at Old Trafford (1912)

Matthews – vs South Africa at Old Trafford (1912)

Kline – vs South Africa at Newlands (1957–8)

Hughes – vs West Indies at the WACA (1988–9)

Fleming – vs Pakistan at the Rawalpindi Stadium (1994–5)

Warne – vs England at the Melbourne Cricket Ground (1994–5)

McGrath – vs West Indies at the WACA (2000–1)

MEGAFAUNA

Kangaroos the size of horses, marsupial lions, a horned tortoise and giant wombats – they may all sound like creations of a drug-enhanced and overactive imagination, but they are not. All these animals are former Australian inhabitants, and Aussie scientists have the bones to prove it.

Before humans arrived on the continent some 60,000 years ago, these giant beasts (collectively known as 'megafauna') were all resident down under. Various finds of fossils estimated to be more than a million years old have had palaeontologists in a spin, with the discovery of complete skeletons at a tomblike cave in the Nullarbor Plain providing irrefutable evidence of the existence of megafauna.

Of all the species identified, it is the discovery of the giant marsupial lion that has most captured the imagination of both the public and the scientists. This deadly predator, which was armed with powerful retractable claws and razor-sharp incisors, was unquestionably the king of the food chain.

The big question now is how the various species of megafauna came to be extinct. Scientists still cannot agree, and they probably never will, but the most popular theories are that mankind's arrival upset the delicate balance of the ecosystem, or that there was a drastic change in climate.

AUSSIE RULES FACT FILE

- Don't try to be clever by referring to the round-ball association game as 'football' or 'footy'. Australians know it only as 'soccer' and they won't be impressed by a discussion of sporting aesthetics and history. They'll simply think you're a pompous idiot.

- Two sets of posts may seem confusing at first, but you'll get used to it. If the ball is kicked between the two larger goalposts (without touching the posts), the attacking team scores six points. If the ball passes between the other posts (the behind posts), a behind is scored and one point is earned.

- There are no goalies in Aussie Rules football.

- Fifteen players are designated positions on the field, but three follow the ball. One of the players assigned to this task is aptly called a 'Ruckman'.

- Each team has three substitutes, who are allowed to enter the match freely at any time.

- No padding is worn, although shin guards 'are permitted'.

- Scoring can be confusing. Each team's score comprises three elements. For example, Richmond South 10 15 75: the first figure (10) represents the number of goals scored; the second figure is the number of behinds (15); and the final figure is Richmond South's total (75), calculated by multiplying the number of goals by six (6 x 10), then adding the number of behinds (15).

- A player can block an opponent getting to the ball – provided he is within 5m (16ft) of the ball – by pushing him in the chest or side, or placing himself between opponent and ball.

- The AFL season runs from the end of March to the end of September.

- Weapons are not allowed.

WIND DOCTOR

The tropical sea breeze that occurs along Australia's west coast in summer is known as The Doctor.

AUSSIE WINE

1788 was a very bad year for wine... To be more specific, it was a very bad year for the winemakers of the Old World, for that was the year Australia planted its first vines at Farm Cove. In effect, it was also the year the Aussie wine industry was born.

Today, Australian wine is among the world's most popular, with over 20 million cases exported each year. It is an incredible feat: in just over 200 years, the country has gone from a grape-free zone to the pinnacle of viticulture.

In reality, however, Australia's winemaking pedigree has been established in a far shorter period of time, for only since the 1950s have technology and knowledge been sufficiently advanced to overcome obstacles posed by the continent's extreme climate. Refrigeration, in particular, was needed to prevent grape juice fermenting too quickly, and the arrival of suitable, affordable equipment in the postwar years precipitated a rise in both production and wine quality.

The Australian climate has been a great asset to the country's winemaking, but so too has the progressive attitude prevalent within the industry. Nepotism and vested interest have hindered progress in some European countries (in France and Italy, for example, the sons of the vineyard owners are put in charge, irrespective of their education or aptitude). However, in Australia there are no such problems – the vineyards are managed by qualified graduates with experience of work placements elsewhere in the world.

RANDOM ASHES-RELATED QUOTES

'A cricket tour in Australia would be the most delightful period in one's life, if one was deaf.'
England bodyline bowler **Harold Larwood**

'Poetry and murder lived in him together. He would slice the bowling to ribbons and dance without pity on the corpse.'
English writer **RC Robertson-Glasgow** on Donald Bradman

'There's Neil Harvey standing at leg slip with his legs wide apart waiting for a tickle.'
Commentator **Brian Johnston** during the England v Australia Test match at Headingley in 1961

'Playing against a team with Ian Chappell as captain turns cricket into gang warfare.'
Former England captain **Mike Brearley**

'Ashes to ashes, dust to dust – if Thomson don't get ya, Lillee must.'
Sydney Telegraph, 1975

'My tactic would be to take a quick single and observe him from the other end.'
Geoff Boycott explains how he'd cope with Australia's star spin bowler
Shane Warne

'The traditional dress code of the Australian cricketer is the baggy green
cap on the head and the chip on the shoulder.'
Simon Barnes in *The Times*

'If the Poms bat first, let's tell the taxi to wait.'
Slogan on banner unfurled by Australian fans in 1995

JAGGER THE BUSHMAN

Perhaps the most famous and undoubtedly the biggest-budget film about
Ned Kelly was that made by Tony Richardson in 1970. It starred Rolling
Stones frontman Mick Jagger in the lead role, and would have featured his
then-girlfriend Marianne Faithfull as Maggie Kelly...had she not been
hospitalised by a drugs overdose. Diane Craig filled the breach and the film
enjoyed reasonable success.

THE KING OF TOXICITY

The inland taipan is the most venomous land snake in the world: when
tested on mice, its venom was deemed to be 50 times more toxic than that
of an Asian cobra. They are found in the northeast of South Australia and
often inhabit rat burrows...having previously killed the burrow's former
tenant. These animals are mainly fairly shy, but they will become
aggressive if cornered, so if you see a taipan in the wild stand back and
admire, but do not move too close.

TERRA NULLIUS

When the English took 'possession' of Australia, they did so under the
principle of *terra nullius*, a concept in international law that means 'a
territory belonging to no one' or 'over which no one claims ownership'.
Effectively, the English ignored the rights of the Aboriginal people they
found inhabiting Australia. However, a High Court decision in 1992
rejected the application of *terra nullius* and, in turn, recognised indigenous
native title.

CYCLONE TRACY

Darwin was decimated by a cyclone during six hellish hours on Christmas morning 1974. It had already been struck by cyclones on two previous occasions in the 20th century, but the impact of Cyclone Tracy (as it was dubbed by the Bureau of Meteorology) was intensified by the city's rapid postwar growth. New suburbs had sprung up in a rapid space of time, frequently without adequate protection against high winds and debris. Most of the city's 48,000-strong population had little idea of the threat that lurked as meteorologists began to report a tropical depression 1,100km (700 miles) out to sea on 20 December.

The depression was upgraded to the status of cyclone as its winds began to speed up, but many Darwin residents remained unperturbed; after all, earlier in December Cyclone Selma had been heading for their city, only to shift direction and disappear. Unfortunately, Tracy did not follow suit, and by midnight on Christmas Eve the cyclone had moved over the city. Rain lashed down and winds estimated at 300kph (200mph) ripped straight through Darwin.

By the time the dust settled at around 7am, Cyclone Tracy had reduced Darwin to rubble. Three-quarters of the city's buildings were destroyed or severely damaged, while all major services were devastated, leaving residents without power, water or sanitation. Darwin was on the brink of a humanitarian crisis. Within a week most of the population had been evacuated, and for six months access to the city was via a permit system. By the end of February 1975, the government had set up the Darwin Reconstruction Commission, which was charged with the A$150 million (£61.5 million) rebuilding of the city. It was a project that would take three years.

CANNIBALISM

The subject of alleged Aboriginal cannibalism is a political hot potato and, as such, it is a topic that should always be avoided by visitors to Australia. Sure, stories of Aborigines eating Chinese gold miners have a macabre appeal that makes us prick up our ears, but such tales should not be taken at face value.

Perhaps cannibalism did take place in 19th-century north Queensland, but the evidence is far from conclusive. So does that mean that the people telling these stories are liars? No, not necessarily, but you have to ask yourself if there would be any political advantage to be gained from making such allegations. The journalists and broadcasters telling the story may just be reporting the facts as they understand them, but there are others – whose

bigotry gets the better of them – who want to use half-baked and frankly irrelevant theories about cannibalism as a stick to beat back liberal sympathy towards Aborigines. Getting the picture? It's definitely a subject to avoid.

THE YOWIE

The Americans have Big Foot, the Himalayan sherpas have Yetis and, in Australia, bushmen keep their eyes open for Yowies. There have been hundreds of reported sightings of these beasts in the last 200 years, but hard evidence is in short supply and scepticism about their existence remains.

The basic facts are simple: people in the bush, outback and throughout sparsely populated areas of Australia claim they have seen a tall, powerfully built, hairy, manlike creature that walks upright and emits bloodcurdling screeches. Sightings began shortly after European settlement in the early 19th century and continue to this day, with south and central coastal regions of New South Wales and Queensland's Gold Coast the most popular areas for sightings.

However, the tale of the Yowie appears to be unnecessarily confused and complicated, drawing upon a mixture of pseudo-science, unreliable secondary sources and Aboriginal myth and legend. There is undeniably a Yowie-like creature represented in Aboriginal folklore and history, and it seems clear that the creature's name (which means 'great hairy man') has similar origins. Some Aborigines believe that the Yowie is actually a sacred creature from the Dreamtime. Whatever the truth, European man seemed to embrace the legend of the Yowie and soon farmers, miners and bushmen were telling the country's fledgling press about the giant, hairy beasts that were apparently abducting their peers and terrifying their womenfolk.

Today, Yowie spotters can be extremely earnest people, and are frequently unimpressed by the way some commentators glibly dismiss their work, which they believe should be respected on the grounds of science. These experts have theories about the animal's behaviour, diet, size and distribution around the globe – apparently it came to Australia, probably from Asia, during the last great Ice Age. A myriad of books and websites have been written on the subject, but it is important not to get too worried about these giant beasts, as redback spiders and rednecks present a much more immediate threat to outback tourists.

FLYNN'S IN

Legendary Tasmanian actor Errol Flynn starred in more than 50 movies. His major screen credits run as follows.

1933
In The Wake Of The Bounty

1935
Murder At Monte Carlo
The Case Of The Curious Bride
Don't Bet On Blondes
Captain Blood
The Charge Of The Light Brigade

1937
The Green Light
The Prince And The Pauper
Another Dawn
The Perfect Specimen

1938
The Adventures Of Robin Hood
Four's A Crowd
The Sisters
The Dawn Patrol

1939
Dodge City
The Private Lives Of Elizabeth And Essex

1940
Virginia City
The Sea Hawk
Santa Fe Trail

1941
Footsteps In The Dark
Dive Bomber

1942
They Died With Their Boots On
Desperate Journey
Gentleman Jim

1943
Edge Of Darkness
Thank Your Lucky Stars
Northern Pursuit

1944
Uncertain Glory

1945
Objective, Burma!
San Antonio

1946
Never Say Goodbye

1947
Cry Wolf
Escape Me Never
Always Together

1948
Silver River

1949
Adventures Of Don Juan
It's A Great Feeling
That Forsyte Woman

1950
Montana
Rocky Mountain

1951
Kim
Hello God
Adventures Of Captain Fabian

1952
Mara Maru
Against All Flags
Cruise Of The Zaca

1953
The Master Of Ballantrae

1954
Crossed Swords
William Tell

1955
Let's Make Up
The Warriors
King's Rhapsody

1956
Istanbul
The Big Boodle

1957
The Sun Also Rises

1958
Too Much, Too Soon
The Roots Of Heaven

1959
Cuban Rebel Girls

AUS·TRA·LOID (ADJ.)

When you are referring to 'the ethnic group that includes the Australian Aborigines and certain other southern Asian and Pacific peoples', feel free to use the word 'Australoid'.

SAMOA CALLING

Although Sydney-born midfielder Tim Cahill plays his club soccer in England, with Millwall, he (curiously) made his under-20 international debut at the age of 14 – for Western Samoa. For several years, it appeared that Cahill's appearance for Samoa would bar him from representing Australia, but in 2003 FIFA granted him permission to play for the country of his birth.

THE ABORIGINAL FLAG

Unsurprisingly, given their distinct history and culture, Australia's Aboriginal people have their own flag. The flag was first unfurled on National Aborigines' Day (12 July) in 1971, just two years after indigenous people were first granted citizenship. Harold Joseph Thomas, a Luritja man from central Australia, was charged with designing the flag, and his creation is divided horizontally into equal halves of black (top) and red (bottom), with a yellow circle in the centre. The black represents the Aboriginal people, the yellow circle symbolises the sun (which Aborigines believe is the constant renewer of life), and the red stands for the Earth and man's relationship with it. The flag can be seen flying above Aboriginal centres throughout Australia.

AUSTRALIAN RULES FOOTBALL

Aussie Rules football is often (somewhat negatively) referred to as 'Aussie No Rules', since, to the uninitiated, it seems that anything goes in this apparently brutal ball sport. Aficionados, of course, claim that it is simply a game of skill and courage that rewards athleticism and should make no apology for its physical nature.

The game itself is something of a rugby/soccer hybrid, and is played with an oval ball on an oval pitch with two sets of goalposts. Teams consist of 18 players and games last for four 20-minute quarters. There is a 20-minute break for half time and shorter breaks between the first and second, and third and fourth quarters.

The rules of the game were codified in 1858 -- earlier than either association football or rugby union -- and in the 150 years since, Aussie Rules has built up a huge following throughout Australia. In New South Wales and Queensland, rugby league is the dominant sport, but elsewhere 'footy' is the undisputed king of sport.

CORK HATS

The stereotypical Aussie cork hat is still worn by some bushmen. The corks are meant to keep flies from your face and are hung from thread or string and attached to the brim of an old hat.

CHINESE ARRIVE IN GOLD FIELDS

The Australian gold rush of the 1850s brought with it a wave of immigration from China, prompting a racial tension that would remain for far longer than the gold sought by the prospectors. The Europeans, who had got into the habit of treating non-whites with a lack of respect after their unsavoury dealings with Aborigines, were instantly suspicious and frequently aggressive towards the new arrivals from the Orient.

The Chinese, for their part, were law-abiding and hard-working. They also kept themselves to themselves, and continued to observe their own customs and practices. Their European counterparts were not universally impressed, and the Chinese frequently found themselves blamed for anything that went wrong at the gold fields. They were also castigated for mining on areas abandoned by others and extracting gold that their counterparts had been unable to find. European miners regarded these seams as an insurance policy that they could return to in harder times.

As anti-Chinese feeling intensified, more Chinese arrived. Around 10,000 headed for the gold fields in 1855 and soon violence became commonplace. The government tried various dubious entry taxes and quota levels but none proved effective, and the Chinese continued to arrive for as long as there were rich pickings of gold. When the gold ran out, many immigrants returned home, while others dispersed to form Chinese communities in Australian cities, most notably Melbourne.

THEFTS FROM CARS

According to the International Crime Victims Survey (ICVS), thefts from motor vehicles in Australia were most commonly reported to the police in order to recover property (35 per cent). A sense of obligation to notify the police (18 per cent) was the next most common reason for reporting, followed by the need to stop the crime reoccurring (18 per cent).

RACE RELATIONS

It seems inappropriate to comment on race relations in a light-hearted book of this kind, but it is impossible to understand anything of Australia's social and cultural dynamic if you know nothing of the relationship between European settlers and Aboriginal people. The simple fact of the matter is that the Europeans arrived in the 19th century and spent most of the next 200 years behaving appallingly to Australia's existing inhabitants and committing a catalogue of crimes, the legacy of which is still felt to this day.

Visitors to Australia should be aware of this history and, in particular, should give short shrift to any prejudice directed at Aboriginal people. As a visible minority, Aborigines are an easy target for the small-minded and ignorant, and you will frequently find an entire race judged by the actions of one or two individuals. Do not fall into the trap of buying into this half-baked sociology of nonsense. One drunken Aborigine is exactly that – just one person, not a representative sample of an entire community.

Bear in mind the following (but by no means exhaustive) guide to the race crimes directed at Aborigines by both individuals and the state during the last two centuries:

Aborigines had been resident in Australia for 50,000 years when the white man arrived in the 18th century. They were evicted from their homelands, with many killed and others enslaved. The history books would later record (inaccurately) that the Aborigines gave up their land without a fight.

Throughout the 20th century, the lives of Aborigines were governed by the state-run Aboriginal Protection or Welfare Boards. These boards could decide where indigenous people could live, who they could marry, how their children could be raised, which jobs they could take, where they could travel and what property they could own.

Perhaps the most heinous of state crimes against Aborigines was the 'kidnap' of indigenous children, who were then taken away from their families and placed in assimilation programmes. This practice began in the late 1800s and continued until 1969. Other children (usually those with fair skin) were adopted or fostered by white families. It is estimated that 100,000 children were taken from their families as part of this policy. These Aborigines are known as the 'Stolen Generation'.

Aborigines were not recognised as Australian citizens until 1969. Up until then, only indigenous people who were judged to have reached 'acceptable standards of non-Indigenous civilisation' were granted a type of 'honorary' citizenship.

The Aboriginal population of Tasmania was decimated by systematic murder perpetrated by European settlers.

European colonisation brought with it a host of health problems for Aboriginal people. Smallpox, influenza, VD, typhoid, tuberculosis, pneumonia, measles and whooping cough all took their toll on the indigenous population.

Average life expectancy of Aborigines is 15 to 20 years lower than for Australians of European origin.

CAVALRY CHARGE AT HARBOUR BRIDGE

When it comes to grand ceremonial openings, you'd have to go a long way to find a more dramatic affair than the one that marked the inauguration of the Sydney Harbour Bridge on 19 March 1932. The plan was that Premier Jack Lang would cut the ribbon in front of the bridge, the crowd would cheer and everyone would go home smiling. However, one man had other ideas.

Retired cavalry officer Francis De Groot was not happy that Lang had been given the scissors on such a historic occasion. De Groot believed that only a member of the royal family should grace such a job on such an occasion, and in the absence of King George V, De Groot decided he would do the job himself. He somehow got himself selected at the head of the honour guard at the bridge opening and, as Lang arrived, the cavalryman seized the moment – De Groot galloped forwards and slashed the ribbon with his sword.

The police immediately seized the maverick horseman, arrested him and took him to a psychiatric hospital to be assessed. He was declared sane, but it soon emerged he was a member of the right-wing New Guard political party. De Groot was fined £5 and charged with offensive behaviour. Back at the bridge, the ribbon was tied together and the ceremony resumed.

FLUFFY MARSUPIAL

Koalas are painfully cute creatures but, like pandas and seals (both of which are also adored by pre-teenage girls and soft-toy manufacturers), they face an uncertain future. Although not officially an endangered species, these fluffy marsupials are struggling to contend with the destruction of their natural habitat, not to mention a variety of diseases and the perils of new predators (including the motor car). Estimates suggest that there are fewer than 8,000 koalas living in the wild today.

NATURE'S GIFTS

Australia can boast the following natural resources: bauxite, coal, copper, diamonds, gold, iron ore, lead, mineral sands, natural gas, nickel, petroleum, silver, tin, tungsten, uranium and zinc.

AUSSIE POPULATION

Australia's total population was estimated to be 19,731,984 in July 2003. More than three-quarters of that figure were apparently Christian, with equal numbers Catholic and Anglican.

PARALYSIS TICK

For the most part, ticks are no more than a nuisance. They bite, you scratch, you attack them with tweezers and apply a sticking plaster. However, if the wrong kind of tick bites you, you can insert 'progressive paralysis' somewhere between being bitten and applying the plaster.

The Australian paralysis tick (*Ixodes holocyclus*) lives in bush areas on the eastern side of the continent, and its saliva contains a toxin that causes paralysis by (to quote the Australian Venom Research Unit) 'interference with presynaptic transmission in motor nerves'. In truth, your dog is more likely to fall victim to a paralysis tick than you are, but humans do occasionally become hosts. During the 20th century, at least 20 people died through tick poisoning in New South Wales.

TRAINSPOTTING

Australia does not have one national train company. Each state has its own rail service that runs independently and, what's more, they all operate on different-gauge tracks. Be warned: tickets from one network are not necessarily valid on another.

CAPITAL FACT

The capital city of Australia is Canberra – not Sydney (or anywhere else!). Don't get it wrong.

THE MYSTERY OF HAROLD HOLT

Just as England has Lord Lucan, Australia has Prime Minister Harold Holt. The 59-year-old Conservative leader disappeared after going for a swim in heavy seas off Cheviot Beach in Victoria on 17 December 1967. Holt's body has never been discovered, and the last 36 years have seen a succession of conspiracy theories unveiled to explain away his disappearance.

For three weeks after the Prime Minister's disappearance the police scoured the area by land, sea and air, but they could find no corpse. Nevertheless, the file into Holt's death remains open with the Victoria coroner's office, and a new inquiry was launched as recently as August 2003.

And, just as the English press has dreamed up a host of theories about what happened to Lord Lucan, so too has the Australian press in the case of Harold Holt. Here are some of the best.

• He was abducted and taken on board a Chinese submarine.

• Holt was a spy who defected to the Chinese, and in fact swam out to meet the submarine that took him away.

• The CIA bumped him off for planning to withdraw Aussie troops from Vietnam.

• He swam out to meet a man on a speedboat, who promptly took him off to Europe to be with a French lover.

• Shark attack.

• He was abducted by aliens/mermaids/the KGB/the Partridge Family.

• He was lured away to join the circus.

• (Controversial, this one…) He got into trouble in the rough current, drowned and his body was washed out to sea.

STATES AND TERRITORIES

Australia has six states (New South Wales, Queensland, South Australia, Tasmania, Victoria, Western Australia) and two territories (Northern Territory, Australian Capital Territory).

CLUBBING DOWN UNDER

The boomerang might be the most famous of Aborigine weapons, but it was not the only one. Wooden throwing clubs – frequently carved with painful, tissue-tearing patterns – were also used for hunting and combat.

BROWN SNAKES

Rattlesnakes and cobras may have the looks and style to terrify snake-fearing humans elsewhere in the globe, but down under the serpent responsible for most deaths is the brown snake.

The name may sound less than terrifying, but when a 1.8m (6ft) brownie comes flying at you fear is very much at the forefront of your mind. Brown snakes come in several different varieties – including the common or eastern brown, dugites and gwardars – but all belong to the genus Pseudonaja. They feed on rodents, lizards and birds and tend to inhabit dry areas, frequently around farms. Streamlined in appearance, their colour varies from light brown to black. They are also reputed to be extremely aggressive.

A brownie will strike rapidly and repeatedly, flying at its prey from a distance, with jaws open and fangs ready to inject several millilitres of toxic venom into the victim. They will strike repeatedly and will chase retreating prey. The venom contains powerful neurotoxins that cause progressive paralysis as well as procoagulants that prevent the blood from clotting and, though antivenin is available, occasional fatalities do occur.

BINGO IN AUSTRALIA

The game of bingo gained popularity in Australia in the 1950s, when it was called housie, housie. It has been outlawed at various times and in various states, but bingo lovers have always found a way to keep playing...often by setting up games across state boundaries.

NATURE'S HAZARDS

Australians have to contend with the following natural hazards: coastal cyclones, severe droughts and forest fires.

ELECTRICITY SUPPLY

Australia uses 220 volt to 240 volt supply. Electrical devices connect via a flat three-pin plug.

ROMPER STOMPER

The controversial 1991 Australian film *Romper Stomper* portrayed the relationships and disintegration of a gang of brutal and racist Melbourne skinheads. Starring current Hollywood heartthrob Russell Crowe, it was not a movie that appealed to everybody – its British premiere was marked by a

demonstration by the Anti-Nazi League – although the film did enjoy critical acclaim. Nominations and awards followed for both Crowe and the film's director Geoffrey Wright, but it would never be as widely discussed as other Australian films like...*Priscilla Queen Of The Desert*.

THE TRIVIUM TAVERN

The word 'trivia' comes from the Latin word *trivium*, 'a place where three roads meet'. The Romans regarded the trivium as the ideal location to gossip and exchange stories and news. In the Australian outback, the place where three roads (or tracks) meet is called the pub!

STD HITS KOALAS

The single greatest threat to Australia's falling numbers of koala bears is a sexually transmitted disease. Chlamydia, which also affects humans, is estimated to have killed more than 2,000 koalas in 2002.

STINGING ANTS

As if Australia didn't already have enough biting, stinging, venomous critters to contend with, other aggressive and toxic strains of stinging ant have recently turned up down under.

Fire ants are thoroughly unpleasant insects that can inflict a painful sting that leaves their victim with a burning sensation around the resultant blistered sting site. They can also cause an allergic reaction in some people.

The tropical fire ant is an import from Asia that has established itself in the coastal areas of the Northern Territory, while the South American fire ant arrived in southern Queensland as recently as 2001. Neither species is welcome. The Queensland Government Department of Primary Industries became so worried about fire ants, in fact, that it issued an advisory document for householders, warning against the dangers of these creatures. Stings, they said, should be washed with soap and water, blisters should be left intact and a cold compress applied to relieve swelling. Residents were invited to report any nests detected, which should be disposed of by environmental health agents. Maverick ant killers were discouraged.

Jumper ants and bull ants also boast a venomous gland in their tails, and are not afraid to use it. The result is a painful, itchy swelling. As with the fire ant, incidences of allergic reaction should be taken very seriously and medical attention sought immediately.

NO TO REPUBLIC OF OZ

In 1999, the Australian government staged a referendum on the issue of whether the country should become a republic. The result was a narrow defeat for the republicans and no redundancy package for the Queen.

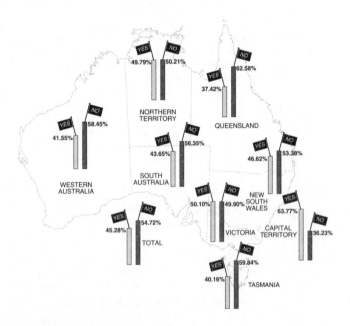

DRIVING DOWN UNDER

The good news for English visitors is that Australians drive on the left-hand side of the road. To the rest of the world, of course, this is more than a little irritating. Other facts worth noting by the visiting car user down under are:

• Aussie cops use speed cameras

• it is illegal to use a hand-held mobile phone while driving

• it is more expensive to rent a car at the airport than in town

• there is less traffic on the road, but much more wildlife

• the use of seatbelts is compulsory.

ROSALEEN NORTON

Australia's most famous witch was not actually Australian, and many would contend that she was not even a witch. Rosaleen Norton was dubbed 'The Witch of King's Cross' by a grateful and sensationalist media eager to label one of the country's most colourful characters with an evocative title that would titillate and intrigue the country's conservative majority.

Rosaleen was born in New Zealand on 2 October 1917, but at the age of seven moved to Sydney with her Protestant parents. By the time she had reached her teens, her interest in art, sorcery and the supernatural had begun to combine in paintings that landed her in trouble at school. She was eventually expelled.

After leaving school, she continued painting, studying art and writing horror stories for *Smith's Weekly*, but it was not until after World War II that her work began to reach a wider audience. An exhibition of her art, which included depictions of gods and demons, attracted a great deal of interest, including a visit from the police that resulted in four paintings being seized and charges being brought. These were subsequently dropped, but the incident led to a special kind of notoriety that would remain. Three years later came the publication of *The Art Of Rosaleen Norton* and, with it, another court appearance. This resulted in the publisher being fined £5 because several of the pictures were judged to be obscene.

Rosaleen's appearance and lifestyle did little to challenge the media's portrayal of her as a witch. She wore pagan clothes or black gowns that matched perfectly her jet-black hair and sharply plucked eyebrows, and rumours of pagan rites, black masses and satanic rituals soon began to circulate. Sometimes Rosaleen freely admitted to the media's accusations, further fuelling her reputation as a witch, but she was not uncomfortable in the glare of the celebrity spotlight and remained something of a headline regular throughout the 1950s and 1960s.

The dawning of a more tolerant era in the 1970s, along with Rosaleen's advancing years, saw her fade from public life, yet she remained faithful to her lifestyle and her devotion to the god Pan. Rosaleen died of colon cancer on 5 December 1979, at Sydney's Roman Catholic Sacred Heart Hospice.

TV ARRIVES

Television arrived in Australia in 1956, spreading rapidly across the nation until all the major cities were served by 1962.

AUSTRALIA II MAKES HISTORY

In 1983 the 12m (40ft) sloop *Australia II* broke the United States' stranglehold on the America's Cup, bringing to an end the longest-running winning streak in modern sporting history. The controversial boat, which featured a radical winged keel, was skippered by John Bertrand and had been built for a syndicate headed by Alan Bond.

Australia II's keel became the subject of an inordinate amount of interest, with the New York Yacht Club challenging its legitimacy – despite the fact that they had never seen it. The Americans were right to fear the Australian challenger that defeated the defender *Liberty* in an epic duel. *Australia II* was subsequently exhibited in Sydney's National Maritime Museum.

KOALA FACT FILE

Koalas are not bears. Their nearest relative is, in fact, the wombat.

They are marsupials and carry their young (called joeys) in pouches that open to the rear.

More than 2 million koalas were killed during the first 30 years of the 20th century. Most were killed for their fur.

Koalas live exclusively on eucalyptus leaves.

Koalas smell of eucalyptus leaves.

Koalas live around the east coast of Australia.

They sleep for up to 19 hours a day. The rest of the time, they hop around trees looking for eucalyptus leaves to eat.

Koalas can live to see their early 20s, and even in the wild they will often live to be over 15 years old.

They are solitary creatures and (particularly males) become extremely territorial during the breeding season (November to February in the south, September to January further north).

Koalas are deceptively quick runners (nearly as fast as rabbits) and also strong swimmers.

YOUNG BOYS GO METAL...

The line-up of Australian rock band AC/DC has, at various times, featured three siblings in the shape of the Youngs – George, Angus and Malcolm.

THE LEGEND OF NED KELLY

When it comes to the legend of Ned Kelly, Australia's greatest folk hero, it is not easy to sort fact from fable. There have been numerous films, books, plays and documentaries over the years, each purporting to capture the 'true' story of Ned and his gang. It is difficult to say which, if any, have achieved their aim, though what is clear is that Ned Kelly was an intelligent man who was no angel. His crimes were many and his violence notorious, but he also wore home-made armour, and for that typically Australian innovation a nation applauds his memory.

Ned was born the son of an Irish ex-convict in 1854, and grew up in a remote district of northeastern Victoria. The Kelly family were poor and frequently found themselves on the wrong side of the law, as did most squatters in 19th-century Australia. Ned's adolescence saw him in trouble for fighting and thieving, and he was soon serving time in jail for such offences. The young Kelly had been arrested on suspicion of being an accomplice to a well-known bushranger, but the allegation was dismissed, and throughout his early 20s Ned's wrongdoing was restricted to the unextraordinary and distinctly small time. However, in 1878, things began to change.

Kelly Copper Comes A Cropper

Ned Kelly may have always been destined for a life as an outlaw but the man most responsible for his rapid descent into criminality was – ironically – a policeman. Alexander Fitzpatrick called at the Kelly house one night in April 1878 to issue warrants for the arrest of both Ned and his brother, Dan. However, according to folklore, Fitzpatrick had already taken a drink en route to the Kelly house and made a drunken pass at Ned's sister, Kate. His unwanted affections precipitated a scuffle and the policeman departed; however, he returned with some wild allegations, and reinforcements, later in the evening. By now, though, Ned had gone bush with his brother and friends Joe Byrne and Steve Hart, so instead the police arrested Mrs Kelly (Ned's mother). Fitzpatrick would later be discharged from the police for misconduct in another case.

Ned Gains Popular Support

Ned and his gang were all excellent horsemen and, having taken to the hills, they successfully avoided police detection for six months, drawing on their skills as bushmen and their connections in the local community in order to survive. But when a group of four police officers disguised as prospectors happened upon the outlaws in October, things got even more serious. A gunfight followed, with Ned shooting dead three of the officers, so precipitating a huge but unsuccessful manhunt. For another 18 months the

THE LEGEND OF NED KELLY (CONT'D)

Kelly gang remained one step ahead of the lawmen. Ned and his henchmen also frustrated the police by emerging from the bush to pull off two audacious bank robberies that left the coppers looking foolish but ever more determined to catch the man who had rapidly become Australia's 'most wanted'.

Despite his record of violent crime, Kelly enjoyed popular support, however, and for the oppressed squatters (many of whom shared Ned's Irish origins) he became something of a folk hero. Ned was also a natural at PR, preying on anti-English and anti-authoritarian feeling to justify his actions, which were explained in public letters left at the scenes of his crimes.

Shootout At Glenrowan

By June 1880, it seems that Ned had got a little carried away and, with his confidence running at an all-time high, he embarked on an audacious and ultimately fatal final fling. The motivation for his plan remains unclear, though some believe he was attempting to inspire a popular uprising among his supporters. If that were the aim, he miscalculated the depth of feeling towards him.

The plan began with a murder. Late at night, the gang knocked on the door of a suspected police informer. The man answered and was promptly shot dead by Joe Byrne. The outlaws then rode to the hamlet of Glenrowan, which sits on the main Melbourne railway line. They found a group of men working on the line and – at gunpoint – instructed them to rip up the line, before marching them to the Glenrowan Inn along with other hostages.

They planned that the police would learn of the murder, send a large detachment of officers to the scene by train, all of whom would be killed when the train ran off the tracks at Glenrowan. However, this was scuppered when the murder wasn't reported immediately, and in the delay a hostage escaped. The police were tipped off and promptly disembarked the train ahead of the broken line. The inn was surrounded and on the morning of 28 June the inevitable gunfight began. The outlaws were massively outnumbered, but their confidence was undimmed, as they had worked out a contingency plan to combat such a scenario. The Kelly gang had made some rudimentary 6mm (1/4in) armour from stolen agricultural equipment, and when the police opened fire they donned their ironware, striding out onto the veranda of the Glenrowan Inn to return fire.

The police bullets rebounded from the men's helmets and breastplates, but their armour had a glaring vulnerability. There was no protection for either arms or legs, and the outlaws took several hits to their limbs before Ned fled into the bush and his cohorts returned inside. The siege continued with

bursts of gunfire as the reinforced police presence looked to flush out their targets. Ned soon returned to the battle; cutting an immense figure as he stormed through the bush with an oilskin over his armour and a Colt revolver blasting at the lawmen as he called out to his men to rejoin the fight.

The police took aim at Kelly, but were bemused to see their bullets bouncing off his torso, which was of course protected by his hidden armour. As panic descended, one alert police marksman took aim at the outlaw's legs, bringing him to the ground with a shotgun blast. Having already sustained a bullet wound to his left arm, Ned was left prostrate and, despite his manful struggles, was dragged off and incarcerated.

Kelly Finds Immortality

Reports about Ned's injuries vary enormously, with some accounts suggesting that he was shot 20 times but continued to return fire. Whatever the truth, he was clearly outgunned and sustained several bullet wounds, which he nevertheless survived. His counterparts, however, would not survive the shootout at Glenrowan.

With Ned down, the siege continued to its inevitable and bloody conclusion. Joe Byrne was fatally struck by a stray bullet, while Dan Kelly and Steve Hart fought on. Eventually the police set the building on fire and freed the hostages. The charred remains of Kelly and Hart were found later, though it appears they had died in a suicide pact.

Ned Kelly, for his part, recovered from his injuries and was tried and convicted of murder in Melbourne. He was hanged on 11 November 1880, though he would find immortality in the plethora of books, films and plays written about his life. In fact, 26 years after his death, he was the subject of the world's first feature-length film, *The Story Of The Kelly Gang*, which was screened in Melbourne in December 1906.

ONE THOUSAND POUND NOTE

In 1913 Australia issued a number of new currency notes, among them a £1,000 bill (or A$2,440). The four-figure paper money lasted for just two years before it was withdrawn from circulation after complaints...presumably from bus drivers and newspaper vendors.

ANT-EATING DEVIL

There is more than one devil down under. In addition to the Tasmanian devil, Australia is home to the thorny devil – a kind of walking cactus that feeds on ants and can eat as many as 2,500 of these insects in one sitting.

BOX JELLYFISH

The Australian Venom Research Unit's (AVRU) website recommends that you give the box jellyfish a very wide berth, for they are big, they are bad and, if they sting you, you are in serious trouble. In recent years, they have starred in numerous wildlife documentaries, and most of us are familiar with their status as potential killers. However, the AVRU's assertion that they are 'the most dangerous jellyfish, and indeed one of the most dangerous venomous creatures, in the world', makes for chilling reading.

These transparent invertebrates lurk unnoticed in the coastal waters of northern Australia in the summer months, exercising their tentacles, which can number as many as 60 and stretch over 2m (6½ft). A flick of one tentacle is enough to leave you with a painful wound, and feeling ill and disorientated. However, should you come into contact with a large number of stinging cells over a wide area of skin, your problems could be of a more profound nature. In such situations, victims tend to pull at the tentacles in an effort to remove them, but this usually leads to further envenomation. Respiratory problems and cardiac arrest can result after a serious attack, making it imperative that victims exit the water as quickly as possible. Unfortunately, patients do not have long to get treatment, and death can result in as little as five minutes after a massive attack.

Paramedics and lifeguards on some beaches will be equipped with antivenin to halt the rapid onset of symptoms. Acetic acid (table vinegar) can also be used to inactivate remaining undischarged stinging cells. Of course, it is best to avoid being stung in the first place, so consider the following.

Wear a stinger suit when swimming in the sea.

Go to beaches that have been netted to keep box jellyfish at bay.

Lie on the beach and swim in the pool.

DOLLARS REPLACE POUNDS

Australia went decimal in 1966, rejecting the pounds, shillings and pence of the British in favour of dollars (A$) and cents (c). The Aussies resisted the temptation to issue a $1,000 bill – presumably fearing a backlash from disgruntled bus drivers and newspaper sellers. The largest denomination was – and remains – the $100 bill, so should anybody offer you a larger note it won't be legal tender.

MANDATORY SENTENCING

Since the mid-1990s, several Australian states have been operating a policy of mandatory sentencing in criminal cases involving offences against property. The basic principle of the system is that discretion over sentencing is withdrawn from the judge or magistrate, who must simply apply a prescribed punishment according to pre-defined criteria. The system is intended to be hardline and tough on crime, hitting back at liberal do-gooders who want to excuse the actions of a criminal underclass... You know the argument... It's the one you hear repeatedly on daytime chat shows and phone-ins across the globe.

Under the mandatory system in Australia, sentences become more severe according to the level of reoffending, so, for example, in the Northern Territory, property crimes incur a minimum 14-day sentence for first offenders, rising to 3 months for a second conviction and 12 months for further offences. Mitigating factors are not considered, though in some states additional jail terms are given according to the age of victims (with longer sentences for crimes against the elderly).

As with all crime figures, the statistics can be manipulated and presented to support almost any argument. However, what all penologists (academics who study theories and practices in the field of criminal punishment) will tell you is that it is not the severity of punishment that most deters potential criminals – rather it is the likelihood of detection. Cynics might say that mandatory sentencing policies have been implemented (irrespective of effectiveness) in order to silence a vocal and disgruntled moral majority.

DRONGO

The word 'drongo' is a common insult in Australia, and is used to describe a hopeless loser who can get nothing right. The term has its origins in a 1920s racehorse of the same name that was a game competitor but failed to win any of its 37 races.

MASS MOONING

The governor of Tasmania found himself staring at 300 women's backsides when he visited the Cascade Female Factory in 1832. He had gone to the factory to give a talk about moral values, but the 300 convicts who made up his audience decided to treat him to a mass mooning that has gone down in Tasmanian folklore. By all accounts, the 'ladies' accompanying the governor found the whole episode extremely amusing.

THE LANGUAGE OF AUSTRALIA

Strine is the language of Australia. It may not be recognised as an official dialect like American English, but it exists nonetheless, and is far more colourful and evocative than any other English variant. The term 'Strine' comes from the local pronunciation of the word Australian, as in '(Au)str(al)i(a)n-e'.

The Shorter Oxford English Dictionary suggests that Strine is spoken 'especially' by the uneducated, but this is no longer the case, and the *OED* also gives as its example of Strine the phrase 'Emma Chissitt?', which translates as 'How much is it?'

The scope of Strine extends beyond quirky pronunciations, though, and includes phrases and expressions that are uniquely Australian in origin. Several celebrity exponents of Strine have been instrumental in extending the boundaries of this Antipodean vernacular: comedians Roy Slaven and HG Nelson have frequently introduced new words and phrases to a receptive Aussie audience, for example.

Visitors should note that Strine is not always to be taken literally, as irony and sarcasm are key components, along with a smattering of rhyming slang. It has been suggested that Strine developed as an intentionally oblique code that enabled convicts to insult one another (and their guards) without detection. Expression and emphasis are often the best way to second-guess a Strine word or expression you are not familiar with.

Strine glossary

avago – make an attempt; literally, 'have a go'
beg yours – excuse me, I beg your pardon
bluey – used in a variety of circumstances, most usually to describe a blanket
chook – poultry (usually chicken)
U-ey (*chuck a*) – (do a) U-turn
crook – sick, injured, useless or substandard
cut lunch – sandwiches
dinki-di – alternative to dinkum (see below)
dinkum (usually *fair*) – honest, reliable and genuine
donk – engine
don't come the raw prawn – don't lie to me
drongo – fool
dunny – toilet
fair go – OK or fair chance
g'day – hello
go-er – persistent battler (esp horseracing)
good on yer – congratulations

lolly – confectionery
mate – a friend, good bloke
no worries – OK
ring, tinkle – call on the telephone
sheila – single woman
snag – sausage
snorter – on a rampage, aggressive
stubbie – can of beer
troppo (as in *gone troppo*) – the tropics (Darwin)
wowser – overly moral killjoy
yobbo – aggressive male

POLICE APPROVAL

If Russell Crowe and his colleagues were in any doubt as to the accuracy of their portrayal of a gang of neo-Nazis in 1991's controversial *Romper Stomper*, the Melbourne police were not. On one occasion the actors, resplendent in full skinhead regalia, were arrested near a Melbourne housing estate.

BROWN SPIDERS

Not every poisonous brownie is a snake. The brown spider is a relative of the redback spider, which it resembles in size and shape. They are town dwellers and often found in domestic gardens, garages and sheds. A bite from one of these toxic arachnids can cause headaches and nausea.

BOOMERANG

There are few more instantly recognisable symbols of Australia than the boomerang. Of course, boomerangs are more than just tourist souvenirs to be hung alongside your Spanish bullfighting poster: they are essentially weapons that were used by Aboriginal hunters and, just in case you've never seen one, they're made from pieces of wood carved flat and bent at a 135-degree angle. The surface of the boomerang is usually carved with an aerodynamic design that helps it to cut through the air.

The classic boomerang will, if thrown correctly, return to the thrower. It is believed that such weapons were used to herd prey towards hunters, who would kill them with spears. Larger, heavier boomerangs cut with a less acute angle were also used for hunting, and were thrown lower and directly at the legs of their intended victims. A kangaroo or wallaby could easily be crippled by a direct hit, leaving the hunter free to move in with a spear.

ALERT CUSTOMS OFFICERS SPOT TROUSER SNAKES

You'd think there were enough dangerous snakes in Australia, but some people are never satisfied. A 28-year-old Swede, for example, was clearly not happy with the stocks of brown snakes, deadly adders and the rest, so decided to import a few king cobras from Thailand. Thankfully, alert customs officers – yes there are some – searched the man and found the snakes strapped to his calves.

INSULTS AS COMPLIMENTS

Allegations of racism have long dogged Australian society, with tensions between Aborigines, Europeans and Asians frequently running high. However, many Aussies will argue against claims they are racist, pointing out that they freely insult peoples of all kinds, irrespective of skin colour and ethnicity. Aussies, it seems, have a nickname for every nation and race, with some more offensive than others. It might appear a trite argument, but it should also be considered that many Australians regard insults as terms of endearment. For example, it is expected that 'blokes' will refer to their best friend as a 'total bastard', whereas friends who are less close will simply be 'bastards'.

AUSTRALIAN BALLOTS

The secret ballot is an accepted and expected part of any modern democratic election, but it may come as a surprise to learn that the practice was pioneered in Australia. The first known secret ballots were used in Victoria and South Australia in the mid-19th century. They were initially called kangaroo votes, but soon became known as Australian ballots. The name is still used by some today.

ESKY

An esky is a beer chiller or coolbox – Australians like beer and they like it cold. An esky will be taken to the beach, the cricket, the racing…or the living room. The speed with which a host gets you a cold beer from his esky acts as a barometer of his blokeness: a good bloke will keep them cold and keep them coming.

IT'S A BIGGUN

Australia is the world's sixth largest country.

WOWSERS

The overly moral and the smug self-righteous are known as wowsers in Australia. The word apparently has its origins in the colony's early days, when deported convicts coined the term to lampoon guards who displayed these characteristics. Wowsers are still despised by most Australians and intolerance of self-righteousness remains something of a national characteristic.

THE KING OF THE ANTIPODES

When music promoters failed to entice Elvis Presley to Australia in the 1960s, they turned to New Zealand's leading rock 'n' roll star Johnny Devlin to fill the breach. Devlin proved a huge success, but the King of the Antipodes never enjoyed the same international acclaim as the other King, from Tupelo, Mississippi.

NATIONAL SERVICE BY LOTTERY

When the Australian government needed to bolster its military forces in the 1960s, it instigated a scheme of 'selective national service' (it didn't need every young man in Australia to join up, but it did want quite a few). But how do you decide who gets the uniform, the 5:30 alarm call and the chance to go to Asia with a gun? The Aussie government had a simple, though not unique, idea that was pure genius – a lottery. Yes, marbles with numbers corresponding to birthdays were put in a lottery barrel and drawn at random. You can imagine the tension as young Aussie blokes waited desperately to hear if the military had grabbed their balls.

The procedure began in 1965 and there were two ballots a year until national service came to an end in 1972. Men unlucky enough to be called up served for two years, followed by three years in the Reserve. Conscription had been justified on the grounds of concerns – some might say paranoia – about the growing tide of communism in Asia, particularly in Korea and Vietnam. Australia was one of America's major allies in Vietnam, and around 19,000 conscripts served in this unpopular and long-running conflict.

Involvement in Vietnam was a controversial topic in Australia, just as it was in America, and the longer the war went on, the less popular it became. Throughout the 1960s, draft dodging became a problem as opposition to conscription grew. The Australian Labor Party led the dissenters and made it clear that it would end national service and recall the country's troops from Vietnam. The ALP duly won an election in December 1972 and Prime Minister Whitlam proved as good as his word.

NO SNAKES IN, NO SNAKES OUT

And, just to prove that animal smuggling is a two-way trade, a pensioner tried to smuggle a menagerie of snakes and lizards through Sydney airport in 2002. And, yes, once again alert airport security staff clocked the scam and intercepted the animals from luggage bound for the Czech Republic. Good work, fellas.

THE WITCHES OF OZ

According to 2001 census figures, witchcraft is the fastest-growing religion in Australia. There were fewer than 2,000 witches in Oz in 1996, but five years later the figure was almost 9,000. The fact that several states in Australia decriminalised witchcraft at around this time may explain this increased statistic: Queensland, for example, won a bid in Parliament to repeal the offences of witchcraft, sorcery and fortune telling from the Criminal Code. There was also a significant rise in the number of pagans (from around 5,000 to 10,000). Interestingly, there was also a strong rise in religions deemed to be 'inadequately described'. This category included several people who described themselves as Jedi.

TOP 10 IN 2002

According to the Australian Record Industry Association, Australia's Top 10 singles in 2002 were:

1 'I'm Outta Love' – Anastacia
2 'Teenage Dirtbag' – Wheatus
3 'Freestyler' – Bomfunk MCs
4 'Music' – Madonna
5 'Say My Name' – Destiny's Child
6 'Poison' – Bardot
7 'Bye Bye Bye' – N'Sync
8 'Who The Hell Are You?' – Madison Avenue
9 'Groovejet (If This Ain't Love)' – Spiller
10 'Shackles (Praise You)' – Mary Mary

GOVERNMENT GRANT FOR SOCCER

Low attendances were the least of Soccer Australia's problems in September 2003. The association found itself in financial trouble and, after rumours that it would be insolvent within two months, the government stepped in. A A$15 million (£6 million) rescue package provided a life-

saving injection of funds, while a new chairman, Frank Lowy, planned to
steer the ailing organisation to a bright new era.

THE LEGEND OF PHAR LAP

It says much for Australia's love of horseracing that one of the country's most
enduring sporting heroes is the long-deceased chestnut gelding Phar Lap.
Born in New Zealand but trained and part-owned in Australia, he dominated
racing like no horse before or since, winning 37 of his 51 races in a career
that began in 1929 and ended prematurely three years later. For all his
achievements, Phar Lap was an unextraordinary young horse: he cost a
modest 160 guineas, and didn't win any of his first nine races. However, his
courage, intelligence and sheer speed soon began to show, thus rewarding
the faith shown in him by his part-owner/trainer, Harry Telford.

His first win came in April 1929 in the Maiden Juvenile Handicap at
Rosehill, and was followed by a further four successes, including the AJC
Derby at Randwick. Phar Lap's astounding form continued throughout 1931
and 1932, providing the Australian public with much-needed cheer during
the dark days of the Depression. With career winnings of more than
£50,000 (A$120,000) and with no worthy rivals in the Antipodes, the 'Red
Terror' was dispatched to Mexico to contest the richest race in the world –
the Agua Caliente Handicap – in April 1932.

Despite the unfamiliar conditions and the long journey, Phar Lap
overwhelmed the field, winning by two lengths to set a new race record
and making headlines around the globe. However, just when it seemed the
career of Australia's best-loved horse was about to rise into the
stratosphere, disaster struck. On 5 April 1932, 16 days after he had won
the Agua Caliente, Phar Lap appeared listless and unwell. A vet wrongly
diagnosed colic and within hours the great horse had died. A conspiracy
was suspected, with many believing that he had been poisoned. As
Australia mourned, a post-mortem was performed in Mexico – the verdict
was acute gastroenteritis caused by an unknown toxic substance. The
ballyhoo that followed would last for the remainder of the 20th century.

However, authors Geoff Armstrong and Peter Thompson have put forward a
convincing new explanation to explain Phar Lap's death. They believe that
the champion gelding was in fact killed by a disease – *anterior enteritis* – that
had not been discovered back in 1932. If correct, it seems this remarkable
horse (who was discovered to have a heart 50 per cent larger than average)
met a less remarkable end than many Australians previously believed.

SPECTATOR SPORTS

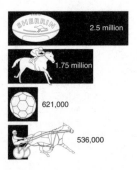

Soccer may be top of the popularity polls when it comes to participation, but Aussie Rules remains the biggest spectator draw in Australian sport. An Australian Bureau of Statistics survey for the 12 months ending April 1999 revealed that 2.5 million people attended football matches, compared to the next most popular sport, horseracing, which attracted 1.75 million. Soccer, meanwhile, was sixth in the list with 621,000 patrons…just 85,000 more than harness racing.

BOB HAWKE

Robert James Lee Hawke is probably the most famous politician in Australian history. He held office for eight years (1983–91), having previously caught the headlines, not only for his work for the Australian Council of Trade Unions (ACTU), but also for his capacity to drink beer. In 1954, the 25-year-old Hawke had his first brush with fame, earning a place in *The Guinness Book Of World Records* for sinking 2½ pints of beer in just 11 seconds.

His record-breaking feat clearly did not affect his political career, and by 1970 he was president of the ACTU. After ten years in that role Hawke became an MP, and just months after being made leader of the Labor Party he led the party to victory in the 1983 election. A second election victory followed in 1987, before John Howard took up office in 1991.

Hawke was a popular leader, with excellent oratory skills, and appealed to the people as an ordinary Aussie 'bloke'. He liked beer, he liked sport and he told it straight. Probably the greatest prime minister in the world? Some Aussies still think so.

OUTBACK

A recent survey of Australian eating and drinking habits revealed that adults living in rural and remote areas have the highest mean intake of beer compared to those living in other geographical regions. It was also noted that adults born in Australia had the highest average consumption of beer, while those born in Europe and New Zealand consumed the most wine.

AUSTRALIA HIT BY ORGAN SCANDAL

The removal of body parts and organs from dead bodies without the consent of either the deceased or their relatives is not a cheery subject. Therefore, it was not surprising that the Australian public were not too chuffed to learn that the practice was, first, not illegal and, second, had been commonplace in their country for much of the 20th century.

In the late 1990s, the state of New South Wales revealed that 8,000 specimens held by its hospitals, museums and universities had been taken without consent. A spokesman was quick to explain that the practice had been discontinued and that the law would soon be amended to make removal without consent illegal. The New South Wales revelation came hot on the heels of the Alder Hey scandal in Britain, so it seems that it was (perhaps) a legacy of Commonwealth influence. It was also revealing that many of the samples discovered dated back to the 1800s, while few had been taken in the last 20 years.

DEAD USELESS FACT

The first death entry on the Northern Territory Register of Deaths was recorded on 25 March 1871. The deceased was a mariner called William Read from South Australia, who died on 17 December 1870. Read met his end on the Roper River in grisly circumstances: the cause of death was somewhat zealously recorded as 'Drowning, dragged overboard from a boat by an alligator.' Nice…

THE AC/DC SOUND

'It's definitely distinctly Australian, the audience were the ones who gave us our sound. Australians had a regard for rhythm-based bands.'

AC/DC guitarist Angus Young, when asked in an interview with *Rolling Stone* how the band got its unique sound

DREAMTIME

Aboriginal spirituality is not easily understood by outsiders, particularly those from western secular society. There are no churches or mosques, and there is no holy book; instead, Aboriginal religion focuses on the physical environment and the creation of the Earth by spirit ancestors. All visitors to Australia should have a basic understanding of the country's original culture and religion, and here it is...

Keeping it green – Australian Aborigines were the first true environmentalists, and many of their spiritual beliefs revolve around the importance of the Earth and its resources. The land provided all – sanctuary, sustenance and spiritual connections – and was greatly revered. Hunting and gathering were carefully planned, with people taking only what they needed and using every part of what was harvested. Farming areas and camps were rotated to make sure the land remained fertile. As a result, flora and fauna therefore remained stable and resources constant.

Dreamtime – This is the key concept in Aboriginal spirituality, and perhaps the most difficult for us to grasp. It is essentially a time that runs parallel to life as we know it. It is also the time when the Earth was created by spirit ancestors. There are many stories associated with the Dreamtime – these are often sung, and explain tribal responsibilities, custom and law.

Dreaming tracks – The spirit ancestors laid down tracks, which delineate tribal boundaries and each group's 'belonging place'.

Elders – Tribal elders called karadjis can connect to the world of dreaming spirits. They also ensure that the stories of the Dreamtime are not forgotten.

Walkabout – The practice of breaking away from everyday life and walking in solitude across vast tracts of wilderness is a spiritual experience and a rite of passage for Aborigine men. A walkabout can take in hundreds of kilometres and many weeks, and it is all done without the aid of a map or compass.

Uluru – According to Aboriginal lore, the sacred monolith of Uluru – situated in the Northern Territory's Uluru-Kata Tjuta National Park – was created by two boys playing in the mud during the Dreamtime. It is of immense spiritual significance to Aborigines, with numerous Dreamtime stories centring around it.

Initiation – Young Aborigine males are expected to live away from their family for several months in order to make the passage to manhood. They learn from their elders, who teach them of the Dreamtime and spirituality, as well as more practical skills, including how to hunt animals, and the rules and taboos of their tribe. A successful education is celebrated

with a coming-of-age ceremony that often requires the subject to go without food or sleep, and to undergo slashes across his chest and stomach (which become tribal markings).

KANGAROO ISLAND

If you want peace, tranquillity and Australian wildlife without having to trek into the bush, Kangaroo Island might just be the place for you. Located off the coast of South Australia, this sizeable island is 155km (100 miles) long and is reachable by ferry or plane. Visitors can take cars onto the island, which has a good network of roads; otherwise, it's a case of exploring on foot or by pedal power, as there are no trains or buses. For the less adventurous traveller, there are organised coach and 4WD excursions.

Marsupials, as you would expect, are in abundance on Kangaroo Island and, yes, quite a few of them hop around on their oversized back legs. But aside from roos you will also see koalas, echidnas, wallabies and (if you're lucky) platypi. Other inhabitants include eagles, penguins, dolphins, sea lions, seals and osprey. Kangaroo Island's flora is also impressive, with much of the island uncleared wilderness unaffected by man's incursion. There are five significant Wilderness Protection Areas on the island as well.

THE ROUNDBALL TAKES CHARGE

Whisper it very quietly, but the kids of Australia like playing soccer more than any other sport. The 'blokes' might still love a game of Aussie Rules, rugby or cricket, but adolescents would rather have a simple kickabout than participate in any of the country's traditional games.

A survey conducted by Roy Morgan Research found that 1.2 million Aussies aged over 14 had played soccer in March 2003, as compared to 1.06 million who had played cricket. The 2002 World Cup finals, and the impact of Socceroo stars like Harry Kewell and Brett Emerton in Europe's top leagues, are credited with inspiring the rise of soccer down under. The game had long been regarded as inferior to the more physical contact sports of rugby and Aussie Rules, being somewhat dubiously dismissed as an 'ethnic sport'.

Other sports that are growing in participant popularity are basketball (the third most popular sport) and volleyball, which was more popular than both rugby codes. Netball remained the sport of choice among sporting females.

TOLKIEN LORDS IT

A 2003 survey by bookseller Angus & Robertson has revealed that JRR Tolkien's *The Lord Of The Rings* is Australia's favourite book of all time. The book, which was published in three volumes in the mid-1950s, is a complex tale that involves strange creatures, a curious language and a quest that takes the story's hero – Frodo – through wild terrain and many perils. Rumours that some Australians think it is a factual account written by a gap-year student who went bush are ill-founded.

The other four books in Angus & Robertson's top five were all written by English author JK Rowling, starring apprentice wizard Harry Potter. Top of the list currently is *Harry Potter And The Chamber Of Secrets*.

In sixth place came Bruce Courtney's *The Power Of One*, the only Australian entry in the Top 10. Other Australian authors, including Booker Prize winner Peter Carey, had to satisfy themselves with more modest positions in the poll.

ROUND THE WORLD FOR A TENNER?

For more than a century, emigration from Britain to Australia was subsidised by the state. Parish-assisted emigration operated in the early years before it was replaced by the free passage and bounty system in 1846. After World War II, the British government launched the UK-assisted package scheme, which enabled British immigrants to come to Australia for just £10, with children travelling free. Assisted emigration from Britain came to an end in 1982.

A controversial scheme of assisted migration also operated for countries outside the British Isles for many years after the war. The Displaced Persons programme helped populate Australia with workers from a variety of European nations between 1947 and 1953. The new arrivals were refugees, usually from eastern European countries such as Estonia, Poland, Hungary and Russia. However, the treatment of these voluntary migrants was far from impressive. They were housed in former army camps and set to work for two years, failure to comply bearing the threat of deportation.

Further mass immigration followed in the 1950s and 1960s, but this time they were neither refugees or from eastern Europe. The intention was to build the workforce to maintain the growth of a booming manufacturing industry, so immigrants from Italy, Germany, Scandinavia, Greece and Spain arrived under controlled government agreements.

DEATH ADDERS WANTED

The evocatively named death adder is one of Australia's most poisonous snakes. If you're bitten by one and are not treated with antivenin, you have only a 50-50 chance of survival.

Thankfully, with modern treatment, fatalities are now extremely rare. However, when fire razed Australia's only milking centre for venomous snakes and spiders, a worrying crisis began to brew. The centre, which was situated just outside Sydney, was the only supplier of venom to the Commonwealth Serum Laboratories (CSL) in Melbourne, but the fire in 2000 wiped out its entire stock of death adders.

The milked venom provides an essential ingredient in the antivenin manufactured by CSL, and as the centre in Sydney struggled to rebuild its stock of death adders concerns began to grow. Eventually, in February 2002, the centre was forced to issue an urgent appeal for death adder sightings.

PORN, RELIGION AND NATURAL BREASTS

Academic studies are not usually compulsive reading, but a recent project conducted by the Universities of Queensland and Sydney breaks the mould. What is the topic of their study? Porn or, more specifically, 'a critique of the top 50 adult videos and a national survey of Australia's pornography tastes and buying habits'.

The three-year study is government-funded and intends to demystify the fascination of pornography in Australia. Interim results of the 320 people surveyed up to August 2003 made for revealing reading: 20 per cent of the respondents were younger women, 33 per cent were married and 63 per cent considered themselves to be religious. Furthermore, a majority of those surveyed were Liberal/National voters, both parties that have an anti-porn stance.

So, you're thinking, what sort of porn do Aussies like? The study has examined the top 50 bestselling skin flicks and, according to Dr Alan McKee, found that, 'They tend to have better story lines, better acting, more expensive production values and they actually set up scenarios and fantasies for the lovemaking rather than simply people bump into each other and start having sex.' Dr McKee also noted that there was no particular fascination with women with large breasts, adding that 'in quite a few of the videos they actually make it a selling point that there are no boob jobs and it's all natural breasts'.

Who says academia is boring?

LIONS ROAR TO HAT-TRICK

The Brisbane Lions triumphed over Collingwood in the 2003 AFL Grand Final (Aussie Rules football's showpiece) to win the trophy for the third successive year. It was the first time any team had completed a hat-trick of titles since 1957.

UNDERAGE DRINKING

Recent research into underage drinking in Sydney has revealed that children as young as 10 years old have been treated in the city's emergency departments. An audit conducted by Dr Matthew O'Meara, director of emergency medicine, made for worrying reading, especially for Sydney's health experts: 'The average age of the children is 14 and most are brought in by ambulance or the police and are intoxicated to the point of being unconscious,' explained Dr O'Meara.

FROM RAZOR BLADES TO CELLULOID

Mark Brandon 'Chopper' Read is probably Australia's most dangerous postwar professional criminal. His career, which has taken in killings, assaults, robberies and extortion, is the subject of a successful film and a series of bestselling books.

Although he has now apparently retired to Tasmania, Read's working life was spent among Melbourne's underworld. Chopper's reputation was built in the 1970s and owed much to his free and easy attitude towards violence: he was particularly fond of robbing fellow criminals, and would sometimes make them chew razor blades if they refused to pay him. His own tolerance to pain was just as remarkable as his predilection to inflict violence upon others. On one famous occasion, he persuaded a cell mate to cut off his ears with a razor blade in an effort to get a transfer from Melbourne's harsh Pentridge Prison.

While in prison during the 1990s, Read began to correspond with crime writer John Silvester, who had written a less than glowing article about the erstwhile criminal, who was becoming something of a folk hero. Read did not deny his violence and criminality, nor did he try to excuse it with recourse to mentions of his home life or abuse as a child. The frankness of his letters to Silvester made for compulsive reading and later formed the basis of a series of books that have sold more than 400,000 copies.

The Read books, in turn, provided the framework for the screenplay written by Andrew Dominik that became the film *Chopper*. It proved to be a box-

office success, becoming the first Restricted 18-certificate film to reach No.1 at the Australian box office. However, controversy inevitably dogged the movie, though its makers were quick to point out that the portrayal of Read, who was played by Eric Bana, was far from glamorised. When asked by BBC News Online to explain his conclusions on the character of Chopper Read, Bana said: 'I never felt pressured to come up with some kind of definitive explanation, or judgement of him… People who read his books might like him because of the image he put forward, but the more politically correct might think him an idiot because he's a criminal. Somewhere in between all that, there's a judgement for those who want to judge.'

BABIES' NAMES

According to the Births, Deaths and Marriages Office (and it should know), the top babies' names in the Northern Territory in 2002 were as follows.

Girls	Boys
Chloe	Joshua
Jessica	Jack
Emma	Thomas
Grace	Ethan
Sarah	Liam
Shakira	Jacob
Emily	Matthew
Amy	Mitchell
Hannah	Lachlan
Hayley	Daniel

SLIM DUSTY

In September 2003, Australia mourned the passing of one of its favourite entertainers. Country singer Slim Dusty died of cancer aged 76, just two years after he had sung 'Waltzing Matilda' at the closing ceremony of the Sydney Olympics. Slim recorded more than 100 albums and is credited as the godfather of Australian country music.

Australian Prime Minister John Howard led the tributes to the deceased lyricist: 'We'll always remember that special style, epitomised really by "A Pub With No Beer" [Dusty's most famous song]. He was a one-off, a great bloke in the proper sense of that expression and a great Australian figure and icon.' Not bad going for a lad born on a dairy farm in a remote coastal town…

MARDI GRAS RISES AGAIN

Sydney's annual Gay and Lesbian Mardi Gras began in 1978 as a demonstration of gay and lesbian pride, and has since grown into one of the world's most acclaimed street festivals. However, despite its success and immense popularity (it draws in people from all around the world), the Mardi Gras's organisers found themselves in financial trouble in 2002.

In August of that year, the Sydney Gay and Lesbian Mardi Gras Ltd entered voluntary administration. However, as concerns grew about the future of the world's biggest same-sex party, community meetings led to the formation of four new organisations (the Pride Centre, Gay and Lesbian Rights Lobby, ACON and Queerscreen), which together combined to create a 'corporate entity' called New Mardi Gras. The question remained: could the new group deliver a 2003 Mardi Gras season?

The answer was a resounding yes. Crowds were apparently down – although there was a suggestion that previous estimated figures were somewhat inflated – but profits were up. Around 250,000 people turned up for Saturday night's parade and 17,000 tickets to the post-parade party were sold. Stevie Clayton, co-chair of the New Mardi Gras, was delighted with the 2003 festival, explaining that, 'The community got a real shock when it appeared that Mardi Gras wouldn't be happening. It was then that people mobilised. We think that Saturday night was an amazing success.'

...AND A TRIO OF GIBBS

Another of Australia's most successful bands, the Bee Gees, also featured three brothers – Maurice, Barry and Robin Gibb. Incidentally, the band's first major Australian hit was called 'Spicks And Specks' and was released in 1967.

TEENAGE CABARETS

Following concern over violence among teddy boys at pub gigs during the 1950s, concerned groups helped put on 'teenage cabarets' in Police–Citizen Boys' Clubs. Unsurprisingly, they never really caught on.

RANDOM KANGAROO FACTS

The red kangaroo can reach speeds of 50kph (30mph).

Infant roos spend 190 days inside their mother's pouch.

Kangaroos have an extended middle toe, which they use as an extra limb segment.

The cartoon image of roos boxing is based on fact: young males spar with each other in a boxing-like style, while mature roos fight for real when it's mating season.

If a roo detects danger, he will alert the rest of his group by stamping his foot or thumping his tail against the ground.

Roos use their acute sense of smell to detect water.

The wallaroo really does exist – it is not the creation of a confused tour guide.

Kangaroos are vegetarians.

Some Aussies hunt roos for their skins and meat.

Grey kangaroos live in South Australia, while reds are common all over the country.

FAIRYDOWN

Fairydown clothing may have been good enough for Sir Edmund Hillary's assault on Everest in 1953, and it might be popular with rugged outdoor types the world over, but Australian blokes are not keen.

The New Zealand-based company is a brand leader elsewhere, but has failed to catch on in neighbouring Australia. Could that have anything to do with the name? Fairydown boss Hugo Venteer reckons so: 'I guess the guys in Aussie just didn't feel comfortable going to the footy or the pub in a jacket with "Fairydown" written all over it.' Venteer has decided to change the name to Zone. Much more masculine.

CANBERRA AIR DISASTER

On 13 August 1940, an Australian Lockeed Hudson crashed into a hill on its way in to land at Canberra aerodrome. The crew and all six passengers lost their lives, which was tragedy enough. However, the accident – which came to be known as the Canberra Air Disaster – would cause unprecedented panic and chaos in the Australian government, for among the passengers were three federal ministers and the Chief of the General Staff. The deaths of these senior officials precipitated a major parliamentary reshuffle, and some believe that it contributed to the fall of the Menzies government (via a no-confidence motion from the floor of the house) in 1941.

GOLD CONTROVERSY

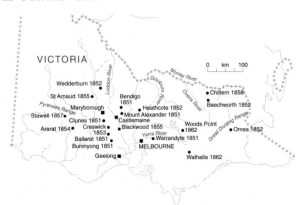

Gold was discovered in Australia for the first time in 1851. However, years later the discovery would be clouded in controversy. The man initially credited with the first find was Englishman Edward Hargreaves, who panned 16 specks of gold at Lewis Ponds Creek in Bathurst.

Hargreaves had been prospecting alongside John Lister when the specks were uncovered, but it was the Englishman who took the worthless find to Sydney to request a government finder's fee for unearthing the gold fields. He would eventually get the £500 fee he wanted. However, while Hargreaves had been negotiating, Lister and two compatriots (James and William Tom) had continued to pan for gold, and had become the first to find nuggets of saleable size, called payable gold.

Hargreaves took all the credit for the discovery of gold and received various payments from the New South Wales government for his role. However, 12 months before he died in 1891, a government inquiry found that Hargreaves had been wrongly honoured, and that Lister and the Tom brothers should have been fêted as the discoverers of the country's first payable gold.

The above map details Victoria's goldfields and their dates of discovery.

AUSSIES CROWNED QUEENS IN SEX POLL

An online survey conducted by condom manufacturer Durex has revealed that Australia and America have a higher proportion of homosexuals than any other country in the world. Based on a 150,000-person sample, 17 per cent

of the Aussie respondents in the survey reported that they had been involved in a gay or lesbian relationship. The survey also revealed that the typical Aussie has sex 125 times a year but, more worryingly, adds that 47 per cent of Australians had admitted faking orgasms at least once. Shame on you.

BRANDY THE WONDER DOG

Even the dogs are tough in the bush. A ten-year-old terrier called Brandy slipped the leash in the Tasmanian bush and had the misfortune of going head to head with a car, leaving her with a broken leg, one eye and a fractured skull.

Despite her presumably uncomfortable injuries, Brandy survived for an incredible ten days before dragging her emaciated body back over the threshold at the house of owner Brennan Fitzallen. 'She was pretty knocked around. Her right eye was missing and half her left leg was gone,' he explained to local paper the *Mercury*. 'She was just sitting there swaying backwards and forwards.' The swaying soon stopped and, after an extended stay at the vet's that took in an amputation, she returned home for good.

FIVE FACTS ABOUT AUSSIE BRIDES

A recent survey conducted by Australia's *Bride To Be* magazine has revealed the latest trends affecting the country's multi-million-dollar bridal industry.

• Only 4 per cent of brides will sign a prenuptial agreement.

• The average engagement lasts 12 to 18 months, with the engagement ring costing around A$2,500 (£1,000).

• Three out of five brides will wear white.

• 50 per cent of bridesmaids will pay for their own dresses.

• 50 per cent of brides will have their teeth cleaned.

TERMITES FOR TEA

When they become ill, Aborigines use a variety of natural remedies, with infusions of leaves and topical applications of other plants commonplace. However, to cure stomach upsets one tribe is also known to eat small balls of white clay with pieces of termite mound. It sounds hideous, but try explaining to an Aboriginal elder that in the West we consume bacteria (in the form of antibiotics) at the slightest hint of any ailment. What's worse: eating bugs or eating bugs' homes?

DESTROYER GROUNDS OFF QUEENSLAND COAST

Everyone makes mistakes at work, but a blunder by a British naval commander off the coast of Queensland left his ship with a 30m (100ft) hole in its hull and a A$95 million (£39 million) repair bill for the Royal Navy. A bad day at the office in anybody's book. The 13m (42ft) destroyer HMS *Nottingham* was grounded and left stranded off Lord Howe Island in July 2002, leaving Commander Richard Farrington in big trouble. The commander (who has an OBE) and his second in command admitted negligently allowing the ship to be stranded. Back in the early days of the 20th century, the Australian coastline was protected by 182 lighthouses, but with the advent of modern technology there are rather fewer active lighthouses today. If only there'd been a lighthouse there to warn them of danger…

TRANSCONTINENTAL RAILWAY

After the building of 90 bridges, 2,980km (1,860 miles) of track, millions of dollars and 145 years of waiting, Australia now has a transcontinental railway. The final piece of track was laid in September 2003, which completes a rail link that runs through the outback from the north to the south coast. An excited Mike Rann, premier of South Australia, somewhat modestly declared that 'the route will be one of the great railway journeys of the world'.

PRINCE OF DENMARK FALLS FOR AUSSIE

No Australian-born woman has ever been crowned a European queen, but all that is about to change, now that the Prince of Denmark has fallen for a Tasmanian from Hobart. Mary Donaldson, daughter of a university lecturer, is engaged to be married to Crown Prince Frederik, the 35-year-old heir to the Danish throne. The couple met at the 2000 Sydney Olympics.

KANGAROO FACT

Doria's tree kangaroos can move their rear legs independently of one another. Other species of kangaroo cannot do this.

PET KANGAROO HAILED FOR SAVING FARMER

In the true spirit of Skippy the bush kangaroo, a partially blind pet roo saved the life of her master with a show of heroism not normally associated with marsupials. Lulu the grey kangaroo turned rescue roo after farmer Len

Richards was knocked unconscious by a falling branch following a severe storm that had battered his farm in Gippsland, southeast Australia.

Lulu found the prostrate Richards and led the stricken man's family to him, standing over his body protectively and barking like a dog. Paramedics soon arrived and were quick to hail the plucky kangaroo for her initiative, explaining that Richards would have died if he had been left for much longer. Good work Lulu… You could make a TV show about an animal as smart as that, but what would you call it?

FROM PRINCE TO JACKAROO

When Prince Harry decided to spend his gap year training as an Australian cowboy at a ranch in Queensland, the media on both sides of the globe cranked into gear. Some Aussies did not want the Queen's grandson in the country, citing the reported £300,000 (A$730,000) security bill as justification. Others wanted the press to leave the prince alone. The rest just wanted to see how he'd cut it as a rodeo rider…

'If it is just a bit of a jaunt, I think maybe we should look carefully at the cost-sharing arrangements with the British government on this, because it's a lot of money,' said Labor Party foreign affairs spokesman Kevin Rudd. An Internet poll, meanwhile, revealed that most Australians just wanted the media to leave the prince to enjoy his stay in their country.

Final word goes to Injune Rodeo president Jamie Johnson, who explained that Harry had declined an invitation to ride a steer but that he had coped well with the banter, both at his cattle station and when attending a rodeo. 'He's having a good time at Tooloombilla [ranch],' said Mr Johnson. 'He's just part of the crowd – just a useless pommy jackaroo like all of them that come out!'

SQUASH KINGS

Australians are very good at squash. The national team has won the men's world championship seven times and is clear favourite for the 2003 title.

STILETTO GIRLS

Working girls from Stiletto – a newly opened, upmarket brothel in Sydney – were keen to maximize the visiting trade expected by the Rugby World Cup in 2003. Their publicity drive saw groups of girls travelling to the airport to greet several of the touring teams – on one occasion holding up a banner that read 'Feel like a ruck?'

BLUFFER'S GUIDE TO THE GREAT BARRIER REEF

It's big, it's coral and, if you don't go and see it when you're in Australia, your friends and relatives will make your life hell. But then again, if you don't fancy it, or if boat trips make you sick, you could always lie to them. All you need do is say that you went and then blag it with our five-point bluffer's guide.

1 Always start the story of your visit to the Barrier Reef by describing it as one of the 'great natural wonders of the world'. If you've been to the Grand Canyon or Niagara Falls, take the opportunity to draw a comparison.

2 Scuba diving on the Barrier Reef is very popular, so you might want to say that you went on a training course (these take several days usually) and then went out with a small group of fellow tourists. Alternatively, if that all sounds a bit far-fetched, you could say you snorkelled.

3 Always include a shark story, but don't get too carried away. Nobody – not even your 104-year-old grandmother – is going to believe that you are the sole survivor of an attack by a shoal of great whites. Maybe go for a straightforward sighting of a reef shark from 50m (165ft).

4 If you've gone all the way to the Reef, chances are you're going to take a boat trip. Probably best to say you went on a glass-bottomed boat so that you could see the 'myriad of marine life on the Reef'.

5 If you want to get specific, you can mention that you went to the Great Barrier Reef Marine Park, which is located off the coast of Cooktown.

DISASTER VULTURES

Natural disasters like tidal waves, earthquakes and cyclones provide an opportunity for communities to rally around and work together to assist neighbours.

But not everybody sees it that way, for some (less scrupulous) souls prefer to profiteer, gloat and spectate as those around them try to save their lives and their property. Australia, of course, has had its fair share of natural disasters and, unfortunately, also its fair share of vulture-like ne'er-do-wells looking to feast upon the misery of those less fortunate.

Just like motorway rubbernecks who can't resist having a sneaky look at a road accident, crowds will always gather around the scene of devastation. Even politicians are not immune from a spot of post-disaster tourism – all done in the name of solidarity and to aid rebuilding, of course. When Cyclone Tracy hit Darwin in Christmas 1974, and when bushfires devastated great swathes of land in 1983, government ministers made a beeline for Disastersville. However, victims of natural disasters rarely want to take time out from their strife to engage in a patronising conversation with besuited bureaucrats, nor do they want to be gawped at by a gloating and intrusive rent-a-crowd.

In 1918, when Queensland was hit by a cyclone and subsequent flooding, boat owners apparently took to the water to aid stranded neighbours who had taken refuge in trees and on rooftops. But rescue came at a price, for if the stricken couldn't (or wouldn't) pay, they were left grimly hanging on. Nice neighbours!

ABORIGINE POPULATION DECIMATED

The Aborigine population of Australia fell from 300,000 in 1770 (the year Captain Cook claimed the country for England) to just 60,000 by the start of the 20th century. Does wiping out 80 per cent of a country's indigenous people count as genocide? Surely not.

BIKINI-LINE QUEEN DETHRONED

For three months in 2003, Perth-based beautician Lareesa Guttery was the undisputed fastest waxer in the world. Guttery had established a new world record in July, after performing 130 waxings in just four hours. But her reign was to be short-lived, as in October Briton Sarah Percival successfully took care of 10 more bikini lines in the same time. And Sarah's achievement was irrefutable, as it took place on a TV show, The Salon.

PROTESTERS TARGET OPERA HOUSE

The 2003 war with Iraq was not a universally popular conflict, and prompted anti-war protests all around the globe. In Australia, two men made a high-profile demonstration of their disapproval by scaling the Sydney Opera House and painting 'No War' on one of the building's sail structures. The two men – Briton Will Saunders (42) and Australian David Burgess (33) – were later found guilty of malicious damage. The estimated bill for cleaning the Opera House was A$100,000 (£40,000). However, at the time of writing, the two men planned to appeal against their conviction, with Saunders declaring, 'I know in my heart that I did the right thing [and] I have no hard feelings toward the jury.' Just for the record, Australia sent 2,000 troops to help with the war effort.

EARLY ART

With the arrival of European settlers in the 18th century came a new style of art. These early painters typically concentrated on portraying the grand new houses of the wealthy, built on green and bountiful landscapes. Little effort was made to paint Aborigines and there was scant prospect of seeing the largely unexplored interior of the country represented on canvas.

The gold rush of the 1850s led to colonial expansion into hitherto unseen areas of Australia, however, and as the 19th century drew to a close the country's first significant school of art was born. The Heidelberg school was formed in the suburbs of Melbourne and drew upon a wide variety of influences to establish a uniquely Australian style of landscape painting. The results were impressionistic, and rich in colour and light. A later movement in Australian art, championed by the likes of Sir Sidney Nolan, fused European influences with the Australian landscape and indigenous elements.

HOOKERS THE KEY FOR WORLD CUP SUCCESS

When the 2003 Rugby World Cup loomed on the horizon three years after the Sydney Olympics, Australian businesses geared up for a tourist invasion, and no industry geared up more than the sex trade. A recent relaxation of prostitution laws meant that the world's rugby fans would be descending upon a country where brothels are effectively legal.

According to a spokesman for the Eros Association, more than 100,000 overseas visitors were expected for the competition, and every effort was made to cater for the different tastes of the oval-ball lovers. For England –

the tournament's favourite and eventual winner – the madams of Australia quickly began stocking up on whips and bondage equipment.

'It's not something that's very big in Australia, so a lot of the brothels are looking at lining up a dominatrix for the tournament,' explained Robbie Swan of Eros. 'If you look at where the game came from, the English public schools, they're very much into correction and all that. You'll get your beer-drinking yobbos but, at the higher end of the scale, rugby union has a clientele that you just don't get with rugby league – the judges, lawyers and big decision makers who are into all this,' he added.

But the fetish-fancying professionals on their sporting break should not feel guilty for their sexual deviances. Many others have made use of the brothels down under. Swan explained that, 'In Canberra, where we're based, the biggest event we ever had was the World Council of Churches in 1994... Business was up 250 per cent, there were all kinds of jokers coming in.'

SEXPO

Forget all the exhibitions about boats, cars and interior design, for Australia's busiest public exhibition is Sexpo. In 2003, the 'Adult Lifestyle Exhibition' visited four cities (Brisbane, Perth, Sydney and Melbourne) and entertained hundreds of thousands of paying visitors, while also attracting legendary guests from the adult industry, including Serenity and Ron Jeremy.

Sexpo's early selling point was that it offered a safe environment for women to buy sex toys and erotica, but today it is a diverse event, attracting exhibitors from a variety of fields, from herbalists and holiday operators to pornographers and *Penthouse* pets.

In its first six years, more than 750,000 people clicked through the Sexpo turnstiles and the show's success owes much to its continued popularity with female Australians. Women make up 40 per cent of the exhibition's visitors, and the opening day is reserved as Ladies' Day (though men are still welcome), when there is more female-oriented entertainment on show.

MONKEY SUITS AND WOODEN LEG

When Novotel conducted a survey of its hotels in 2002, it discovered a cache of interesting and somewhat bizarre lost property. Among the unclaimed items left by hotel guests in New Zealand and Australia were monkey suits and a wooden leg.

EMU SHOT DEAD IN WAR GAME

An Australian–American war game in Queensland's Shoalwater Bay area was brought to a sudden and premature end following a fatal shooting in 2001. However, the deceased was neither an American nor an Aussie soldier, but an emu. As soon as it became known that the flightless bird had been shot, the US Marine Corps halted the exercise and 27,000 military men downed their weapons. The soldiers were duly rebriefed on environmental issues before the exercise continued.

THE OLDEST PROFESSION

Prostitution was deemed essential in the earliest days of settlement in Australia. It was thought that commercial sex would help prevent the greater ills of sodomy, rebellion and the rape of 'good women'.

JOHN BOYLE O'REILLY

The last convicts to be transported to Western Australia arrived in Fremantle in January 1868, and among them was a significant Fenian contingent. Of the 281 prisoners aboard the *Hougoumont*, 64 were supporters of the Fenian society, a popular and rebellious secret society in Ireland at the time. John Boyle O'Reilly, a former non-commissioned officer in the 11th Hussars, was included in this number, having been court-martialled after encouraging his fellow soldiers to join the Fenians. O'Reilly faced 20 years of penal servitude, but instead spent a mere 13 months in Australia before establishing himself in both Irish and Australian folklore.

First he engineered his own escape from the penal colony in February 1869, hitching a ride from an American whaler. Next O'Reilly set up home in Boston, from where he edited the *Pilot* newspaper. Shortly after his escape, the British government granted pardons to the remaining civilian Fenians in Western Australia, but this would not have benefited the erstwhile Hussar, and his thoughts soon turned to the fate of the other military prisoners still incarcerated.

O'Reilly's final and most daring plan was to spring his remaining eight confined compatriots. He set about raising money to help achieve his goal, and in 1875 things began to come together. The plan was complex and did not run entirely smoothly, but was more or less effective. As he had done himself, O'Reilly (with the help of various colleagues) effected an elaborate scam that culminated with the prisoners escaping on a

whaler bound for America. Alas, two of the men were unable to join the escape because they were confined for insubordination, so just six Fenians boarded the *Catalpa* and sailed for international waters that offered sanctuary from the pursuing Australian police.

BLAZING BUSH

Bushfires are a fairly common occurrence in parts of Australia, with New South Wales often suffering significant damage. As recently as 2002, a series of raging fires tore through the county, affecting not only the Blue Mountains but also the suburbs of Sydney. On that occasion the blazes were started by arsonists, but the incandescent combination of tinder-dry eucalyptus forests, scorching temperatures and swirling winds can cause devastation without the need for human intervention. In 1983, 75 people died in appalling bushfires that began on Ash Wednesday.

FROM WHALE HUNTERS TO WATCHERS

The British colonisation of Australia not only decimated the Aboriginal population but also the stocks of whales from around the country's coastline. In the late 18th century British whalers arrived at around the same time as the naval fleet headed for Botany Bay, and soon set about harpooning these giant mammals, largely for their oil. Initially, they concentrated on 'bay whaling' relatively close to the shore around Sydney and Tasmania. However, stocks were soon depleted and the whalers were forced to travel further afield.

The southern right whale was the preferred quarry of 19th-century Australian whalers. The species, which was so named because it was regarded as the 'right' (most profitable) whale to pursue, yielded large quantities of oil and valuable bone. However, in an all-too-familiar tale, the hunters didn't know when to stop and stocks fell drastically, reaching a stage where only a few hundred survived in the early 20th century. Fortunately, a fall in the price of oil led to a sharp decline in whaling, and the southern right whale is now recovering its numbers.

The other species of whale that suffered at the hands of Australian hunters was the humpback, which on two occasions was plundered so voraciously that local numbers dwindled into the hundreds. Humpback stocks are recovering slowly, though they remain an endangered species.

NO BUDGING FOR BOLTE OVER HANGING

Like England, Australia does not employ capital punishment. There are, of course, regular debates about the reintroduction of the death penalty, but whenever the subject is raised the name of Ronald Joseph Ryan comes to the fore. On 3 February 1967 Ryan became the last man to be executed in Australia, amidst a storm of controversy.

Ryan had been found guilty of murdering a prison guard during a bungled escape bid from Pentridge Prison and was duly sentenced to death. However, the case was far from clear cut, and there was a strong suggestion that the guard, George Hodson, had instead been struck by a stray bullet fired by a colleague. There would later be unsubstantiated confessions from prison wardens, which – when added to evidence given at the trial – established enough reasonable doubt to cause concern.

The jury that convicted Ryan, a man previously regarded as nothing worse than a petty criminal and a hooligan, never really considered that he might be hung. After all, the previous 36 death penalties imposed in Victoria had all been routinely commuted to life sentences. It has even been rumoured that the jury believed that capital punishment had been abolished in the state. However, neither the jury nor Ryan had reckoned on the hard-nosed attitude of Victorian State Premier Sir Henry Bolte. In the year between sentence being delivered and Ryan's execution, great pressure was brought to bear on Bolte to reverse his decision, but to no avail. Petitions were signed, the clergy appealed for leniency and even the jurors themselves made a submission that they felt the sentence too harsh. But Bolte would not budge. He seemed to regard it as a battle of wills – his against the people.

'There is no possibility of the decision to hang Ryan being reversed. It is quite definite and final,' explained the premier on 12 December 1966. And he stuck to his word, even rejecting a heartfelt appeal from Ryan's mother to have her son's body returned to her for a proper burial. Ryan was duly hung and buried in an unmarked plot outside Pentridge Prison. He was the last of 108 executed prisoners for whom the prison was their final resting place. Bolte remained unrepentant.

BENAUD ON BRADMAN

'He is probably the most important Australian of all time.'
Former Australian cricket captain Richie Benaud on his predecessor, Sir Donald Bradman

FRANK FORDE

In July 1945 Francis Michael (Frank) Forde was a busy man. His political responsibilities already included Minister for the Army, Vice-Chairman of the Advisory War Council and membership of both the War Cabinet and the Standing Committee on Privileges. Then, to cap it all, Prime Minister John Curtin died. Forde duly took office as Prime Minister and served for eight days – the shortest reign in Australian political history.

MOONDYNE JOE

Joseph Bolitho Johns is quite probably the greatest larrikin in Australian history. Born in Britain in 1831, he was transported to Australia in 1853 and divided the remainder of his life neatly between petty criminality and jail. He was also rather adept at escaping from prison.

When sentenced by a court, Moondyne Joe (as he was nicknamed) seemed to regard the term of imprisonment as somewhat negotiable. He would invariably try to escape, and often succeeded. While he was in Freemantle Prison in 1867, he famously spent days piling up debris while on rock-breaking duty, using it as a screen to hide himself as he cut a hole through the prison wall and escaped via the superintendent's house.

On that particular occasion, Joe managed to evade recapture for two years. He returned to jail and had his sentence duly increased, but as always he was not downhearted. The one-time horse thief had always enjoyed a good rapport with prison governors and would routinely negotiate reductions in his sentence. His greatest achievement came in 1871, when he somehow wangled his freedom an incredible 13 years before he was due to be released. Now, that's parole!

By the late 1870s, Joe was in comfortable middle age and going straight, having married a 26-year-old widow called Louisa. He would remain out of prison (though not out of trouble completely) until he was incarcerated for one final occasion in 1900, after he was found wandering the streets of Perth in a disorientated fashion. He was detained and found to be of 'unsound mind'. Naturally, he escaped from Mount Eliza Invalid Depot on three occasions before he was returned to his second home – Freemantle Prison – for a brief sojourn. He died not long afterwards, meeting his end in Freemantle Lunatic Asylum.

VIETNAM

Around 50,000 Australians served in Vietnam between 1962 and 1973.

SPANISH STRAIT

The Torres Strait is the narrow body of water that separates Australia and New Guinea. It takes its name from Spanish explorer Luis Vaez de Torres, who passed through the strait in 1606. The southern reaches of the strait, just off the tip of northeast Australia, are peppered with an archipelago of islands (imaginatively named the Torres Strait Islands), which are inhabited by a distinct indigenous population.

CROWE FACT

Actor Russell Crowe was born in New Zealand, not Australia. He once released a single, under the name of Rus Le Roq, entitled 'I Just Wanna Be Like Marlon Brando'.

DIDGERIDOO OR DIDGERIDON'T

The didgeridoo is the traditional instrument of the Aborigines, the sound of Australia; indeed, the Aborigines say that if the Earth had a voice it would be the sound of a didgeridoo. Traditionally, an Aborigine would go into nature and listen intensely to animal sounds and voices, the wind, the roar of thunder, the creaking and rustling of the trees. The essences of all these noises were then rendered as accurately as possible by the low-pitched droning sound of the didgeridoo.

The didgeridoo is possibly the oldest musical instrument in the world.

Made from tree limbs and tree trunks (often bamboo), didgeridoos are cut to lengths of between 1.2m and 1.4m (4ft and 5ft).

After being hollowed out by termites, didgeridoos are then cleaned out with hot coals or a stick.

The instrument was used as an accompaniment to chants and songs.

The didgeridoo was originally found in Arnhem Land, northern Australia.

It produces a low-pitched, resonant sound, which is made to play complex booming rhythms.

'Didgeridoo' can be spelled in all sorts of ways – 'didjeridu', 'didjiridu', 'didjerry' and many other variations… Experts say that there are at least 45

synonyms for the didgeridoo (in fact, the word 'bamboo' is still used by some Aborigines when referring to the instrument itself).

CHINESE FOLLOW BRITS TO SYDNEY

Sydney is a truly multicultural city, and its population includes migrants from every continent. The British make up the largest component of Sydney's immigrant population, followed by the Chinese and arrivals from neighbouring New Zealand.

QANTAS

If ever a country needed a reliable airline, it is Australia. Situated thousands of kilometres from many of its closest political allies and trade partners, and with its own cities separated by great distances, it is hardly surprising that Australia was the first English-speaking country to have an airline. QANTAS was born in the excitement of the inter-war aviation boom, growing from the vision of two enterprising former World War I pilots.

W Hudson Fysh and Paul McGinness had first got the idea of creating a civil air service when working at ground level on the 1919 England–Australia Air Race. A wealthy farmer had helped them find the finance they needed to get their project airborne, and in 1920 they took delivery of their first plane and christened the new company Queensland And Northern Territory Aerial Services Limited (QANTAS).

By the start of World War II, the business had grown beyond the wildest expectations of Fysh and McGinness. QANTAS had built its own planes, had facilitated the Flying Doctor Service and had not only expanded its domestic routes but also started to offer overseas services. Much of this success was down to the airline's attention to detail and reputation for delivering a quality service.

The QANTAS success story continued in the postwar era, with the Australian government buying into the airline in 1947. Further expansion of international routes followed, with global services offered by the end of the 1950s. QANTAS was also quick to adopt jet-engine technology and was the first non-US airline to use Boeing 707s.

SYDNEY'S RESIDENTS

The people of Sydney call themselves Sydneysiders.

AUSTRALIAN OF THE YEAR

The annual Australian of the Year awards are a big deal down under. Presented each January, they celebrate the achievements of the country's leading citizens and are given in four categories: Australian of the Year, Young Australian of the Year, Senior Australian of the Year and Local Hero. The winners are selected by the National Australia Day Committee, and receive their awards in a ceremony held at Parliament House, Canberra.

The Young Australian award was introduced in 1979 and was followed 20 years later with a Senior Australian award for Aussies over 60. At the time of writing, athlete Cathy Freeman is the only person to have won awards in two categories and, since she is three decades away from being 60, you can guess which two she's won! Freeman was named Young Australian in 1990 as a 17-year-old, and collected the main prize eight years later. As for the senior prize, which was introduced in 1999 to coincide with the International Year of Older Persons, winners have included singer Slim Dusty and two professors. The other major award – for Local Hero of the year – was only introduced in 2003, and apparently 'acknowledges extraordinary contributions made by Australians in their local community'.

So, who's on the list of past winners? There are certainly a few surprising names and, to be frank, it's something of a mixed bag, combining athletes, entertainers, scientists and politicians… Have a look for yourself.

Australian of the Year 1960–2003
2003 Professor Fiona Stanley AC
2002 Pat Rafter
2001 Lt General Peter Cosgrove AC MC
2000 Sir Gustav Nossal AC CBE FAA FRS
1999 Mark Taylor
1998 Cathy Freeman
1997 Professor Peter Doherty
1996 Doctor John Yu AM
1995 Arthur Boyd AC OBE
1994 Ian Kiernan OAM
1993 No award given, due to change in award dating system
1992 Mandawuy Yunupingu
1991 Archbishop Peter Hollingworth AO OBE
1990 Fred Hollows AC
1989 Allan Border AO
1988 Kay Cottee AO
1987 John Farnham

1986 Dick Smith
1985 Paul Hogan AM
1984 Lois O'Donoghue CBE AM
1983 Robert de Castella MBE
1982 Sir Edward Williams KCMG KBE
1981 Sir John Crawford AC CBE
1980 Manning Clark AC
*1979 Senator Neville Bonnor AO
*1979 Harry Butler CBE
*1978 Alan Bond
*1978 Galarrwuy Yunupingu AM
*1977 Sir Murray Tyrall KCVO CBE
*1977 Dame Raigh Roe DBE
 1976 Sir Edward 'Weary' Dunlop AC CMG OBE
*1975 Sir John Cornforth AC CBE
*1975 Major General Alan Stretton AO CBE
 1974 Sir Bernard Heinze AC
 1973 Patrick White
 1972 Shane Gould MBE
 1971 Evonne Goolagong Cawley AO MBE
 1970 His Eminence Cardinal Sir Norman Gilroy KBE
 1969 The Rt Hon Richard Gardiner Casey Baron of Berwick, Victoria and
 of the City of Westminster KG GCMG CH
 1968 Lionel Rose MBE
 1967 The Seekers
 1966 Sir Jack Brabham OBE
 1965 Sir Robert Helpmann CBE
 1964 Dawn Fraser MBE
 1963 Sir John Eccles AC
 1962 Alexander 'Jock' Sturrock MBE
 1961 Dame Joan Sutherland OM AC DBE
 1960 Sir Macfarlane Burnet OM AK KBE

*Between 1975 and 1979 (excluding 1976), two awards were given by separate Australia Day Councils.

AUSSIE CAR FACT

A new Mini Cooper (you know, like the ones used in 2003's *The Italian Job*) will cost you more in Australia than in Britain. Down under, a typical model will set you back A$32,650 (£13,000) or so – roughly A$4,900 (£2,000) more than you'd pay in Blighty at the current rate of exchange.

MADAME SADDAM

The 2003 Gay and Lesbian Mardi Gras in Sydney featured a float named Madame Saddam and her Weapons of Mass Seduction. It was in the shape of a tank.

REX COMES HOME

The dogs of suburban Victoria are rather resilient. Rex, a pure-bred Maltese terrier, was snatched from outside his owner's house in 2002, only to return home via a local vet after nine weeks away. Dog-nappers really should be more careful with their booty.

MAN AND MEGAFAUNA IN HARMONY

Aboriginal people coexisted alongside Australia's megafauna (giant birds, reptiles and mammals that previously inhabited the continent) for around 30,000 years. Hunting these huge animals was rare – a boomerang was no real threat to a 4.5m (15ft) wallaby – so scavenging was the only way mankind got to taste their flesh. Most species of megafauna were wiped out around 20,000 years ago.

PUTTING THE BOOM IN A RANG

Boomerangs are more than just weapons. They are also – when used in pairs – fine percussion instruments, which have long been used by Aboriginal people to accompany singing. Of course, in the hands of the uninitiated, the boomerang can transform a tranquil public park into a scene from a disaster movie. Few things invoke more anxiety than the sight of a strapping alpha male about to let fly with his new titanium rang (which of course he hasn't a clue how to use) as his new girlfriend and sacrificial pet labrador look on.

STRONG SAMPLE

The spinifex hopping mouse never drinks, as it gets all its fluids from fruit and vegetation. The down side, however, is that its urine is extremely concentrated.

ABORIGINAL ACCOMMODATION

From its arid desert interior to sub-alpine conditions in the southeast, Australia has the full range of climatic conditions. To cope with such variations in temperature and rainfall, Aboriginal people evolved similarly disparate housing solutions to protect them from nature's excesses.

Flimsy sunscreens made of plant leaves, and reed windbreaks were sufficient in the country's scorched interior, but elsewhere rather more substantial accommodation was required to insulate families at night. In some regions, huts were built from timber and bark at ground level, but when the rains came, particularly in the north, shelters were built on stilts that raised the inhabitants away from the boggy ground. Other popular styles of Aboriginal accommodation included dome-shaped dwellings made from bent saplings and bark.

THE STING OF THE STONEFISH

According to the Australian Venom Research Unit, the stonefish 'may be described as the world's most dangerous stinging fish'. The two species that inhabit Aussie waters are found mainly around the northern coast, and the advice is…tread carefully. The highly camouflaged stonefish wriggles down into the seabed, digging into the sand or shingle, with only its array of 13 venomous spines exposed. Walk on these spines, which are connected to venom glands, and you will enter a world of extreme pain. Your foot will swell (very quickly), the pain will be excruciating and you will feel weak. A fast exit from the water is absolutely essential, as is first-aid treatment. The good news is that fatalities are rare (at the time of writing, there had been not one death in Australian waters) and there is an antivenin available. The bad news is that tissue damage can occur, the stinging spines can be left in the wound and pain is always evident.

RACING ON THE MOUNT

Bathurst's Mount Panorama racetrack is one of the most important circuits in Australian motor sport. Situated on an extinct volcano, the mountain hosted its first race in Easter 1938, when Englishman Peter Whitehead won a 240km (150 mile) grand prix meeting. The helmetless Whitehead averaged around 106kph (66mph) on the dirt track course. There have been four further GPs at Bathurst, with Lex Davidson winning the last in a Ferrari in 1958.

BAD GRACE

Cricket purports to be a 'gentleman's game', but it's hard to reconcile the sport's somewhat arrogant self-image with a reality that has taken in match-fixing scandals, drug offences and the routine use of verbal intimidation for tactical advantage. And the truth is that none of this behaviour is new, certainly not when Australia and England face one another.

The first reported incidence of gamesmanship between these two great rivals came in 1882, and is alleged to have involved none other than the great WG Grace. The story goes that, during a lull in play, the legendary English cricketer called one of the Aussie batsmen towards him for a chat, but as the man left his crease and approached, Grace ran him out. Surely not?

MEL GIBSON... A NON-AUSSIE

Contrary to popular belief, Mel Gibson was not born in Australia. The tabloids might have dubbed him an Aussie heartthrob, but Mel was in fact born in New York (in 1956), and only moved to Sydney when he was 12. With ten siblings, it is perhaps no surprise to find that Gibson attended a Catholic school upon arrival down under.

A stint at the National Institute of Dramatic Art followed, before Mel got his big break in George Miller's acclaimed movie *Mad Max*. Mel had arrived at his *Mad Max* audition in poor shape after a pub brawl, and believed he had little chance of impressing Miller. However, the rough-and-ready-looking Gibson was exactly what the director was looking for and he bagged the lead role.

After *Mad Max* came a successful switch to Hollywood, with the *Lethal Weapon* films (alongside Danny Glover) bringing Mel to the attention of a wider audience. An acclaimed performance in the 1990 film version of *Hamlet* brought critical acclaim, but it was *Braveheart* (1995) that is perhaps his greatest success. Not only did he star in the film, Mel also directed it, and he must have taken great satisfaction from its success, which culminated in five Oscars.

ROO HIDE POSES ETHICAL DILEMMA

Kangaroo skin is soft, flexible and resilient, and it remains the favoured material of many top soccer boot manufacturers despite the objections of animal rights campaigners. If you don't believe us, take a look at an advert for footwear in a soccer magazine and you will see that high on the list of selling points is the leather used to make the boots. Kangaroo skin is the

EVERYTHING YOU DIDN'T NEED TO KNOW ABOUT AUSTRALIA

top choice and is usually reserved for professional-line boots that cost in the region of A$250 (£100) a pair.

The kangaroos used for football boots are killed by licensed hunters, with the larger roos targeted in particular. Anti-hunting campaigners claim that these animals are the ones that should be protected because without them the species' gene pool will be weakened. Larger animals, the protesters say, are better equipped to survive a drought or the outbreak of a virulent disease, and without them it is left to smaller, weaker animals to breed.

The anti-hunting lobby also focuses on the issues of animal cruelty and conservation. Man's incursion into the Antipodes has already seen the extinction of six species of kangaroo, and the fact that a further 17 species are endangered or vulnerable offers a persuasive argument against hunting. Macabre stories of hunters inhumanely slaughtering worthless baby roos (joeys) – whether true or not – have also done little to endear the men behind the guns to the Aussie public.

The hunters argue that they are involved in a commercial exercise that should invoke no more moral outrage than fishing or livestock farming. They suggest that kangaroo populations need to be managed and controlled, and ask whether there is any ethical difference between wearing shoes made from cowhide or kangaroo skin. Well, is there?

ABORIGINAL ART

The paintings of Australia's Aboriginal people are widely admired throughout the world, enjoying a significant place in the history of art and great respect from students of aesthetics. With rock engravings that date back tens of thousands of years, and paintings of spirit ancestors, animals and landscapes that depict a changing continent, the art of indigenous Australians also provides a valuable resource for both historians and anthropologists.

HAYDEN SETS TEST RECORD

Aussie batsman Matthew Hayden set a new record for the highest individual score in a Test match when he struck 380 off only 437 balls against Zimbabwe at Perth in 2003. The previous record of 375, which was held by West Indian Brian Lara, had stood for nine years. Lara telephoned Hayden at the close of play to congratulate him on his score, and the West Indian told the press, 'The record for Matthew is a testament to Australian cricket and their fast pace of play.' Hayden's score included 38 fours and 11 sixes.

ABORIGINAL LAND RIGHTS

The tensions between Australia's Aboriginal people and European settlers has many causes, not least the cold-blooded slaughter that accompanied the white man's arrival. However, in the 20th century the issue of land rights came to dominate relations between the two communities.

Before the white man arrived, Aboriginal people had no concept of land ownership. They didn't build towns and cities, and would often move around to utilise natural resources and grazing areas. However, while they didn't care to 'own' the land, they needed it for both practical and spiritual reasons. The needs of the indigenous people were of little consequence to the Europeans, though, and in the space of 150 years the Europeans had systematically wrested control of every part of Australia they wanted. Sacred lands, pastures, fertile areas, fishing coves and lands rich in minerals were all taken without any consideration for the people in residence.

In some cases, Aboriginal people were driven out bloodlessly, but at the gold fields in the 1850s and at the seal hunting grounds of the south a cocktail of murder and rape further devastated the evicted Aborigines. Ham-fisted attempts to relocate the dispossessed to reserves were both insensitive and ineffective – and, in any case, if the reserves were on valuable sites they would be moved or cut down to size. The result was that by the early 20th century many Aboriginal people had been so marginalised that they were left to inhabit impoverished dwellings on the fringes of towns and villages.

In 1938, Australia's Aborigines began to fight back through politics. A gathering in Sydney during January declared a 'Day of Mourning' for the fate of the country's indigenous people. The fight had begun, but it would take many years before their opponents could even understand their argument, and throughout the postwar era Conservative governments attempted (misguidedly) to improve the lot of Aboriginal people through policies of assimilation. It was only following the election of a Labor government in 1972 that things began to improve, starting with the creation of a Department of Aboriginal Affairs.

In 1975, Gurindji workers at a cattle station in the Northern Territory earned a further notable victory when they were granted a pastoral lease on part of the station that covered their traditional lands. The success of these workers was followed by the first Aboriginal Land Rights Act in 1976, and within ten years the Aboriginal peoples of the Northern Territory had regained 40 per cent of the Territory's land. The fight would rumble on for the remainder of the century, but in 1993 came the most significant victory. The Australian High Court overtured

the application of *terra nullius* (whereby a territory is claimed as vacant and free from prior ownership), thereby acknowledging the Aboriginal people and Torres Strait Islanders as the original owners of Australia.

KYLIE MINOGUE FACT FILE

After the best part of 20 years in the showbiz limelight, there are three things we know about Melbourne's favourite daughter: she's small, she's sexy and she's here to stay. The diminutive diva first danced onto our TV screens as Charlene in *Neighbours* in 1985, and since then she's enjoyed the kind of prolonged success not usually associated with a soap-starlet-turned-pop-princess. Some love her, some loathe her, some are merely indifferent to her charms, but there is no escaping her... So here's a quick guide to the life and times of Ms Kylie Minogue.

- Kylie is born in Melbourne on 28 May 1968.

- Her mum is Welsh.

- After early TV outings as a child star, Kylie breaks into the big time with a part in *Neighbours*.

- She hooks up with Jason Donovan on the set of *Neighbours* and embarks on an on- and off-screen relationship that makes nobody happier than editors of tabloid newspapers.

- Kylie launches her pop career in 1988, releasing the groundbreaking and deeply insightful pre-teen anthem 'I Should Be So Lucky'. It goes straight to No.1 in England (where they know about music).

- Even better follows for Kylie, who teams up with Jason to record the unforgettable ballad 'Especially For You'. It goes to No.1 for Christmas 1988. Some joyless souls describe the record as 'mushy'.

- The pop hits continue, but Jason fades into the background and Kylie gets it together with INXS's Michael Hutchence.

- By the mid-1990s, the sugar-sweet veneer of the post-*Neighbours* pop princess has been traded for a new sexy image. Collaborations with Nick Cave and Robbie Williams help, too.

- Kylie's pop career reaches new heights with the double-platinum album *Fever*. The single 'Can't Get You Out Of My Head' breaks the US market in 2002.

- Lots of Antipodean soap stars try to follow Kylie's lead, but none (not even her devilishly sexy sister Dannii) manages to match up.

THE WATTLE

Australia has two national emblems. The golden wattle is the country's floral emblem, while the kangaroo flies the flag for the animal kingdom. The wattle was memorably lambasted by the Monty Python crew in a famous sketch from their acclaimed *Flying Circus* TV show. The skit, in which a group of Australian academics – who all wore cork hats and were called Bruce – bring out a wattle to collective excitement, before the leader recites the following verse:

This here's the wattle – the emblem of our land,

You can stick it in a bottle – or you can hold it in your hand,

Amen

HEATHCLIFF GOES HOLLYWOOD

Aussie movie actor Heath Ledger, whose credits include *A Knight's Tale*, *The Patriot*, *10 Things I Hate About You* and *Black Rock*, was named after the character Heathcliff in Emily Brontë's classic *Wuthering Heights*.

10 FACTS ABOUT BATHURST

Bathurst is more than just a racing town – it was also Australia's first major interior settlement and a key location in the gold rush of the 19th century. Check out the following facts.

The first European settlers arrived in Bathurst in 1815.

Bathurst is located less than 160km (100 miles) from Sydney, but in 1815 that was a long way, and it took over a week for the interior pioneers to make the trip.

The area was previously occupied by the Wiradjuri people (the largest Aboriginal group in New South Wales), and the arrival of the Europeans led to a bloody conflict. The Wiradjuri suffered horrendous casualties during four months of martial law in 1824, and after 120 deaths they called for a truce.

In 1829, a convict was flogged for swimming in the view of Governor Darling and his party. The incident prompted an 80-strong convict rebellion. This was eventually suppressed and 11 men were subsequently hanged.

The first payable gold in Australia was found in nearby Ophir, and Bathurst soon became a pivotal town en route to the diggings.

Coach company Cobb & Co established its headquarters in Bathurst in 1862. Tourists can now follow a Cobb & Co Heritage Trail.

The railway arrived in Bathurst in 1876, and within ten years the population had increased by 50 per cent to around 9,000.

Bathurst was declared a city in 1885.

Bushranger John Piesley was one of a number of outlaws to be hanged at Bathurst jail in the 19th century. The jail moved location in 1888, however, so the current historical site is not the one where Piesley and friends met their sticky end.

The Bathurst 1000 motor race was first contested in 1960.

SYDNEY SPRAWLS TO THE SUBURBS

Sydney's population is generously spread out over a wide area that incorporates numerous suburban developments. This gives the city one of the lowest population densities of any major city in the world. (3.5 million people in an urban area of 3,500 square km [1,350 square miles].)

ABORIGINAL BURIALS

Some Aboriginal peoples practised 'secondary disposal' of their dead, whereby they buried the body and then subsequently (usually once the cause of death had been established) dug up the bones and reburied them after a second ceremony. Secondary disposal was predominant in the north of the continent; elsewhere, straightforward burial (sometimes in trees) and cremation were practised.

CHURCH OF OZ

Australia got its own branch of the Protestant Church in 1981. The Anglican Church of Australia took over from the Church of England, which then packed its hymn sheets and headed back to Blighty.

GHOST BAT IS NO VAMPIRE

The Australian ghost bat is also known as the false vampire bat because it was once thought that it fed on blood. In fact, this nocturnal resident of northern Australia favours birds and lizards.

NAT HAILS QUEEN KYLIE

Kylie Minogue has been more than just a role model to the new wave of Aussie soap-stars-turned-pop-divas. In the case of Natalie Imbruglia, Ms Minogue turned mentor, offering advice and support to her compatriot. 'Kylie was very supportive and told me to stick at it,' Natalie told *Hello!* magazine. 'She was always there for me.' Holly Valance, for her part, has described Kylie as an 'absolute goddess'.

NICOLE KIDMAN

Surely the stunning Oscar-winning star is as Australian as a kangaroo eating a Vegemite sandwich outside the Sydney Opera House? Afraid not. The beautiful redhead was born in Honolulu, Hawaii, though to be fair she did move to Australia as a tot, so the accent is for real.

BUNNY PLAGUE

The British did many daft things when they arrived in the Antipodes, a prime example being the introduction of several animal species to an ecosystem not intended to support them. Rabbits were the worst offenders, arriving in Australia in the mid-19th century, along with foxes to provide sport for the hunt-loving Brits, who were clearly not happy to pursue the indigenous animals.

The European bunnies wasted no time making themselves feel at home, and within months they were breeding like…er…rabbits. There was no natural predator to keep the rabbit population in check and before long there were half a billion bunnies bounding around the countryside. Landowners tried everything to cull them, but no amount of poisoning, shooting and trapping could control the ballooning population of a species that breeds seven times a year (a single pair of rabbits can spawn 100 youngsters in a year). The effect on the Australian landscape and ecology was akin to a plague, and as the bunnies grazed, other indigenous species saw their usual pastures destroyed, soil was left exposed and the rabbits' burrows further eroded the landscape.

In the 1890s, hundreds of cats were released into the wild in Western Australia in an attempt to introduce a natural predator to the rabbits. However, the cats made little or no impact, struggling to adapt to the unfamiliar conditions, and many died through hunger. The 1950s saw the authorities introduce a biological attack on the rabbits, with scientists unleashing the disease myxomatosis on the fluffy-tailed plague. It proved

effective and killed millions of rabbits, but when the animals became resistant to the disease the rabbit population began to rise again, reaching an estimated 250 million by the mid-1990s.

The scientists went back to the lab and soon got wind of a virus afflicting rabbits in China. Rabbit calicivirus was duly imported and tests began to see if it would work on Australia's bunnies without affecting other species. However, before the tests were completed the virus escaped from a quarantine area and began rapidly spreading through the country, leaving rabbit corpses lying in its wake. An official release followed, and early signs suggest that the rabbit population has now been significantly reduced. The big question, of course, is what the Aussie scientists will do if the bunnies develop a resistance to this bug just as they did with myxomatosis.

BIG-MOUTHED BIRDS

Australia has two major species of big-mouthed birds: nightjars and frogmouths. Both use their cavernous mouths to hoover up their prey – insects in the case of nightjars, the frogmouths' tipple being small animals.

THE BODY

Elle Macpherson is one celebrity who is irrefutably Australian. The model, businesswoman and actor was born in Sydney in 1964, and was a student at the city's university when spotted by a model scout while on holiday in America. Her perfectly proportioned figure soon earned Elle the nickname 'The Body', along with a succession of high-profile modelling assignments. Elle's list of credits include featuring on the covers of most of the world's top fashion magazines, and three successive appearances on the front cover of *Sports Illustrated*'s swimwear edition. Away from modelling, Elle runs a successful lingerie company and has featured in several leading TV shows and movies, including *Friends* and the Australian film *Sirens*.

BALLS BY THE THOUSAND

An estimated 1,000 rugby balls were used at the 2003 Rugby World Cup finals in Australia.

MONEY FOR GUNS

The Australian government spends around 2 per cent of its Gross Domestic Product on its military.

10 LESSER-KNOWN AUSSIE MARSUPIALS

Rufous bettong – A medium-sized rat kangaroo with a penchant for building conical nests.

Parma wallaby – This shy resident of eastern Australia was thought to be extinct, but was rediscovered in the 1960s after decades spent successfully eluding man.

Quokka – A small species of wallaby that was nearly eradicated by predators introduced by European settlers, most notably the fox. It now survives only on islands of the southwest coast of the country.

Swamp wallaby – Also called 'the stinker', this nocturnal creature feasts on vegetation including hemlock.

Little pygmy-possum – The name gives it away: the little pygmy-possum is tiny – around 5cm (2in) long. They're also nocturnal loners, so you'll be lucky to see one in the wild.

Striped possum – Australia is home to several species of possum, and this one is notable for its skunk-like ability to give off a foul stench from its nether regions. It's also striped black and white like a skunk. Avoid it at all costs.

Squirrel glider – Like the larger greater glider, this marsupial flies from tree to tree using a membrane parachute that runs from foot to foot. It can traverse distances of more than 30m (100ft).

Pygmy glider – This tiny glider has sharp claws and an elongated tongue, which it uses to dig out pollen and nectar from flowers.

Brushy-tailed ringtail – The rainforest of northeast Australia is home to this monkey-like marsupial, which uses its powerful tail to manipulate its way through the forest canopy.

Kowari – This small burrow-dwelling carnivore is found in the deserts of central Australia, where it preys upon lizards and insect life.

CAMELS DOWN UNDER

The white man introduced many things to the Antipodes, including camels. The first of these beasts arrived from the Canary Islands in 1840 and today the feral camel population of Australia is estimated to be around 500,000.

The camels were initially used by Victorian adventurers eager to explore the country's arid interior, and by the 1860s imports were being supplemented by Aussie-bred animals from studs. The camels used were mainly dromedaries

– the one-humped, long-legged variety – which are better suited to the hot desert conditions. Once the exploring was done, however, the redundant beasts were set free in the wild, most of them in the Northern Territory and Western Australia.

In recent times, Australian camels have found fame on the racetrack, with the Lions Club Camel Cup race in Alice Springs pioneering a sport that has grown in popularity since its inception in 1971. Those that don't race, however, are in peril of ending up as meat, as camel cuts have grown significantly in popularity during the last 20 years.

PRICE KNOCKED DOWN

Too much confidence can be a terrible thing, as John Price found out when he stepped among disgruntled prisoners at Williamstown in 1857. The hard-line Inspector General of Penal Establishments prided himself on being able to deal with convicts and on understanding their behaviour. However, he got more than he bargained for when he attempted to impose his authority to quell a disturbance over rations. The prisoners closed in and beat Price with fists, tools and rocks, leaving him mortally wounded. He died the next day. Twelve convicts were tried for murder, eight of whom were subsequently hanged.

THE MAGIC OF McOZ

It seems that Australians like Americans so much that they've even adopted McDonald's as their favourite restaurant. The first Aussie McDonald's opened in Yagoona, Bankstown (Sydney), on 30 December 1971 and there are now more than 600 of the fast-food restaurants, employing thousands of workers throughout the country.

McDonald's, for its part, has given Australia its own dish – the imaginatively named McOz burger, which consists of 100 per cent Australian beef, cheese, tomato, lettuce, onion and beetroot on a freshly toasted bun. The burger has apparently been designed to 'satisfy the tastes of Australian customers'.

The success story of Australian McDonald's reached a new high when the burger chain was named the Official Restaurant Partner of the 2000 Olympic Games in Sydney. However, despite serving more than a million sandwiches in the three weeks of the Olympics, there were no McOz burgers on the menu at the Sydney Olympic Park. Athletes, it seems, had to make do with more traditional fare, like Big Macs and chicken nuggets, to fuel them through the rigours of international competition.

LOOK! ROOS ON THE MENU

The last ten years have seen a 50 per cent rise in the human consumption of kangaroo meat, with both domestic and export sales increasing sharply in the wake of legislation clarifying the laws on both the hunting and eating of Australia's favourite marsupial. Of course, controversy is never far away when it comes to the emotive subject of animal welfare, and kangaroo killing is no exception.

Demand for roo meat has never been greater, with kangaroo cuts exported around the globe and consumed in a variety of forms, from sausages and burgers to haute cuisine. Strict quotas in each region dictate the number of roos that can be slaughtered, with figures calculated according to projected populations (which are estimated with the aid of aerial photographs).

Animal rights campaigners, however, are unconvinced that the quotas are either accurate or enforceable, and they are also worried that the Council of Nature Conservation Ministers' code of practice, which lays down guidelines for the humane killing of kangaroos, is sufficient to protect the animals from cruelty. They argue that the code is undermined by regional variations in laws and practices – for example, in most territories it is illegal to use dogs and some forms of poison, but not so in Tasmania – and point out that pouched young are often left to die from malnutrition or exposure rather than being killed immediately.

The meat industry, of course, refutes suggestions of cruelty, and claims that kangaroos are spared the stresses of pre-slaughter herding and handling. 'Headshot' is, apparently, the correct term for the preferred mode of slaughter for these nomadic herbivores, although of course not every animal is clean-shot.

However, the main thrust of the pro-kill lobby's argument is that roo meat tastes good. It was an undoubted hit with visitors to Sydney for the 2000 Olympics, illuminating gourmet menus ahead of exotic dishes containing crocodile and emu. According to one restaurateur, it tastes 'very flavoursome and not too gamey' and is succulent and versatile. It is also low in fat and high in protein, with some nutritionists claiming that it can even help to reduce cholesterol.

AUSSIE PARROTS IN BRIEF

Australia is home to numerous species of parrots, including that classic cage bird beloved by grandmas the world over – the budgerigar.

Wild budgies are always green and yellow. The other colours you see in pet shops are domesticated remixes.

The swift parrot is small, endangered and only breeds in Tasmania.

Galah cockatoos are common down under. They're also pink. If you like cockatoos, but not pink, watch out for the mean-looking black and red palm cockatoo, which can be found in northeast Australia.

Male and female eclectus parrots do not look alike. The male is bright green with a yellow bill, while the female is red and blue with a black bill.

The classic cockatoo (white with a yellow crest) is called the sulphur-crested cockatoo and inhabits most of eastern Australia. Trapping of these birds for the pet trade remains a problem.

Rosella parrots are found only in Australia.

The visually striking rainbow lorikeet, with its tiger-striped breast and colourful plumage, is an unwelcome visitor to Australia's vineyards. It feeds in flocks and is capable of devastating large areas in very quick time.

Cockatiels are common throughout most of Australia.

Macaws and parakeets are not native to Australia, so you'll have to stop off in South America if you want to see them in the wild.

CRICKET AUSTRALIA CRACKS DOWN ON SLEDGING

In the summer of 2003 Australia's cricket authorities announced that they were cracking down on sledging (the practice of using verbal intimidation to unsettle an opponent – usually a batsman) and that those who transgressed would face severe penalties, perhaps even a life ban from the sport. The move provoked immediate controversy, with some arguing that it was too little, too late, while others suggested that it was an overreaction to something that is a minor part of the game. Former Australian fast bowler Dennis Lillee was clearly not impressed, explaining that 'Sledging has gone on since WG Grace and it will go on as long as any sport is played, not just cricket. If they think it's too bad, the authorities are there to stop it.'

Lillee's mantle in the current Australian cricket side is held by Glenn McGrath, a bowler offering similar levels of ferocity and intimidation with both ball and voice. The new code of conduct issued by Cricket Australia (CA) is thought to have been precipitated by a confrontation between McGrath and West Indies batsman Ramnaresh Sarwen during a game in 2003. McGrath, who was seen pointing a finger at the Windies batsman as he hollered at him in full view of TV cameras, duly made his peace with Ramnaresh. But CA apparently made it clear to Aussie captain Steve Waugh that he was to get his players in line and that there should be no further outbursts. Waugh, for his part, is eager to defend the reputation of his team-mates and his country, and refutes suggestions that the Aussies are among the world's worst when it comes to sledging. He does, however, concede that 'Occasionally there are things said on the cricket field and we have examples of it during the last six to twelve months. I am very aware that we do not want that to happen in my side, as we play the game hard and fair.'

Waugh has a hard job to do in convincing others that Aussies don't sledge, however. Even one senior official at the ICC (International Cricket Council) has been reported to say that, 'Australians are not liked around the world… In cricket, particularly the Australian team, it [sledging] seems to have got worse.' Perhaps now, with a new code of conduct and some stern penalties in place, things will improve.

DYING IN TRANSIT

The death rate on the early convict ships was 1 in 30, but by the 1820s only 1 in 120 prisoners passed away during the long passage from England. Credit for this improvement was given to surgeon William Redfern, who made recommendations about health care to the colony's governor after suffering a similarly gruelling journey himself.

CROSSING THE SEA

When the people of southeast Asia began settling in Australia more than 40,000 years ago, they would have had to traverse an open stretch of water at least 40km (25 miles) wide.

FREE PRESS

Australia is ranked 12th out of 139 countries in the Worldwide Press Freedom Index.

HOGAN GOES HOLLYWOOD

Sydney-born actor Paul Hogan found fame as Crocodile Dundee, the caricatured bushman who took Aussie blokedom to Hollywood in the 1980s, but he began his working life as a painter on the Sydney Harbour Bridge. A venture into comedy propelled Hogan on the path to celebrity, with his long-running TV sketch programme, *The Paul Hogan Show*, spanning more than 60 episodes before movie stardom beckoned.

FROM JAIL TO COLONY

The rapid urbanisation of Sydney in the first half of the 19th century owes much to the vision and foresight of the colony's Scottish governor, Lachlan Macquarie, who held office from 1809 to 1821. Though a hardline disciplinarian, Macquarie was not your typical belligerent colonial despot, and was keen to see the new country grow under his guidance.

Although many of the convicts were uneducated and untrained, there was still a significant number of artisans and professionals among them, and Macquarie was eager to utilise these talented individuals. The men were housed in Hyde Park Barracks and deployed on a range of projects from the construction of civic buildings to planning agricultural production.

The untrained and unskilled played their part, too, with Macquarie motivating them to serve their sentences and remain in the colony by offering them land grants along with their freedom. Soon Australia had more free men than convicts, and there are numerous examples of criminals making good and earning both money and social standing. One such criminal was convicted thief Samuel Terry, who overcame illiteracy to establish several thriving businesses and an unrivalled estate of land.

When Macquarie completed his time in office in 1821, he declared, 'I found New South Wales a jail and left it a colony.'

ALGAE GIVES BIRDS THE BLUES

In 2003, St Mary's Creek in Alice Springs got just a little smellier than usual after an outbreak of deadly blue-green algae formed on its water. It was thought to have grown after effluent had overflowed from the nearby Alice Springs sewerage works. Fences were duly erected around the affected area, although this did not stop a number of birds from drinking the water and duly dropping out of the sky with botulism.

BLOKES TO DIE FIRST

Australian women have a 90 per cent chance of reaching the age of 65. However, Aussie blokes have only an 83 per cent probability of making it to the same age.

DIGGERS TAKE TO THEIR CAMELS

As if Gallipoli wasn't enough, Australian troops were also called upon to ride camels for the World War I effort. A revolt by pro-Turkish tribesmen in Egypt in 1916 left the Allies needing a mobile force in North Africa, so who better to call upon than the Aussie Diggers. The Imperial Camel Corps (ICC) was made up of four battalions, two of which were comprised entirely of Australians, while one contained a mix of Aussies and New Zealanders. The ICC did its job and quickly impressed the British command, who later sent them off to see more action in the Sinai desert. In June 1918, having seen combat in the Second Battle of Gaza, the ICC was disbanded.

THE EIGHT-HOUR DAY

The working man of the 18th century was expected to work for ten hours a day, six days a week. Today, such a regime would be unthinkable, but throughout Britain and its empire it was standard practice and was accepted by all – well, nearly all. The Australian workforce, despite the fact that many of its number had only recently been freed from convict conditions and forced labour, was not at all impressed with the idea of a 60-hour week.

The fight for shorter working hours began in Melbourne, with stonemasons protesting at their terms of employment while working on the city's university in 1856. In April of that year, the masons marched to Parliament House to put pressure on the government and their employers. Victory duly arrived in the shape of a 48-hour working week, and on 12 May the masons embarked on a celebratory parade that soon became an annual event.

THE BLACK WAR

The slaughter of Tasmania's Aboriginal people began the second the English arrived on the island in 1777. Having spent the previous 10,000 years living in splendid isolation following the submergence of the land bridge that had formerly connected them to the mainland, indigenous Tasmanians now woke up to a horrific world of torture, brutality and death.

The tales of hellish barbarism inflicted on Aborigines make for stomach-churning reading, with the colonial oppressors displaying a seemingly demonic and insatiable blood lust that knew no bounds. Women and children were tortured, raped and put to death without mercy, while corpses were defiled and widows taken as sexual slaves.

The colonial authorities took little or no action against those who tortured, killed and oppressed. No European was ever tried for the murder of an Aborigine, and torturers (for example, those who mutilated children) rarely got more than a few lashes. In 1828, martial law was declared against the Aborigines, with whites authorised to 'kill blacks on sight'. A bounty was offered for the capture of 'blacks' – £5 for every adult and £2 per child. For their part, the Aborigines fought valiantly to defend their people and their land, but their clubs and spears were no match for the white man's well-armed military and police.

The captured were rounded up and taken to concentration camps before being shipped to a bizarre Christian prison on Flinders Island. By the early 1840s, a mere 50 Aborigines survived on the island, as illness and malnutrition did the work of the British government, which accelerated the situation by reducing funding and therefore rations. In 1868, the death of William Lanney, also known as King Billy, meant that only one full-blood Tasmanian survived.

GREAT WALK TO CHINA

Some geographically challenged convicts believed they might escape from penal servitude in 19th-century Australia by walking to China. Of course, rather than the Great Wall and paddy fields, they merely found arid desert and certain death.

WHEN BLUEY MET SHORTY

A person with red hair in Australia is generally called Bluey. This simplistic irony (call it inverted logic) is also at work when nicknames such as Shorty, Skinny or Speedy are applied.

PIE FLOATER

Forget the barbecued prawns and the roo fillets – if you want a real Aussie culinary delicacy, look no further than the humble pie floater. This no-nonsense food is easily constructed and full of stodgy goodness. All you need do is take a meat pie, smother it in tomato sauce and then drop it in a bowl of pea and ham soup. Not for the health-conscious, nor vegetarians, nor romantic dinner dates.

AUSSIES WORKING OVERTIME

Despite the efforts of the Melbourne masons back in 1856, Aussies are still working too hard. A recent union report has revealed that, in terms of working hours, Australians are the second-hardest-working country in the developed world.

BALLERINA

British Ballerina Margot Fonteyn was a frequent visitor to Australia – her first working trip was in 1957, when she performed with the Borovansky Ballet. Several guest appearances with the Australian Ballet followed before her Antipodean swan song as Hanna in *The Merry Widow* in 1977.

BLACK SWANS

When the first British visitors to Australia reported that the new country's wildlife included small grey bears that sat in trees all day and giant rabbits that carried their young in pouches, the response was one of intense fascination. But when they told tales of the red-billed black swans that inhabited the Australian waterways, the assumption was that the intrepid explorers had gone well and truly mad on their long voyage.

'Black swans. Yeah, right!' was the general consensus. The explorers, who were doubtless unimpressed by the sceptism that greeted them, duly replied (in true playground style), 'Don't believe me? Well, I'll show you, then!' Numerous black swans had been dispatched back to the motherland by the early 1820s, and quickly became something of a Victorian curiosity.

RANDOM FACT

Only four countries in the world have more narrow-gauge train track per capita than Australia. Now that truly is a useless piece of Australian trivia.

PAINTER GRANTED CITIZENSHIP RIGHTS

The first Aboriginal Australian to be granted full citizenship was artist Albert Namatjira, in 1955. Albert enjoyed both popular and critical acclaim as a landscape painter in the 1940s and 1950s, with his exhibitions frequently selling out. His new-found freedom made it possible for him to own property and stay in hotels, among other things.

FROM SANDWICH SPREAD TO SONG SUCCESS

Vegemite is widely regarded as Australia's national food. This sticky brown savoury paste has graced sandwiches down under for 80 years and was the brainchild of chemist Cyril Callister. Vegemite's fame peaked in the early 1980s, when it earned a mention in Men At Work's international chart-topping song 'Down Under'.

BRITS TEST BOMBS DOWN UNDER

When testing nuclear devices, it's makes a lot of sense to do it a long way away from where you live. So, when the Brits needed to test out their atom bombs in the 1950s, the boffins at the Ministry of Defence found a globe and, after much deliberation and some rigorous measuring, calculated that Australia was just about as far away from Blighty as they were going to get.

The colonial overlords duly packed up their plutonium and headed for the Antipodes. The first nuclear device was detonated at Emu Field in northwest South Australia in 1953 and was followed by further tests at Maralinga in southwest Australia. Security around the test sites was far from rigorous, and security and army personnel were intentionally exposed to the radioactive blasts as part of the experiment, though they were not told of the risks they were undertaking. More than 10,000 Aussies were involved with the tests, which were also conducted at a third site on the Monte Bello Islands off Western Australia, and the fallout from the explosions is thought to have affected great swathes of the countryside.

Further controversy was caused by the fact that all warning signs surrounding the test sites were written in English, making it impossible for local Aboriginal people to understand the magnitude of what was going on and the danger that had been brought to their lands. To this day, local Aborigines are fighting their case for compensation in the Australian courts.

The tests ceased in 1958, when, of course, the Americans arrived in the Pacific region to test their bombs...and all with the blessing of the good old Brits.

SKYHOOKS

According to their fans, Melbourne band Skyhooks single-handedly saved the Australian music industry, not to mention its own record label, from entering an abyss in the 1970s. Though the band's supporters may have exaggerated the situation somewhat, there is little doubt that the 'Hooks' were a refreshing and original act that undeniably helped revive an Aussie music scene that had become both overly derivative and unimaginative.

The Hooks' debut album, *Living In The Seventies*, sold 300,000 copies and became a fixture at the top of the Aussie charts, with the country's teenagers eagerly snaffling up the band's garish image and irreverent lyrics. Capes, make-up, spacesuits and exploding phallic mushrooms all featured in the inimitable Hooks shows of the mid-1970s.

Changes in line-up followed, but the band endured throughout the decade, before breaking up for the first time in 1980. Periodic re-formations have followed, usually for particular tours and festivals, but their place in Australian music's hall of fame seems assured.

SUMMERING IN SYDNEY

In Sydney, the warmest month of the year is January, with an average temperature of around 26°C (79°F). July is the coldest month, with temperatures falling as low as 8°C (46°F).

JACK BRABHAM

Australia's greatest ever motor racing driver was Sydneysider Jack Brabham. The legendary wheelman was three times a Grand Prix champion, rising from modest beginnings as a mechanic to reach the pinnacle of his sport. Brabham, who spent two years in the Air Force, won his first championship in 1959, driving for Charles and John Cooper. He repeated the success the following year, adding a third historic title in 1966, when he became the first Formula One driver to win the sport's greatest prize in a car of his own construction.

CLOWNFISH GIVES DIVERS LAST LAUGH

Clownfish are not just pretty little things sent to adorn the coral at the Great Barrier Reef. These brightly coloured fish – given the title role in 2003's Disney-Pixar film *Finding Nemo* – are able to live among anemones without getting stung, owing to a special coating on their skin.

And, after careful analysis in laboratories, scientists have uncovered the chemical components in the clownfish's protective coating. The result of this research is SafeSea, an application worn by divers to protect them from exposure to nematocysts (stinging cells on corals, anemones, hydroids and jellyfish).

MYALL CREEK MASSACRE

Massacres of Aboriginal people were not unusual in 19th-century Australia, but on 10 June 1838 a group of 11 white stockmen and settlers embarked on a merciless blood-letting at Myall Creek that would spark hitherto unseen levels of controversy and outrage. However, the public backlash was for the most part directed at the authorities, who for the first and only time took legal action against the perpetrators of such an atrocity.

The massacre itself was motivated out of nothing more than mindless prejudice, with pathetically transparent murmurings about lost cattle the best the stockmen could come up with to justify their actions. Men, women and children were indiscriminately slaughtered, to the hideously familiar accompaniment of rape and torture.

The stockmen, of course, could reasonably expect to get away with their murderous behaviour, or at worst suffer no more than a few lashes. But on this occasion the authorities did the right thing and pursued the assailants, bringing them to trial despite disgraceful public objections. When brought before the court the following November, the jury sat patiently and listened for half an hour as the charges against the 11 accused were heard.

The case was a political minefield and soon became a complicated affair dominated by spurious legal arguments about the identity of victims and reliability of witnesses. A first trial ended in the accused being acquitted, but the government and judiciary continued to pursue the matter and found grounds for a second trial. This time, seven of the men were convicted of murder and sentenced to death.

GEESE GET IT, TOO

It wasn't just indigenous people who were hunted to the brink of extinction by white settlers in Tasmania. The Brits also shot their way through most of the island's stock of Cape Barren geese. And, just for the record, the new arrivals were even more successful in eradicating emus from the island. There really is nothing quite as paternal and civilising as the responsible influence of colonial power…

SHARK TAKEAWAY

If you see 'flake' on the menu in an Australian chip shop, don't expect to get a chocolatey treat in a yellow wrapper. Down under, 'flake' is the popular name for deep-fried, battered shark flesh.

OLYMPIC SWIM QUEEN

Dawn Fraser is arguably Australia's greatest Olympian. The Sydney-born swimmer overcame asthma to become the first athlete to win gold medals in the same event in three consecutive Olympics. Her first gold in the 100m freestyle came as a teenager at the 1956 Olympics in Melbourne and was duly followed by repeat performances at both the Rome (1960) and Tokyo (1964) games. Dawn's haul of medals swelled at the Commonwealth Games; indeed, at the 1962 Perth games, she was the first woman to break the one-minute barrier. Fraser took up a career in politics in the 1980s.

POLITICAL PIONEER

In 1971, Neville Bonner became the first Aboriginal Australian to be elected to the Federal Government. Bonner, who hailed from Ukerebagh Island, took office as senator for Queensland after a classic rags-to-riches tale that saw him rise from a life of a disenfranchised bush dweller to the height of public office. After marrying in 1943, Neville moved to Palm Island, and in 1967 (following changes in the political climate and the law) he took the plunge and joined the Liberal Party. He remained in office for 12 years. Bonner died of lung cancer in 1999, aged 76.

RECORD-BREAKING BRIDGE

Sydney's famous harbour bridge was the longest single-span arched bridge in the world when it was built in 1932.

FREE MEN ARRIVE DOWN UNDER

The first free immigrants arrived in Australia in 1793.

TASMANIA'S ABORIGINAL PEOPLE

When the last known Tasmanian Aborigine, Truganini, died in 1876, it seemed that the English invaders had successfully wiped out the island's distinct indigenous people. Even today, it is widely reported that there are

EVERYTHING YOU DIDN'T NEED TO KNOW ABOUT AUSTRALIA

no Tasmanian Aborigines, and academics have long recorded that the English completed the only true genocide in history when Truganini met her end.

These commentators, however, had failed to appreciate that by 1876 many Aborigines had already dispersed into the countryside, merging into various communities and often remaining silent about their genealogies for decades. They lived alongside Maoris, Caribbean slaves and various settlers from all round the globe, and their descendants were often not told of their ancestry. There was also a sizeable Aboriginal community on the islands of the Bass Strait, which had grown from the offspring of women stolen by, or sold to, white sealers in the 19th century.

Today, Tasmania has an Aborigine population of 16,000 (out of a total population of 470,000). However, there is much controversy over who can truly claim to be a Tasmanian Aborigine, with various individuals and communities doubting the claims of others. In the 1990s, the situation deteriorated to an all-time low when one group 'stole' the bones of 19th-century Aborigines after they had been returned from European museums into the custody of a rival Aboriginal group. The controversy rumbles on.

SEX, LAW AND CONTRADICTION

Like most countries, Australia's laws on sex are a bizarre mix of the liberal, the conservative and the seemingly contradictory. Local government is responsible for specific policies on issues such as prostitution and the sale of X-rated films and magazines, so be warned that you cannot expect to meet the same attitudes and practices from one state or territory to the next. In some states, for example, you may find that brothels have been decriminalised but that X-rated videos are banned from sale. If in doubt, you could always ask a policeman…

NO ALLIGATORS, JUST CROCS

The largest species of crocodile in the world is the saltwater croc, which is found in northern Australia. These animals, which occasionally eat humans, are also the largest reptiles on the planet and have been recorded far out to sea. Saltwater crocs are often referred to as alligators locally, but they are definitely crocs rather than gators. The other species of croc native to Australia is the freshwater crocodile (or freshie), which is considerably smaller than its saltwater counterpart. Both species of croc are protected in the wild in Australia. However, commercial farms where animals are bred for their prized skins do exist. Crocodile meat has also become something of a delicacy on gourmet menus in recent years.

MARIJUANA USE

According to the 2001 National Drug Strategy Household Survey, 15 per cent of Australians who had drunk alcohol in the previous year had also smoked marijuana during the same period. The figure for those who hadn't partaken of alcohol was only 3.3 per cent. Aussie stoners obviously like a drink with their spliff.

SAM PROVES TO BE AUSTRALIA'S FAVOURITE UNCLE

A recent survey by Charlton First Communications asked Australians who they believed to be their closest international ally. Over half of those polled felt that the Americans were their best buddies in the global community. The Brits came out second (33 per cent), and China third (9.5 per cent).

PANDEMIC LEAVES NSW IN CRISIS

Having survived Gallipoli and the threat of the Axis forces, Australian troops faced a new peril when they returned to their homeland in 1919. Influenza had gripped the continent, reaching pandemic proportions in the winter after the cessation of hostilities. Many returning heroes found themselves quarantined at North Head and the Sydney Cricket Ground rather than welcomed back into the bosoms of their families.

The influenza crisis was most profound in New South Wales, where it would claim the lives of more than 6,000 poor souls. The situation deteriorated to such an extent that the government made it compulsory for people to wear masks in public places from theatres to libraries. Strict quarantine rules were applied, as were restrictions over travel and on shop sales that might attract crowds. The infected were to be kept isolated, and influenza medication was subject to stringent price controls to prevent unscrupulous pharmacists profiting at the expense of the health of fellow citizens. The crisis eventually abated early in 1920.

SAY IT WITH FLOWERS

If you had a bouquet to represent all the Australian states made up of their floral emblems it would contain Royal Bluebell (Australian Capital Territory), Common Heath (Victoria), the red-flowered Waratah (New South Wales), Sturt's Desert Rose (Northern Territory), Cooktown Orchid (Queensland), Sturt's Desert Pea (South Australia), Tasmanian Blue Gum (Tasmania) and Red and Green Kangaroo Paw (Western Australia). A florist might also add Golden Wattle, the bloom that represents the Commonwealth of Australia.

AUSSIE GOATS HEAD EAST

Aside from kangaroo and sheep, the Australian meat industry also exports significant quantities of goat flesh to markets in Asia and North Africa. The feral goats of the Gascoyne outback are particularly popular, owing to their lean, rich and succulent meat.

JELLYFISH WITH A DIFFERENCE

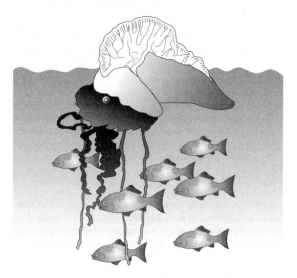

The Portuguese man-of-war is a curious jellyfish, although it is in fact not a single creature but rather a colony of four kinds of co-dependent polyps. At the end of the day, if you're stung by one you will be far more interested in getting first aid than marvelling at the biology of this toxic invertebrate, of course. They are found in many of the world's seas, including those surrounding Australia, and a severe sting can lead to respiratory failure and severe pain. Though not as dangerous as the box jellyfish and the irukandji, the Portuguese man-of-war can be a troublesome critter, owing to its long tentacles -- which can grow to lengths of up to 30m (100ft) -- and its habit of forming into large colonies at sea. If stung by one, the best advice is to seek immediate medical attention. Do not pull off any remaining tentacles with a towel; rather you should use tweezers to extricate the offending stingers.

MOZZIES

The humble Aussie mosquito is not a friendly critter. He'll bite you if he gets the opportunity and, if he does, there's a fair chance he'll leave you feeling more than a little unwell. A mozzie bite could leave you with any of the following.

Ross River virus infection

This arbovirus is most prevalent in Queensland and the Northern Territory, leaving patients with a fever, a rash, and muscular aches and pains. Arthritis also occurs in around 40 per cent of cases.

Dengue fever

On a global scale, dengue fever is a major problem and, while Australia is not among the worst-hit countries in the world, occasional epidemics can cause significant problems. A major outbreak in 1981, for example, saw 3,000 people infected in northern Queensland. Dengue fever is rarely fatal but will leave its victim with flu-like symptoms and a violent headache. However, more severe forms of the virus can occur. Dengue haemorrhagic fever can result in internal bleeding, while dengue shock syndrome is most prevalent in young children and babies.

Barmah Forest virus infection

Scientists have known about this disease since the mid-1970s when it was identified in mozzies trapped in the Barmah Forest in Victoria. It has since been reported as responsible for outbreaks of illness in the Northern Territory, New South Wales and Western Australia. The afflicted show a variety of symptoms, including lethargy, fever, rashes, and aches and pains in their joints.

Malaria

This is the big one. It's extremely rare in Australia, but all the pre-conditions exist to make this most deadly disease a killer down under: the continent has the mozzies, the climate and a suitable contingent of infected humans. However, Australia has remained free from endemic malaria since the early 1980s, thanks in no small part to the vigilance of the country's health authorities.

DINGO ATTACKS

There have been several high-profile cases of dingo attacks on humans, particularly children.

The death of baby Azaria Chamberlain at Uluru in August 1980 resulted in a murder trial for her mother Lindy, and became the subject of the

acclaimed film *A Cry In The Dark* (starring Meryl Streep). Yet, while Chamberlain sat in the dock telling how dingoes had been prowling the area where she had been camping, other Australians were driving around with car stickers declaring 'The Dingo is Innocent' or 'Save our Dingoes'. The bumper stickers could not prevent a cull of dingoes at Uluru, however. Chamberlain, meanwhile, was convicted but later exonerated.

A dingo attack also led to the tragic death of nine-year-old Clinton Gage at Fraser Island in 2001. Five years earlier, after several well-publicised cases of dingo aggression on the island, the Queensland government had warned how adult dingoes can view children as prey. Culling dingoes, particularly those on Fraser Island (which are reputed to be the purest examples of the breed living in the wild) has angered traditional Aboriginal owners, who argue that with better management of the environment both tragedy and culls could have been avoided.

DOCTOR ON THE WING

When you're sick and the nearest hospital is hundreds of miles away across rough tracks then you begin to know the meaning of the word 'panic'. It was a prickly sensation known only too well to those who populated the Outback years ago, many of whom died in agony for want of basic treatment. Then came the flying doctor, an everyday hero who is summoned by radio and comes in a plane to tend casualties. It was the delay in radio technology rather than flight that held up this innovation. That was finally cracked in 1928 by radio engineer Alfred Traeger when he developed a small, pedal-powered transceiver with a 500km (300 mile) field of operation. The first flying doctor was on the wing in Cloncurry, Queensland, the same year. Other areas wanted to mimic the service and in 1933 the Presbyterian Church, which had been running it, made way for the Royal Flying Doctor Service (RFDS). Today there are a dozen RFDS stations in an area as large as western Europe, giving medical service to even the most isolated outpost.

BLOWING IN THE WIND

In America they are known as dust devils, spirals of desert particles whipped tornado style to heights of 30m (100ft) by a warm wind. In Australia each fast-moving whirlwind is known as a willy willy – honestly. Some Australians claim never to have heard the term but most will be aware of its proper meaning. Why not try asking about one when you are over there? What's the worst that could happen, bushwacker?

EVERYTHING YOU DIDN'T NEED TO KNOW ABOUT AUSTRALIA

COINING IT

There are five coins currently in circulation in Australia. The A$1 and A$2 coins are gold, while the 5-, 10- and 50-cent pieces are silver. Any other coins will not be accepted by slot machines or shopkeepers.

BIG COUNTRY

Australia is a big place. Take a two-week holiday there and you'll only have time to see a fraction of what this diverse continent/country has to offer. To prove the point, here are the road distances between some of the major cities.

Sydney to Canberra 288km (179 miles)

Sydney to Brisbane 1,017km (631 miles)

Sydney to Adelaide 1,427km (885 miles)

Melbourne to Canberra 647km (401 miles)

Melbourne to Brisbane 1,669km (1,035 miles)

Darwin to Sydney 3,991km (2,474 miles)

Darwin to Adelaide 3,042km (1,886 miles)

Perth to Adelaide 2,725km (1,690 miles)

Brisbane to Cairns 1,718km (1,065 miles)

Brisbane to Melbourne 1,669km (1,035 miles)

ON THE LAMB

In Australia there are more than 150 million sheep – that's about 14 per cent of the world's sheep population. Consequently, it is the global leader in wool production, supplying 30 per cent of the total on the world market.

THE THINGS THEY SAY ABOUT AUSTRALIA AND AUSTRALIANS

'Sport is the religion of Australia and Saturday is the day of worship.'
Jonathan Aitken

'The countrey tho is general well enough clothd appeard in some places bare; it resembled in my imagination the back of a lean cow, covered in

general with long hair, but nevertheless where her scraggy hip bones have stuck out farther than they ought accidental rubbs and knocks have intriely bard them of their share of covering.'

Botanist **Joseph Banks** in his journal as he sailed up the east coast in 1770

'The continent had to be discovered emotionally. It had to become a homeland and feel like a home. The sense of overpowering space, the isolation, the warmth of summer, the garish light, the shiny-leafed trees, the birds and insects, the smell of air filled with dust, the strange silences, and the landscapes in all their oddness had to become familiar.'

Historian **Geoffrey Blainey**

'It really is the most extraordinarily lethal country. Naturally, they play down the fact that every time you set your feet on the floor something is likely to jump out and seize an ankle. Thus my guidebook blandly observed that "only" fourteen species of Australian snakes are seriously lethal, among them the western brown, desert death adder, tiger snake, taipan and yellow-bellied sea snake. The taipan is the one to watch out for. It is the most poisonous snake on earth, with a lunge so swift and a venom so potent that your last mortal utterance is likely to be: "I say, is that a sn—".'

Bill Bryson in *Down Under*

'Australians have liberated themselves from the fate of being second-rate Europeans.'

Manning Clark in *A Short History Of Australia*

'Life was very dear, but life was not worth living unless they could be true to their idea of Australian manhood. Standing upon that alone, when help failed and hope faded, when the end loomed clear in front of them, when the whole world seemed to crumble and the heaven to fall in, they faced its ruin undismayed.'

CEW Bean about the Australians at Gallipoli in *The Official History Of Australia In The War Of 1914–1918*

'We are all visitors to this time, this place. We are just passing through. Our purpose here is to observe, to learn, to grow, to love...and then we return home.'

Australian Aboriginal proverb

SPORTING GESTURE

Eight months after western forces began creating havoc in Iraq the national soccer team flew to Australia to wreak its revenge. The Iraqi team – placed 52nd in the world rankings – was achieving remarkable success under new manager Bernd Stange from Germany before the crisis blew up. Now it struggles to find balls, a field and sufficient kit with which to play at home. Consequently it was with some relief that the players flew down under to take advantage of some Aussie hospitality. The Australian government contributed A$50,000 (£21,000) to stage a game between the visitors and an Australian representative side. Iraqis living in Australia were on hand to offer a warm welcome and Bernd Stange, former coach of Perth Glory, was particularly well received. The match at Arena Joonalup in Western Australia ended in a win for Iraq, the only goal coming from a last-minute header by striker Abbas Hassan.

FROM A JACK TO A KING

Six years after McDonald's, Burger King followed its rival into the Antipodes in 1977, opening its first restaurant in Perth under the name of Hungry Jacks. The company had been unable to use its American brand name, after it found it had already been trademarked by a man running a single takeaway restaurant of his own. The Hungry Jacks franchise was run by owner Jack Cowin and quickly became a success, expanding to 148 outlets and developing the Aussie burger (fried egg, bacon, onion, beetroot, meat, lettuce and tomato). Alas, the relationship between Cowin and Burger King soured in the mid-1990s and eventually ended in a legal battle, centring on the terms of the franchise and the name of the restaurant chain. The case was eventually heard in 2001–02, with the judge finding in favour of Cowin.

MAN OF THE MOMENT

When you exclude all the convicts that first came to Australia and the servicemen sent to control them, the country is somewhat bereft of legitimate founding fathers. That's why characters like Lachlan Macquarie loom large in Australian history. Macquarie (1761–1824) was a high-handed Scot who passionately believed that Australia had a bright future. More than that, he was prepared to work with the felons who tipped up there, following their incarceration, to make it so. In a dozen years in charge, Macquarie introduced currency and established the colony's first bank in 1817. He promoted exploration of the seemingly impenetrable Blue Mountains.

Contentiously, he wanted ex-cons to be given land or promotions in the hierarchy to give them a stake in this new land of opportunity. And it was this last issue that placed him on a collision course with existing landowners and finally unseated him from power. Macquarie died on his estate on Mull in Scotland's Western Isles in grief and some measure of public disdain. Only later could history prove that his intentions for the colony were sincere and honourable. Nevertheless, there is plenty to remember Macquarie by in today's Australia (that's what happens when you help finance overland expeditions) and you can't travel far without being reminded of his existence.

Port Macquarie (New South Wales)

Macquarie River (New South Wales)

Macquarie River (Tasmania)

Lachlan River (New South Wales)

Lachlan Valley

Lake Macquarie (New South Wales)

Macquarie Harbour (Tasmania)

Macquarie Island (off Tasmania)

Macquarie Marshes (New South Wales)

Mount Macquarie (New South Wales)

Macquarie Ridge (Pacific Ocean)

On a lesser scale there are also Macquarie Fields, Macquarie Pass, Macquarie (town), Macquarie's Point, Macquarie Plains and Mrs Macquarie's Chair (a point overlooking Sydney Harbour).

The name is further associated with a bank, a university, a shopping centre and it's a common feature on street maps of Australian towns.

BACKPACK BONANZA

More than 10,000 British school leavers head down under every year to backpack their way across Australia, and the government believes Prince Harry's high-profile visit will encourage many more. Tourism minister Joe Hockey claimed Harry's working holiday sent 'a fantastic message to the world that the number one destination for young Brits is Australia'. Surely a reason for the world to holiday elsewhere.

SUCK IT AND SEE

No self-respecting Aussie heterosexual male ever baulks at the sight of a Sheila's bare breasts but, well, it's different when there's a baby attached. In 2003 Victoria state legislator Kirsty Marshall was kicked out of the parliament chamber when she started feeding her baby during a debate, while TV presenter Kate Langbroek got an angry reaction – wonderfully described as 'a bit of a hissy' by her producers – when she gave baby Lewis his tucker live on air.

Doctors say high-profile women need to challenge opposition to public breastfeeding for the sake of mother and infant health. 'People have to get over the embarrassment or concern about breasts being publicly displayed in this context,' said Dr Ingrid Tall of the Australian Medical Association.

STRAIGHT-TALKING POLITICIAN

As you might expect, Australian politics is riven with earthy insults and imagery. Just to give you a flavour of the blunt verbal jousting that takes place, here are some of former Prime Minister Paul Keating's quips.

'I am not like the Leader of the Opposition. I did not slither out of the Cabinet room like a mangy maggot...'

'I go out for a piss and they pull this one on me. Well, that's the last time I leave you two alone. From now on, I'm sticking to you two like **** to a blanket.'

To Wilson Tuckey, Liberal politician:

'Shut up! Sit down and shut up, you pig!'

'You boxhead, you wouldn't know. You are flat out counting past ten.'

To Andrew Peacock, former Liberal Party leader:

'What we have here is an intellectual rust bucket.'

'You've been in the dye pot again, Andrew.'

'The Liberal Party ought to put him down like a faithful dog because he is of no use to it and of no use to the nation.'

To former Shadow Treasurer Jim Carlton:

'I was nearly chloroformed by the performance of the Honourable Member for Mackellar. It nearly put me right out for the afternoon.'

To former National Party leader Ian Sinclair:

'What we gave as a leader of the National Party is a political carcass with a coat and tie on.'

Descriptions used by Keating about the opposition during debate:

'scumbags', 'intellectual hoboes', 'rabble', 'blockheads', 'cowboys', 'clowns', 'dummies and dimwits', 'desperadoes', 'motley, dishonest crew', 'animals', 'frauds', 'cheats', 'irrelevant, useless and immoral' and also, frequently, 'thick'.

DRY PUB...AND DUSTY

Australian country crooner Slim Dusty won worldwide fame in the mid-1950s with his song 'A Pub With No Beer'. But it was on home territory that he became a true icon, taking his music into outback towns and villages where he was accorded superstar status by whites and Aborigines alike. Aborigine tribes nicknamed him Moogai – their word for elder.

By the time Slim died of cancer on 19 August 2003 he had become one of the country's most prolific artists, notching up album sales of above five million. He was seen as a symbol of what it meant to be Australian and projected this to the world during the closing ceremony of the 2000 Sydney Olympics when he performed 'Waltzing Matilda' to a television audience of four billion.

Slim was given a state funeral at which thousands of mourners lined the streets of Sydney. Prime Minister John Howard described him as 'a one-off, a great bloke and a great Australian figure', although perhaps the most fitting tribute came from rock singer Peter Garrett, of the band Midnight Oil. 'Slim didn't come from the wrong side of the tracks,' said Garrett. 'Where he came from there were no tracks at all.'

NIGHTS IN WITH PUSSY

Wildlife protection is a big deal in Australia but it's not just about illegal croc and roo hunters. The government has realised that a major threat to rare birds, lizards and small mammals in national reserves comes from household moggies, who apparently snack on anything up to 35 critters a day – especially at night.

The problem is particularly acute in South Australia where the state's environment department is pleading with owners to keep pussies in at night. If a curfew doesn't work officials may ban cat ownership around national parks and reserves altogether.

S'LOT OF MONEY

The gambling urge is woven in to the genetic make-up of Australians but their obsession with slot machines, or 'pokies', is proving a bad bet. In 2001–02 they lost A$8.9 billion (£3 billion) on these games compared to A$2.5 billion (£1 billion) at casinos, A$1.7 billion (£700 million) at the bookies and A$1.2 billion (£500 million) on lottery-type draws. This works out at an average loss of A$1,017 (£430) per adult, a rise of A$22 (£9) on the previous year.

The difficulty for ministers is that thousands of local sports clubs depend on a percentage cut from the machines to remain solvent. Not many politicans fancy telling voters that pokies are banned and, by the way, taxes are going up to replace the income they generated.

Even so, *something* has to give. Australia has an estimated 300,000 'problem' gamblers (ie those whose lives become dysfunctional as a result of their addiction). They lose, on average, A$12,000 (£5,000) per year each. And they're never far from a pokie – there are thought to be 184,000 machines in the country, half of which are located in New South Wales.

PACKER PUNCHLINE

The greatest living Australian gambler is unquestionably media billionaire Kerry Packer, a man who during the '90s reportedly took the Las Vegas MGM Grand casino for A$35 million (£15 million) playing six hands of blackjack at a time over several nights. He also knows about bad luck. In September 1999 the British press carried rumours that he'd kissed goodbye to £11 million (A$26 million) at Crockfords in London – the biggest losing streak in UK history.

One of the best Packer stories may be apocryphal...but it's too good to ignore. The great man was apparently seated at a Vegas casino table alongside a mouthy Texan oilman who persisted in attempting to seduce a girl with stories of his massive wealth. Seeing the girl's discomfort, Packer stepped in to help. 'How much d'you say you're worth?' he asked. 'One hundred million dollars sir,' replied the American. Packer thought for a moment. 'Tell you what,' he said brightly, 'I'll toss you for it.' The Texan made his excuses and left.

SOME WOMBAT!

The wombat is considered a placid, easily domesticated animal which rarely grows above 1.2m (4ft) in length. Rather different, then, from its ice-age ancestor *Diprotodon optatum* which, at 2.5 tonnes (2.75 tons), is thought to have been the largest marsupial ever to inhabit Australia.

Scientists are unsure how poor old *Diprotodon optatum* became extinct 30,000 years ago but suspect it wasn't just the result of human hunting. This was after all a piece of megafauna bigger than a rhino. And, in case you didn't know, a wombat's teeth don't stop growing until it dies.

'I wouldn't say early Aboriginals couldn't kill them,' says Dr Stephen Wroe of the University of Sydney, 'but they would have been less efficient hunters of this species than the Clovis Indians, with their stone spear points, were of mammoths in North America.'

THE GREAT TOOTHFISH CAPER

Comforting news for the endangered Patagonian toothfish. When the Uruguayan trawler *Viarsa* illegally netted 85 tonnes (93.7 tons) worth of this protected species in Australian waters off Heard Island in the Southern Ocean, the captain believed he could out-run a nearby naval patrol ship. Unfortunately, he made the basic mistake of underestimating Aussie grit.

The Navy vessel, *Southern Supporter*, battled through 10-metre waves, thickening ice floes and hurricane-force gales to track the *Viarsa* for 20 days across 10,000km (6,000 miles). The Uruguayans gave up 3000km (1,900 miles) southwest of Capetown when the Australians, with help from two South African warships and a Royal Navy frigate, finally cut off all chance of escape. Crew and boat were escorted back to Australia to await prosecution.

It may seem a lot of fuss about a fish but some estimates put the value of the *Viarsa*'s haul at a cool A$1.6 million (£675,000).

DOPE COVER-UP

For such an enterprising people, Aussies can be surprisingly conservative. When a company called Corporate Phone Covers introduced the latest executive must-have – marijuana-scented phone covers – at a Sydney trade fair there was immediate uproar. New South Wales state premier, Bob Carr, condemned 'anything that suggests the normalisation of a mind-altering drug like marijuana and its promotion to young people' and fair organisers ordered the offending spliff-sniff item to be removed.

Corporate Phone Covers owner, Robert Punch, said the product was among a range that offered other distinctive smells such as cherry and strawberry. His defence? 'You wouldn't go and buy a big block of chocolate after smelling the chocolate one.'

PARABLE OF THE GOOD BLOKE

Bearing in mind that the Bible has been translated into 2,000 languages it's amazing that an Australian version has only just appeared. Endorsed by no less than the Archbishop of Sydney, it aims to present Biblical language in familiar everyday words. Thus the Three Wise Men are 'eggheads from out East' who greet the baby Jesus with the words: 'G'day your majesty.' Elsewhere we find the Virgin Mary as a 'pretty special Sheila' and the Good Samaritan as the 'Good Bloke'.

'We wanted to be careful not to change any facts, not to change the sequence of events, anything like that,' said Christian writer and broadcaster Kel Richards. 'I was just changing the language.'

He's not kidding. Here's the Aussie Bible account of the shepherds receiving news of Christ's birth:

'There were drovers camped out in the paddock nearby keeping an eye on their mob of sheep that night. Their eyes shot out on stalks when an Angel of the Lord zapped into view and the glory of the Lord filled the air like 1,000 volts. "Stop looking like a bunch of stunned mullets. Let me give you the drum," said the angel.'

Nativity plays will never be quite the same again.

STRIPPING FOR PEACE

These days no serious campaign group can make its case without going naked. That's why 700 women posed nude on a hill above Byron Bay, New South Wales as a protest against Australian military involvement in the second Gulf conflict. The women, aged 20 to 60, used their bodies to form the words NO WAR, insisting it was the best way to get Prime Minister John Howard's attention. Aerial photographs appeared in much of the world's media and almost certainly *did* get Howard's attention. But he still didn't bring the boys home.

HOW MUCH IS THAT COCKROACH IN THE WINDOW?

Answer: A$71.50 (£30) for three, including sand, food and insect accommodation. According to pet shop suppliers the much-maligned cockroach is establishing a new image as Australia's trendiest household pet. They are clean, odour-free, great with the kids and simple to care for. The roach-lovers favourite – *Macropanesthia rhinoceros* – is an 80mm- (3in-) long 'monster' native to northeast Queensland, where it lives mostly underground.

FIRST AUSTRALIANS

Archaeologists have long fallen out over when the first humans arrived in Australia. The latest theory, based on the reassessment of a skeleton uncovered at Lake Mungo, New South Wales, in 1974, suggests that the Aborigines' ancestors first tipped up about 50,000 years ago, some 10,000 years later than some experts had claimed. This conveniently fits in with the 'Out Of Africa' theory, which has humankind stemming from the same group of humanoids on the African continent.

Whatever the truth, everyone agrees that Lake Mungo is among the most important archaeological sites in the world. It has produced the remains of Mungo I – the oldest known cremated human, dating back 26,000 years – and Mungo III, source of the world's most ancient smidgen of mitochondrial DNA.

DISCOUNT SEX FOR PENSIONERS

There aren't many benefits that come with growing old but male pensioners in Brisbane have reason to celebrate. A brothel called the Viper Room has begun offering OAPs a Sunday Special in the form of a 5 per cent discount. Managers say 20 per cent of weekend clients are above pensionable age and one apparently still shows plenty of enthusiasm at 80.

Owner Neil Campbell says his girls are trained in first aid and resuscitation in the event that the excitement proves too much. 'All other businesses offer pensioners a discount,' he said. 'We get a lot of seniors in, especially on the weekends. Sunday is a big day for pensioners to go out and relax. They usually come in and see us before their day out at the bowls club or golf day.'

Prostitution is legal in parts of Australia although brothels have to meet strict licensing standards and ensure girls get regular medicals. You can even buy sex on the Australian Stock Exchange. A Melbourne brothel called the Daily Planet became the first to be listed in May 2003.

FALLEN HEROES

Around 102,000 Australians died in the two world wars and, in terms of population percentage, the country sustained more losses in World War I than any other nation. The sacrifice of these men is marked in Europe by the Australian War Memorial at Hyde Park Corner in London, which carries the names of the 24,000 home towns that sent their sons to fight for the Allies. At the monument's dedication on Remembrance Sunday 2003, the Queen told onlookers: 'We will be eternally grateful at how, in our darkest hour, Australia stood by our side.'

AUSTRALIAN HEROES

Australians are known to relish a fight. No surprise that they pitched in to conflicts on behalf of the British Empire in some considerable style. In four separate wars, no fewer than 96 Australians won the Victoria Cross, created in 1856 to reward extraordinary bravery.

The stories behind the medals still make astonishing reading. Seven medals were given to men in the Lone Pine trenches in Gallipoli, Turkey, on or about 9 August 1915. Turkish troops aiming to beat the Australians back to the sea made repeated attempts to flush out the trenches. Time and again, Australian servicemen blocked their path with sandbags, working under a hail of bullets and bombs. One man, Leonard Keysor, insisted on picking up live bombs thrown by the enemy and hurling them back where they came from. Corporal Alexander Burton was killed, while Captain Alfred Shout died later from his injuries. The others – Lt Frederick Tubbs, Corporal William Dunstan, Private John Hamilton and Keysor – all survived to receive their medals.

Their exploits, courageous though they were, were somewhat overshadowed just ten days later in another Australian trench by the efforts of one man. Albert Jacka, 22, surprised attackers by mounting a one-man rearguard attack. He shot five Turks with his rifle, bayonetted two others and forced the rest to flee. Yet this wasn't all. Serving on the Western Front in the summer of 1916 Jacka led a lone charge on Germans rounding up Australian prisoners. Wounded three times, his astonishing heroism was nevertheless sufficient to inspire the Australians to shrug off the Germans in hand-to-hand combat. One official war historian described it as 'the most dramatic and effective act of individual audacity in the history of the Australian Imperial Force'. For this he was awarded the Military Cross.

A year later, as Jacka worked under cover of darkness to gather intelligence for a surprise attack he was spotted by two Germans. When his revolver jammed, Jacka rushed at the Germans and dragged them back to his own lines as prisoners. In doing so plans of the attack remained secret and Jacka won a bar for his Military Cross. Most observers agreed he deserved a Victoria Cross three times over.

Having joined the army at the outbreak of the war he served almost continuously until May 1918 when he was gassed. He recuperated in England before returning home on 6 September 1919 to a hero's welcome. The effect of the war and a string of injuries began to take its toll, however, and Jacka died in 1932 a broken man. When he was buried, eight other Victoria Cross winners acted as pallbearers.

For the record, six Australians were awarded the Victoria Cross during the Boer War, a total of 66 got the gong during World War I and the North Russian conflict, 20 on duty in the World War II and four in Vietnam.

DEATH BY MISADVENTURE

Like other continents, Australia appeared ripe for exploration during the Victorian age. In its interior, however, adventurers discovered a pitilessly harsh environment that would claim the lives of many. Expeditions had the best hope of success if they were well planned and adequately prepared. One Australian explorer bucked the trend and paid dearly for the debacle he designed.

Irish-born Robert O'Hara Burke, a former policeman in Melbourne, was picked to lead a party charged with navigating a south-to-north route suitable for an overland telegraph. Massive amounts of money were invested in the expedition, which set off from Melbourne on 21 August 1860 with 18 men, 28 horses and 24 camels together with three Pakistani camel drivers. They were laden with 19 tonnes (21 tons) of provisions including brandy for the men, rum for the camels a stationery cabinet and 680kg (1,500lb) of sugar. It was slow going, especially as they were travelling in the summer heat. It took Burke and his team two months to cover 640km (400 miles) already charted and frequently used by mailmen on horseback, who could cover the distance in two weeks. When it became clear that Burke was a woefully incompetent leader there was back-biting and desertion among the men.

Burke established a depot at Cooper's Creek and forged on to the north coast with a selected few. They got within sniffing distance of the sea but were unable to set eyes on it due to an inhospitable swamp in their path. A tale of endurance and hardship ended when the weary crew returned to Cooper's Creek, with one of their number already dead from dysentery, to discover the men manning the post had left earlier that same day. Ironically, Burke decided to head for Mount Hopeless, the nearest known point of civilisation. He and his partner William Wills died of starvation in June 1861. Aborigines cared for a third man, John King, until a rescue party arrived.

At the time, newspapers were scathing. 'The whole expedition appears to have been one prolonged blunder throughout,' screamed the *Melbourne Age*. Later historians were more kindly towards Burke, commending him for his courage and for the fact he succeeded in travelling south to north. He is remembered in a memorial near Melbourne's Parliament House.

TERRITORIAL OZ

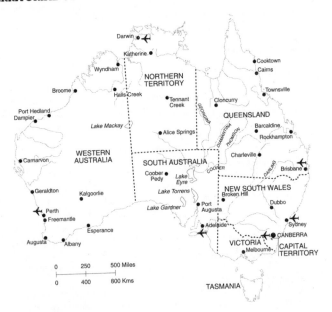

AUSTRALIAN STATES

Australian Capital Territory
Capital: Canberra

Population: 330,000

Area: 2,400 sq km (927 sq miles)

Aka: The Nation's Capital

Animal emblem: None

Tasmania
Capital: Hobart

Population: 475,000

Area: 67,800 sq km (26,178 sq miles)

Aka: The Holiday Isle

Animal emblem: Tasmanian tiger

Victoria
Capital: Melbourne

Population: 4.8 million

Area: 227,600 sq km (87,877 sq miles)

Aka: The Garden State

Animal emblem: Leadbeater's possum

New South Wales
Capital: Sydney

Population: 6.35 million

Area: 801,600 sq km (309,499 sq miles)

Aka: The First State

Animal emblem: Platypus

South Australia
Capital: Adelaide

Population: 1.5 million

Area: 984,000 sq km (379,925 sq miles)

Aka: The Festival State

Animal emblem: Hairy-nosed wombat

Northern Territory
Capital: Darwin

Population: 191,000

Area: 1,346,200 sq km (519,771 sq miles)

Aka: Outback Australia

Animal emblem: Red kangaroo

AUSTRALIAN STATES (CONT'D)

Queensland
Capital: Brisbane

Population: 3.48 million

Area: 1,727,200 sq km (666,876 sq miles)

Aka: The Sunshine State

Animal emblem: Koala

Western Australia
Capital: Perth

Population: 2 million

Area: 2,525,000 sq km (974,908 sq miles)

Aka: The State of Excitement

Animal emblem: Numbat

BROADLY SPEAKING...

Australia is 3,940km (2,450 miles) long and 4,350km (2,700 miles) wide. Within its coastline there is approximately 7,682,300 square km (2,966,200 sq miles) of territory. It is the world's sixth largest country and also the globe's biggest island. Uniquely, Australia is an island, a continent and a country.

AUSTRALIA'S OFF-SHORE INTERESTS

Christmas Islands
Population: 2,500

Area: 135 sq km (52 sq miles)

Where is it? Lying about 1,400km (870 miles) off Australia in the Indian Ocean, south of Indonesia

Cocos Islands
Population: 1,200

Area: 14 sq km (5 sq miles)

Where is it? Also called Keeling Islands, these are two coral atolls in the Indian Ocean between Sri Lanka and Australia

Norfolk Island
Population: 2,300

Area: 35 sq km (14 sq miles)

Where is it? In the southwestern Pacific, about 1,670km (1,000 miles) northeast of Sydney

Lord Howe Island
Population: 400

Area: 17 sq km (7 sq miles)

Where is it? This dependency of New South Wales lies in the southwestern Pacific some 700km (435 miles) from Sydney

Macquarie Island
Population: Numerous penguins but no permanent human population

Area: 123 sq km (47 sq miles)

Where is it? Although treeless, this outpost, some 1,450km (900 miles) southeast of Tasmania in the realms of Antarctica, is a nature reserve and is the only known breeding ground of the royal penguin

MONEY TROUBLES

From about 1850 to 1912 bank notes in Australia were issued not by Britain or state authorities but by individual banks. There were at least ten banks in existence, issuing notes in as many as five different denominations, so the market was filled with unfamiliar money. It was a fraudster's dream. Even after the Commonwealth was formed in 1901 bank notes were still many and various. Rather than print its own, the Commonwealth purchased unissued notes from banks and had the words 'Australian Note' printed across them, alongside the signatures of two Treasury officials. Only from 1913 did Commonwealth-designed and printed notes hit the street. Bankers weren't entirely thrilled with the new arrangement. In fact, bank managers in Perth organised a boycott of the first ten-shilling note, branding it 'too small'.

AUSTRALIA'S HIGH MOUNTAINS

1.	Kosciusko	2,229m (7,314ft)
2.	Townsend	2,209m (7,249ft)
3.	Clarke	2,200m (7,219ft)
4.	Twynham	2,195m (7,203ft)
5.	Carruthers Peak	2,145m (7,039ft)
6.	Sentinel	2,140m (7,039ft)
7.	Northcote	2,131m (6,992ft)
=8.	Gungartan	2,068m (6,786ft)
=8.	Tate	2,068m (6,786ft)
10.	Jagungal	2,062m (6,766ft)

ANTHEM ANATHEMA

Following federation several national competitions were held to find a suitable anthem for Australia, producing some of the most memorably poor poetry ever penned. In 1971, one entry contained the lines: 'Koalas bark, and the platypus quack, Jackasses laugh their loud Ha Ha's. Should I depart, I must soon come back. Yirra, Yirra, Yirra – Ka La, Ka La, Ka La, Ka La.' Unsurprisingly, it was dispatched to the dustbin. A newspaper was moved to comment that only one entry, submitted by humourist CJ Dennis to a competition held in 1908, was really on the money as far as Australians were concerned. It went:

'Git a ******* move on,

Have some ******* sense,

Learn the ******* art of

Self-de*******fence.'

ESSAY, ESSAY, ESSAY

At the close of the 19th century, Australians hotly debated whether to federate or stay as individual states. Anxious to air the issue a bookshop owner, Mr EW Cole, of Melbourne, offered a prize of A$240 (£100) for the

best essay in favour of federation. He put up a similar amount for the best essay in opposition. Local editor James Edmond won both prizes, one under his own name and the second under a pseudonym. When the ruse became known Cole refused to hand over another £100, claiming the double entry was 'contrary to the spirit of the competition'.

FIRST PAST THE POST

The first film known to have been made in Australia focused on the 1896 Melbourne Cup.

ISLAND AGONY

While Australia was known as a harsh penal colony it was, in fact, a soft option compared with Norfolk Island. Lying 1,600km (1,000 miles) off Australia, the island should have been a Pacific idyll. In fact, it was the hellhole to which the worst and most persistent offenders of the Australian convict community were consigned. Prisoners – who were denied knives and forks and forced to eat like dogs – were subjected to constant floggings for minor or imagined offences, and spells in the 'dumb' cells, devoid of light or sound. Only after an uprising in 1834 did the plight of the convicts come to the attention of the authorities in Sydney. A judge dispatched to subject the renegades to justice was so horrified by conditions on Norfolk Island that he instantly revoked the death sentence on 21 men – who wept in anguish at the news they were being kept alive. Ultimately, 14 men were sentenced to the noose and cried with joy at the prospect. Efforts to curb the excesses of those in charge of Norfolk Island largely failed. By 1855 the island was left deserted when the last of its wretched prison population was returned to Australia. Two years later it was settled by residents of Pitcairn Island, descendants of the Bounty mutineers.

TV SCREAM

Television first came to Australia in 1956, heavily promoted by the *Sydney Daily Telegraph*, which troubled international celebrities for messages of goodwill. Enthusiastic Antipodean officials weren't quite prepared for the response they got from American columnist Robert Ruark, though. 'I think Australia suffers sufficiently without television,' he cabled. 'Down with it!'

TESTING TIMES

The Australians have always been notoriously picky about who they would allow into their vast open spaces. No surprise then that would-be immigrants were once compelled to take what amounted to a spelling test in a language familiar to Australians before being allowed to settle. In 1934 the government wanted to use this blunt instrument for its own political purposes against Egon Kisch, a Czechoslovakian anti-fascist invited in by the Australian Anti-War Council. Realising the cultured Kisch was fluent in several languages officials chose to test him in the little-used tongue of Scottish Gaelic. Kisch failed, was arrested, prosecuted as an illegal immigrant and jailed for six months. Sympathisers mounted a legal appeal and it was deemed that Scottish Gaelic was too obscure to be used in a legitimate test. Kisch was freed but failed a second test. He subsequently left Australia voluntarily.

COMIC GENIUS

One of Australia's best loved comic writers was Lennie Lower (1903–47), who was acclaimed for his sole novel *Here's Luck* alongside a wealth of newspaper columns. Following a spell in the Australian Navy and some months spent out of work, he got a job at the *Labor Daily*, where he exercised his ire against the social elite and the fawning newspaper reports written about them in rival journals during the tough years of the Depression.

'The charming home of Mr and Mrs John Bowyang, tucked away in Pelican Street, Surry Hills, is a revelation in piquancy. From the backyard one has a view of every other backyard in the street, and the tall chimneystack of Tooth's Brewery looms majestically in the distance.

'Mrs Bowyang has an artistic taste and an eye for effect. Two lines have been stretched between long poles at either end of the yard, and when these lines are full of clothes, the sight is bewitching in the extreme. The motif throughout the whole house is one of antiquity. The wallpaper is mellow with age and the ceilings have not been kalsomined for forty-seven years…'

BAD TASTE

In training as Australia's cultural attaché, Barry Humphries confesses that he was once banned from a national airline for eating salad. The mischievous Humphries smuggled a carton of Russian salad aboard a plane

and secretly spooned it into a sick bag. After feigning illness when he was airborne he then stunned cabin crew by eating and savouring the diced carrot, potato and pea pieces covered in sticky mayonnaise. One steward who witnessed the spectacle – and believed the salad to be something second-hand – gagged, beginning a chain reaction among staff and passengers. Humphries was consequently barred for his in-flight exploit.

SWEET THOUGHTS

It is hard to discern just what contribution Australia has made to the high table of international cuisine. The country's one copper-bottomed claim to fame is the pavlova, a meringue shell filled with whipped cream and topped with fruit. It was created by chef Bert Sachse at Perth's Esplanade Hotel in 1935 and named for famous guest, the Russian dancer Anna Pavlova. There's a strong rumour that Victoria sponges emanated from the state of Victoria. Other than that, it is back to the floater (see page 124).

ON THE BALL

When billiard player Walter Lindrum took up his cue his opponents stood back in awe, frequently unable to score. Lindrum was, quite simply, a genius at pocketing billiard balls. His best ever break was 4,137, achieved in England against the then world champion Joe Davis, whose own most impressive break amounted to just 1,247. Sporting authorities tried to change the rules to temper Lindrum's success. Audiences – at first wowed by his phenomenal shots – stayed away after getting bored with his faultless performances. Opponents refused to play him. When he retired in 1950 Lindrum held 57 world records. To extend himself still further, Lindrum devoted his later years to playing exhibition matches for charity. After his death in 1960 he was buried in Melbourne Cemetery beneath a marble billiard table with pockets, a cue and three bronze billiard balls.

WHAT A DIFFERENCE THE REIGN MADE

When Queen Victoria came to the British throne in 1837 Australia consisted of four separate colonies (New South Wales, South Australia, Western Australia and Van Diemen's Land) with a total (white) population of less than 160,000. When she died in 1901 the Commonwealth of Australia was a federation of six sovereign states – the same as those in existence today – and a population of 3.75 million (white) people.

SWIM CITY

Poolside, Australia is always a contender for the top slots in swimming championships. Indeed, Oz has a special place in the history of swimming. Fred Cavill, an immigrant from England and already a noted swimmer, sowed the seeds when he built a 'natatorium', or swimming school, in Sydney. He advertised it thus:

'Come everyone, each mother's son and every bonnie daughter

And learn to swim with sturdy limb and sport amid the water.

For should you wish to swim like fish you have not far to travel

To Farm Cove go and soon you'll known the famous teacher Cavill.

His bath secure, the water pure, no fear of monsters finny,

For Cavill's there – his charge is fair.

He'll teach you for a guinea.'

The natatorium was swept away by a gale in 1909 but Cavill now found himself at the head of a dynasty of dynamic swimmers. He had fathered a handful of swimming champions, significantly Arthur, nicknamed 'Tubbs', who is credited with inventing front crawl and Sydney, pioneer of the butterfly. Another brother, Dick, was the first man in the world to swim 100 yards in less than a minute (58.6 seconds, actually). Dick was dubbed 'the greatest swimmer of all time' after winning every championship available to him.

KEEPING TABS ON THE LADIES

As the 20th century dawned in Australia menfolk could be distinguished by a pall of pipe smoke. The amount of tobacco smoked here in a year amounted to three pounds per head, more than double the consumption of the United Kingdom. Yet it was virtually unknown for women to take a puff. Times were a-changing, though, and by 1908 a female columnist in *Punch* revealed that more and more women were becoming hooked. 'The cigarette habit has apparently come to stay. Little smoking is done in public. Our women have not attained the Continental disregard for worn-out conventions. In Paris and London it is "the thing" to smoke unabashed, provided you have got over the splutter and choking stage.

'A Melbourne tobacconist, who has made a specialty in dainty cigarettes to suit the feminine palate assures me that quite fifty per cent of the "best

people" are now smoking in this city… The Railway Commissioners are said to have ordered designs for ladies' smoking carriages, out of respect for the prejudices of men who do not like the company of ladies when smoking.'

SHEEP AUSSIE LANDSCAPE

Europeans brought sheep to the Antipodes in the early 19th century and these unwelcome herbivores, which were left to roam free-range style around the countryside, settled in extremely quickly. By 1890 their numbers had risen to in excess of 100 million. All good news for Australia's mint sauce producers and knitwear designers but not so for the countryside. Savannah lands were turned over to pasture and scrub land was voraciously chewed up and turned to virtual desert. The delicate balance of the Australian ecosystem was profoundly altered and sheep overgrazing has been linked to the decline of several species of marsupials and is also thought to have contributed to the simultaneous rise in the rabbit population.

SOLDIERS SET FREE

Among Australia's first free settlers was a significant contingent of former British army soldiers. Military men were encouraged to retire down under rather than stay at home, and were offered land, cash gratuities, free passage and the promise of convict labour to help with building work and agriculture. There was even the chance for these erstwhile gunners to continue their military careers following the formation of the Enrolled Pensioner Force in the 1860s.

BETTER THE DEVIL YOU KNOW…

Back in the 18th century English convicts were frequently overwhelmed with fear and confusion when they were sentenced to transportation. Some, like Sarah Mills, chose to take their chances in the miserable conditions of the hulks (beached ships used to incarcerate prisoners) or the hangman rather than travel overseas to the unknown. 'I would rather die than go out of my own country to be devoured by savages,' she exclaimed when she was sentenced in 1786.

FOUR MILLION VISITORS

Between 1 July 2001 and 30 June 2002 more than 4 million temporary visa holders entered Australia. Not bad for a country who's permanent population stands at around 20 million.

MULLET MADNESS

If there is such a thing as a national haircut, then Australia's is the mullet. Elsewhere in the world it was an '80s fashion fad that proved fleeting, but down under it remained at the pinnacle of male grooming for the best part of a decade. To those fortunate enough to be too young to remember the mullet, ask your dad or big brother to dig out an old picture of England footballer Chris Waddle (circa 1989) or radio DJ Pat Sharpe; alternatively take a look at Patrick Swayze in *Dirty Dancing* (though don't feel obliged to watch the entire film). Got the picture? Long at the back, high over the ears and with a cheeky spiky look on top.

For those with money to burn and a well-honed sense of sartorial style, the icing on the cake was undeniably the addition of blonde streaks (highlights to use modern parlance). Australian soap actors from Jason Donovan to the entire cast of *Sons And Daughters* championed the mullet cause, and by the early 1990s the outbreak had gripped Australia from Sydney to the distant principality of Earls Court (which on a map appears to be in London). Thankfully, few mullets survived the crew-cut cull of the mid-1990s down under, but a revival of '80s fashion in England has raised suspicions that hair fashion's greatest faux pas could be returning to the Antipodes any day soon.

THE SIGNS THEY ARE A CHANGING

It's human nature to try and wriggle out of trouble. Who hasn't uttered those immortal words, 'I'm sorry, I can explain…'? And when it comes to traffic offences we'll all try every trick in the book to get away with our misdemeanours. But nobody has come up with a more ingenious scam than the Sydney motorist faced with two unwanted speeding tickets for exceeding a 60kph (37 mph) limit in 2003. Stealthily he returned to the scene of his crime and installed a 70kph (44mph) sign beneath the speed camera that had snapped him. He then duly took a photograph of the new ensemble which he presented in court to prove his innocence. Alas, his efforts were in vain. He was seen swapping and snapping the signs and the court quickly rumbled his caper. The speeding tickets were upheld and he was fined more than A$1,200 (£500) for his cunning plan that failed.

SHOT WITH A PEN

Being shot is never a good thing, but being shot accidentally by your friend with a James Bond-style pen gun in a busy nightclub must be particularly excruciating. Just ask the Canberra woman who suffered such a fate in 2003.

The victim's friend had spotted something on the floor of the club and bent down to pick up the pen-shaped object. But this was no ballpoint, and as she grasped it the firing mechanism triggered, sending a metal projectile into the chest of a nearby friend.

The woman was taken to hospital where she required surgery to remove the projectile. Police, meanwhile, began analysing the gun, which apparently resembled an item featured in *Never Say Never Again*. One Australian will certainly *never again* pick up anything she sees on a nightclub floor.

EGG MARKET DROPS

According to the Australian Bureau of Statistics, Australian egg consumption has declined significantly since the war. In the 1940s the typical Aussie (you remember Bruce, don't you?) ate 255 eggs a year, but by the late 1980s this figure had fallen to just 137.

KANGAROO COURTS

The origin of the phrase 'kangaroo court' is not entirely clear and it seems possible that it is not even Australian in source. The phrase is used to describe a court that ignores legal process and principles, and that acts irresponsibly, and frequently without proper authority.

There are many theories on the origins of the phrase but the most pervasive is that it was first used during the American gold rush of the mid-19th century to describe courts set up to deal with claim jumpers. Other theories suggest that these courts earned their name because of their habit of hopping around from place to place, or because they were set up to deal with Australian miners who had been claim jumping. There is also a theory that the kangaroo reference relates to the way in which these courts were able to leap about in terms of their process and logic, allowing the proceedings to bear no relation to the outcome.

As for possible Australian origins, there are no early examples of the phrase being used in print, but there is no shortage of theories. The most likely of these Antipodean etymologisings is that the phrase grew out of courts set up by early settlers in the absence of an effective legal system. These early courts were apparently called 'Hoppers Courts'. Finally, there is also a suggestion that the phrase may have grown out of English slang which, in the 19th century, used the word kangaroo to describe anything strange, off-beam and quirky.

KANGAROO... I DON'T KNOW

The etymology of the word kangaroo seems certain to be Aboriginal but little else is clear about the origins of the word used to describe the continent's best-loved animal. The most entertaining theory is that the English explorer Captain Cook was out for a stroll one day and spotted a roo. He asked a local to tell him what the animal was called and was told 'kangaroo', which was meant to convey the sentiment 'I don't know'. According to the story, Cook duly thanked the aboriginal gentleman and then went on his way merrily calling every roo he saw 'I don't know'. It's a wonderful theory but the consensus is that it's also a flawed one.

The confusion seems to centre on the fact that the most widely used aboriginal word for these bounding marsupials sounds nothing like the word 'kangaroo'. However, it has been suggested that the Aborigines in the area around where Cook first recorded the term do have a word that sounds like 'kangaroo', but that it was used specifically to describe the large black kangaroo. Cook, of course, did not distinguish between different types of kangaroo and merely went around calling all leaping, marsupial quadrupeds kangaroos.

TWO HUNDRED WORDS FOR ROO

The confusion over the etymology of the word kangaroo is somewhat understandable when you consider that there were more than 200 Australian indigenous languages in everyday usage back in the 18th century. Today there are only around 20 languages which are considered 'strong but endangered', while the others have either disappeared or are being revived by communities.

THRASHING FOR DELINQUENTS

Ah, yes, those were the days...national service, a new queen on the throne and a judicial system that was not afraid to inflict corporal punishment on adolescents. Australia really was a civil society back in the 1950s.

Bizarre as it seems today, the decision of a magistrate to impose corporal chastisement on two boys convicted of wilful damage was greeted positively by both press and public in the Australia of 1956. The two tearaways had committed a string of misdemeanours ranging from criminal damage to car theft, and were basically sentenced to be thrashed by their fathers under the supervision of a police detective. Each lad was given six cuts with a 3ft (1m) long stick that was around 1½ inches (3.8cm) wide.

The magistrate had been encouraged to impose the sentence by Assistant Police Prosecutor GH Huffa, using the authority of the Juvenile Courts Act. It was a decision that was applauded by both sets of parents. One of the boys' mothers went as far as to describe the punishment as 'a progressive move by the magistrate'.

Last word goes to Robert Hill, one of the boys thrashed: 'It hurt. I got six strokes on the behind with a length of wood two inches wide. Another stroke and I would have fainted. I had to have a compress applied later.' Shame.

CADBURY DOWN UNDER

Chocolate giant Cadbury was quick to realise the potential of the new market in the Antipodes, launching Cadbury Australia in 1922, having already enjoyed consistent export sales since the 1880s.

Many of the chocolate bars sold down under are identical to those available in Britain, but others have been developed specifically for the Aussie market. Here's a quick guide to the key players.

1. Cadbury Australia's bestselling bar is the Cherry Ripe, which was launched by MacRobertson's (later taken over by Cadbury) in 1924 and combines cherries, coconut and dark chocolate.

2. MacRobertson's was also the brains behind another of today's favourites. Freddo the chocolate frog was launched in 1930 and sold for one penny. Today you're looking at 2 cents (10p) for your tasty frog-shaped confectionary, but buyers have not been put off, and 90 million Freddos make their way into Australian stomachs each year.

3. Cadbury was the official chocolate supplier to the Australian armed forces during World War II. Rations were supplied to servicemen in brown paper.

4. In 1966 Freddo got a friend in the shape of Caramello the koala. The name gives it away...yep, Caramello is filled with caramel and is moulded in the shape of a koala. Still going strong nearly 40 years after its launch.

5. The Yowie was launched in 1997, taking its name from the mythical Yeti-like creature that is believed to stalk the outback. Cadbury claims the Yowie bar took three years and around A$10 million (£4.2 million) in investment to bring to life, adding that 'The Yowie concept combines environmental awareness with a unique children's confectionery product.' The kids undoubtedly like it and within weeks of its launch it was a bestseller.

GANG HAIRCUTS

Unfortunately, the mullet (see page 156) is not the only criminal haircut to have caused problems in Australia in recent years. The leader of the New South Wales opposition, John Brogden, is also concerned with what he has called gang-style haircuts in the region's prisons. 'It's a growing and genuinely concerning problem in our jail system, so if in any way we can remove the badges of a gang, the marks of a gang, we will do so,' explained Mr Brogden.

However, the commissioner of the NSW Corrective Services, Ron Woodham, is not convinced there is any such problem. 'I've double-checked with our intelligence people who work very closely with other intelligence people involved in gangs,' said Mr Woodham. 'There's no intelligence or information about a special haircut for gang members. It doesn't exist.'

'I have my own sources in the prison system and they tell me hairstyles and the way prisoners wear their clothes in a particular way identify them as a gang member,' countered Brogden's Corrective Services spokesman, Michael Richardson. 'If you have 10 people in the pod of a jail who all have the same hairstyle or wear their clothes in a particular way, that can be intimidating to other people in the pod. This is not something that I've invented. It is an issue in the NSW prison system.'

CALENDAR GIRLS HALL OF FAME

The website of the Official Australian Swimsuit Calendar (which you can visit at www.swimsuitcalendar.com.au if you find that kind of thing appealing), has established its very own hall of fame, with calendar buyers voting for their favourite girls from each year's offering. For the record, the inductees into this most prestigious hall of fame stand as follows:

1993 Nikki Visser

1994 Tonia Lee

1995 Amanda Garrity

1996 Colleen Smedts

1997 Monique Grobben

1998 Renee Eaves

1999 Sharon Hemmings

2000 Siobhan O'Reilly

2001 Tabitha Whitby

2002 Angela Sheather

2003 Tammara Wrenn.

The most recent inductee, Tammara Wrenn, is 18 and a Leo. The website explains that Tammara's ideal man should be 'outgoing, funny, open-minded and extreme'.

THE WIGGLES

Contrary to the view of students and other daytime TV addicts, Australian TV has more to offer than mere soap operas and surf dramas. *The Wiggles*, for example. This sugar-sweet sing-along show has become one of the world's most popular kids' TV programmes, winning over tots with its unabashed mix of bad fashion, curious choreography and implausible cheeriness. The quartet of all-singing all-dancing presenters (they wear outfits that vaguely resemble those worn by the crew of the Starship Enterprise) are joined by an ensemble of guest stars that includes Wags the Dog, Captain Feathersworld and Dorothy the Dinosaur, as they croon their way through such classics as 'Yummy, Yummy', 'Hot Potato' and 'Fruit Salad'.

BOER WAR VC WINNERS

The Victoria Cross is regarded as one of the military world's most distinguished honours, and is only awarded to servicemen who have shown the highest levels of bravery. The first Australians to win the VC were combatants in the Boer War of 1899–1902. Australia sent 16,500 men to assist the British against the Dutch Boer Republics, losing just over 500. The six VC winners were:

FW Bell

JH Bisdee

NR Howse

LC Maygar

J Rogers

GG Wylly.

SALMON BAN

In 1975 Australia imposed a ban on imported uncooked salmon in an effort to keep fish diseases away from the continent. However, when the World Trade Organization ruled that the salmon ban violated trade obligations, the Australian government ended 24 years of protectionism and lifted the ban.

THE NON-SMOKERS' MOVEMENT OF AUSTRALIA

The NSMA is a non-profit body founded in 1977 and it produces a bi-monthly newsletter, *Non-Smokers' Update*.

BIG GUNS UNDER THE ZOO

In 2002, workers at Sydney Zoo got a major surprise during excavations for a new exhibit. Beneath the usual soil and detritus they found not one, but three, cast-iron 18th century cannons. Archaeologists duly got excited as the ancient Scottish weapons were carted off to be examined by puzzled historians, who eagerly tried to work out how the big guns got there in the first place.

QUEEN HONOURS WAR DEAD

In 2003 Queen Elizabeth II honoured the 102,000 Australians who lost their lives in the world wars by unveiling an Australian War Memorial at London's Hyde Park Corner. The memorial was carved from green-grey granite stone quarried in Western Australia and is in the form of a curved wall that is inscribed with battle names and the home towns of the Australian servicemen and women who died.

NAMIBIA SUFFERS AT HANDS OF RAMPANT WALLABIES

The Rugby World Cup of 2003 proved a momentous occasion for both Australia and the game of rugby union. Namibia, by contrast, did not enjoy its trip to the finals, finding the Pool A game against Aussie hosts in Adelaide a particularly gruelling encounter. The match ended in a 142–0 victory for the Wallabies, who set a host of records en route to their resounding triumph.

- It was the biggest winning margin in Rugby World Cup history, exceeding the 145–17 mauling Japan suffered at the hands of New Zealand in 1995.

- Chris Latham became the first Aussie to score five tries in a Test match.

- Matt Rogers established a new individual points-scoring record for Australia.

- It was the fist time an Australian Test side had exceeded the 100-point mark.

10 FACTS ABOUT VEGEMITE

1. Vegemite was invented in 1922 by Dr Cyril P Callister, an employee of the Fred Walker Cheese company (later to become the Kraft Walker Cheese Company).

2. It is made from brewer's yeast and is a rich source of vitamin B.

3. The Vegemite name was chosen after the Fred Walker Cheese Company ran a competition inviting the public to suggest names for its new spread.

4. If you search hard enough on the Internet you will find a recipe for Vegemite milkshake. The ingredients include milk, ice cream and chilli powder. Nice.

5. Initial sales of Vegemite were poor; it was not until the mid-1930s that sales increased sharply after the inclusion of Vegemite redemption coupons in packs of cheddar cheese.

6. Vegemite was included in the ration packs of Australian soldiers during World War II.

7. The 'Happy Little Vegemites' jingle was launched in 1954 and was soon followed by TV commercials featuring the singing tots.

8. By the 1970s, 'Happy Little Vegemites' had been usurped by a new ad campaign featuring the slogan 'Pass the Vegemite please Mum'. The campaign ran for 11 years and ensured continued success.

9. In 1991, Sydney's Powerhouse Museum staged a Vegemite exhibition. Exhibits, which included jars, promotional material, adverts and other memorabilia, were assembled following a national search.

10. Kraft launched the Happy Little Vegemites Awards in 1996 as part of the product's 75th birthday celebrations. The awards began with a competition to find the best rendition of the 'Happy Little Vegemites' song; 900 schools entered, with Emmanuel College, Queensland, winning the A$75,000 (£31,000) prize.

WRECK PRE-DATES COOK

Captain Cook is widely accepted to be the first European explorer to chart the east coast of Australia, but the recent discovery of a shipwreck on Fraser Island has cast the Englishman's pioneering status in doubt. Initial inspections suggest that the wreck, which was armed with a row of four cannons, is of a non-British ship of the 1650s. Cook's exploration of the east coast took place in 1770.

VISA OVERSTAYERS

Australia is, as we all know, a favourite destination for gap-year students, global travellers and other hobos. These assorted backpackers arrive down under on visas for limited periods (usually six months), but often at the end of their supposed stay they are just unable to contemplate life without Vegemite, Victoria Bitter and deadly spiders...so they stay on. Overstaying visas is a major problem for the Aussie immigration department and it compiles all sorts of stats on the rogues who linger too long down under... And it may surprise you to learn that Brits are the worst offenders when it comes to overstaying. The following statistics are for the ten countries with the most overstayers in 2002.

Country of citizenship	Male	Female	Total
UK	3,800	2,600	6,400
USA	3,200	2,200	5,400
China, PRC	2,700	1,200	3,900
Philippines	2,300	1,300	3,600
Indonesia	2,100	1,200	3,300
Rep Korea	1,600	1,200	2,800
Japan	1,400	1,300	2,700
Malaysia	1,200	800	2,000
Thailand	800	900	1,700
Germany	1,000	700	1,700

Most overstayers exceed their visa by one to four years, but a significant proportion forget to go home altogether, with 27 per cent staying on for more than ten years.

FISHY TADPOLE HAS SCIENTISTS IN A SPIN

Australia can boast many things, including, since October 2003, the oldest vertebrate fossil in the world. The fossil was unearthed by Aussie palaeontologists during an excavation in sandstone in South Australia. It apparently looks like an elongated, fishy tadpole and is reckoned to be 560,000 years old. Scientists in laboratories the world over got very excited...though their husbands and wives didn't really understand what all the fuss was about.

MOBILE PHONES

In theory European mobile phones will work in Australia as both use the same GSM system, running at 900Mhz and 1800Mhz. Check with your service provider before you travel, and make sure you have a compatible charger.

QUARANTINE INSPECTORS SCORE HAT-TRICK

Alert Australian quarantine inspectors foiled a trio of deadly pests and diseases in a remarkable week in November 2000. The eagle-eyed spotters first intercepted a boat infested with Formosan termites, which are apparently the world's most destructive species, then turned around a cargo container covered in the pasture weed foxtail barley, before finally completing the hat-trick by stopping a passenger carrying apples that harboured two highly contagious diseases on a flight from Russia.

PEANUTS

Australia is responsible for around 0.2 per cent of the world's peanut production, with Queensland the country's nut heartland. Peanut growing was introduced to Australia by Chinese gold miners in the 19th century, but it was not until the 1920s that it became a significant commercial activity. The formation of the Peanut Marketing Board in 1924, which was swiftly followed by the establishment of the Peanut Growers Cooperative Association Limited three years later, signalled that the Aussies were getting serious about their peanut production. Crops grew steadily over the ensuing years, peaking at more than 60,000 tonnes (66,150 tons) in 1979. Current production is less than 50,000 tonnes (55,120 tons), which narrowly fails to meet domestic demand.

NO UFOS FOR SETI

Australia can boast one of the three biggest SETI centres in the world. 'What's SETI?' you say. The Search for Extraterrestrial Intelligence, of course, and the University of Western Sydney is home to SETI Australia. It's basically a scientific discipline and, somewhat disappointingly, has nothing to do with *Star Trek* travel and sending coded messages into space. The centre's website even states, 'SETI...has absolutely nothing to do with UFOs.' Killjoys.

AUSSIE MILLIONAIRES STILL SWELL

According to recent research conducted by the Boston Consulting Group (BCG), Australia's wealthy have fared better than many of their counterparts elsewhere in the world during the early years of the third millennium. Many millionaires have seen their fortunes dwindle in the wake of falling share markets the world over, but not so down under.

The assets of 'wealthy households' increased from A$460 billion (£193 billion) in 2001 to A$479 billion (£200 billion) last year, while the number of 'wealthy Australian households' rose slightly to about 340,000.

The number of Aussie millionaires (which was based on BCG's measure of US$1 million [A$1.4 million/£600,000] of liquid assets) also rose slightly to 58,000 in 2002.

SAVE THE REEF

The Great Barrier Reef supports more than 1,000 species of fish, a vast number of horny corals, molluscs, sponges and seagrasses, and major populations of endangered marine animals such as whales, turtles, dugongs and dolphins. That's why it's a protected World Heritage Area. Problem is, the prawn fishing is great. And Australians *love* prawns. For many years the Reef was a sustainable commercial fishery. Then came technological improvements to trawlers and fishing gear, and vast areas gradually became the maritime equivalent of deserts. Heavy net rigging was raked across the seabed crushing or burying anything in its path.

By 2000 more than 800 licensed prawn boats were chasing an annual catch worth A$150 million (£63 million) in the lagoon area of the Reef. According to the Wilderness Society of Australia, a fleet that size will dredge up 9–12kg (20–26lb) of marine life per kilo of prawns. Almost all the by-catch is chucked back overboard and promptly dies. One study showed that 13 drags of a prawn net wipes out between 70 and 90 per cent of all living things that get in the way. And all to throw another prawn on the barbie.

WINDMILLS

Windmills are a common feature of the Australian landscape, dotting the countryside, often around farms and other rural settlements. These metal edifices are rarely used today and are frequently in poor repair, but they were once the lifeblood of the countryside, providing water and power to an otherwise uninhabitable landscape.

Australian windmills are similar in appearance to those commonly found in America, and are basically metal wheels set on iron towers. They may not have the same twee white-washed appeal of the mills found in the English countryside but they are, nevertheless, of great social and economic significance.

The rapid spread of electricity and solar power led to a demise in windmill usage during the 20th century, but today windpower is coming back into vogue down under. The Australian government is committed to increasing its use of this free energy and, among other initiatives, is involved in the construction of the world's biggest wind turbines at Mawson Station in Australia's Antarctica Territory. Australia's domestic wind resource has also seen significant growth in the last four years, with capacity increasing from 100 to 740 megawatts.

HARD TIMES

The start of the new millennium has been a challenging time for the world's most vilified Australian – Rupert Murdoch, owner of *The Times*, *The Sun*, BSkyB, 20th Century Fox, HarperCollins *et al*.

Shares in Murdoch's global media leviathan News Corporation plummeted 50 per cent in 2001/02 to a paltry US$22.5 billion (A$31 billion/£13 billion)– partly the result of a lengthy bear run on world stock markets, but also because analysts remain cautious about how he'll deliver further growth.

A general downturn in advertising revenues, plus a vicious tabloid price war, has hit his British newspaper interests, and the controversial appointment of youngest son James as chief executive of satellite broadcaster BSkyB has heightened the sense of nervousness among investors. Then there is the question of the succession. Now in his 70s, not even Rupert Murdoch can go on forever.

Before shedding too many tears, however, it's worth noting that at the nadir of the stockmarket recession Murdoch's personal fortune was still a hefty US$6.8 billion (A$9.5 billion/£4 billion), enough to cover his paper bill during retirement.

GAY AND LESBIAN REFORMS

In October 2003 the Northern Territory government introduced reforms to parliament intended to 'ensure equality in treatment for gay and lesbian Territorians in a number of areas of the law'. The proposals included:

- equalising the age of consent at 16 years of age for all young Territorians

- extending domestic violence laws to gay couples to provide the same protection from abusive relationships as exists for heterosexual people

- amendments to the Anti-Discrimination Act which currently allows discrimination in employment on the basis of sexuality

- ensuring that children raised by homosexual households have equal access to benefits, support and rights as those children raised in heterosexual households.

TRAINING PAY

According to the current Australian Army salary scales, a permanent recruit will receive A$23,089 (£9,700) while undergoing basic training.

SAD TOUR IN SYDNEY

Everyone visits the breathtaking Sydney Opera House but if you're proud to be sad, here are ten of the city's less celebrated tourist attractions.

Bus and Truck Museum of New South Wales (1b Gannon St, Tempe 2044)

Centennial Bakery Museum (319–321 Forest Rd, Hurstville 2220)

Maritime Model Museum (12 Waratah St, Mona Vale 2103)

National Artillery Museum (Scenic Dr, North Head, Manley 2095)

NSW Rail Transport Museum (15a Belmore St, Burwood, 2134)

Sydney Tramway Museum (Pitt St and Princes Hwy, Loftus 2232)

Toy and Railway Museum of NSW (36 Olympian Parade, Leura 2780)

Museum of Camden Aircraft (11 Stewart St, Narellan 2567)

Justice and Police Museum (4–8 Phillip St, Sydney 2000)

Colonial House Museum (53 Lower Fort St, The Rocks, Sydney 2000)

ENTRIES IN THE SYDNEY GAY AND LESBIAN MARDI GRAS STREET PARADE

Dykes on Bikes

The George Michaels

The Bassey Bitches

Saving Ryan's Privates

POOFTA (Proud & Out Footballers Touch Association)

The Gay Mounties

Men in Pink

Tinky Winkies

Temple of More Men

Sisters of Perpetual Indulgence

THORPEDO VERSUS THE EEL

While Ian 'Thorpedo' Thorpe was breaking world records for fun at the Sydney Olympics – propelled by his unfeasibly flipper-like size 17 feet – maverick swimming fans were much more interested in Eric 'The Eel' Moussambani. The 100m freestyler from Equatorial Guinea had never actually swum in a 50m pool before, and judging by the anxious glances from lifeguards, there seemed a strong possibility that his first attempt might also be his last. Nonetheless, Eric completed the distance in a time of 1 minute 52.72 seconds, just 7.37 seconds outside a world record time. Which world record? Ah yes, the 200m one.

DOCS – NOT JOCKS

While most countries see Australian sport as a role model, Aussies themselves are apparently tiring of their stereotypical image as a nation of muscle-bound, win-fixated anoraks. A poll in *The Australian* newspaper in 2001 showed that while 59 per cent of respondents accepted that Australia's big national successes were rooted in sport, only 6 per cent were happy for this to continue. Two in every five wanted their country to be recognised in the fields of science and academia, one in five wanted plaudits for big business, and almost one in six chose 'agricultural output'. Beware Aussies quoting sheep-shearing statistics.

IDENTITY CRISIS

The problem with being a sporting juggernaut of a nation is that not everyone sees him or herself on board. Research by the Queensland University of Technology suggests that more than half of 12 to 16-year-olds believe they do not live up to the demanding standards of skill and physical appearance set by icons such as tennis star Lleyton Hewitt or swimmer Ian 'Thorpedo' Thorpe. Astonishingly, only 48 per cent reckoned to feel 'totally Australian' – even though all 721 survey participants were born in the country to Australian parents.

Dr Nola Purdie, senior lecturer in the university's department of learning and development, thinks today's young Aussies dislike being stereotyped as sporting obsessives. 'I think there may well be a rebellion against that cliched image,' she said. 'Our best guess at the moment is that the feeling of Australian identity is somehow linked with issues of performance and achievement.'

God alone knows what the media would make of a backlash against Aussie sporting supremacy. 'Show me a good loser,' one sports writer has observed, 'and I'll show you someone who's had a heap of practice at it.'

BOMBING PRACTICE

A natural harbour in Australia's Monte Bello Islands was the site for Britain's first atom bomb test in 1952 and, according to de-classified documents released by the Public Record Office in London, the Royal Navy was particularly enthusiastic. This was because the admirals had a secret plan to plant atom bombs near Russian naval bases, using midget submarines to deliver the goodies. If nothing else, it meant the Navy could grab a bigger cut of Britain's huge Cold War nuclear defence budget.

MASTERS OF SURF

Students have a tough enough job defending their lifestyle without some smartass university loading bullets for the critics. Undeterred, the Southern Cross University has launched a year-long diploma course in surfing aimed at coaches, beach managers, lifeguards and promoters. The syllabus includes having to spend 25 hours riding waves on idyllic sun-kissed beaches, watching classic surfie films like *Endless Summer* and *Big Wednesday* and learning slang phrases such as 'shark biscuit' (a scathing term for a body boarder).

However, lecturers insist the course, run at the Tweed Heads campus on the Queensland–New South Wales border, is no place for a beach bum. They point out that surfing is worth a cool A$8 billion (£3.4 billion) to the global economy and that designer labels such as Quiksilver, Pro Curl and Billabong are major wealth-generators in Australia. Students will therefore be taught about surf-related businesses, marketing and PR, event management, human resources and sociology.

'The perception of surfers as lazy dole-bludgers is out of date,' said Dr James Skinner of Southern Cross's International College of Surfing Education and Research. 'Nowadays you have a much broader cross-section of society, from bricklayers to judges; kids to retirees.' Tom Campbell of the sport's governing body Surfing Australia, which has endorsed the new diploma, agrees: 'You can't just be a surfie bum any more,' he says. 'The industry is looking for intelligent people with a proven track record in business management.'

BATTLE OF THE BULGE

Army commanders worldwide have always assumed that the Australian 'Digger' infantryman is a naturally lean, mean fighting machine. This dates back to a famous quote by Field Marshal Douglas Haig in 1917 as World War I was at its height. 'There are certain divisions,' he said, 'which, if given a thing to do, they do it. All the Australian divisions are in this category.'

Alas, no more. In 2000 the Australian National Audit Office discovered that a quarter of the country's servicemen and women were on the tubby side. Soldiers did not meet basic fitness requirements and had only 'a reasonable chance of being combat-fit in 90 days'. Most modern armies expect troops to be ready for action at a month's notice.

According to Maj Gen Peter Phillips, president of the Returned Services League (the Aussie equivalent of the Royal British Legion) the reason for the decline is hardly rocket science. 'Australia is now an urbanised country,' he said. 'When the original Diggers went off to Gallipoli and the Somme, most Australians still lived on the land. Today we get obese young people – just like every other western country. It takes longer to get our soldiers fitter.'

Official figures show the Army discharged almost 700 soldiers – including five lieutenant colonels and 40 other officers – during a fitness crackdown in 1999. Not to be outdone the Navy has since warned 'beer-gutted and big-bottomed' sailors to shape up or ship out.

BACKPACKERS' BIBLE

The first of the now legendary Lonely Planet travel guides – *Across Asia On The Cheap* – was written by Aussie husband-and-wife team Tony and Maureen Wheeler back in the 1970s. Since then, some 500 titles have shaped the backpacking plans of a generation, and the story goes that when Bill Gates visited Australia he told aides there were only two people he wanted to meet – the Prime Minister and 'someone from Lonely Planet'.

ZERO TO HERO

Prime Minister John Howard took a huge political gamble by ordering Australian troops – including an SAS unit – into the front line of the 2003 Gulf War. Hundreds of thousands of protestors demonstrated against the decision and the PM's popularity nose-dived. Then the war ended inside three weeks, the anti-war protestors were forgotten and polls showed 62 per cent of the population suddenly believed Howard was the best leader for the nation. The message from voters is clear. Whatever you do as Australian Prime Minister, don't lose.

NAMING NAMES

Compiling obituaries for Aborigines demands a particularly sensitive interview technique, Perth-based journalist Patrick Cornish told the 2003 Great Obituary Writers Conference in New Mexico, US. This is because, for religious reasons, Aborigines may be reluctant to mention the names of the dead.

12 STEPS TO THE AUSTRALIAN MALE'S DREAM BARBIE

1. Get the tinnies (XXXX, Toohey's New or VB for proper street cred).

2. Get the barbie.

3. Get snags (sausages) and prawns.

4. Get women to do salads (both, ideally, for display purposes only)

5. Invite mates.

6. Start drinking.

7. Clean and fully sterilise barbie (ie, scrape rust with penknife and burn off congealed fat).

8. Fry too many onions. Everyone eats too many.

9. Throw on snags and prawns.

10. Cook while drinking and spilling tinnies (sometimes known as 'coldies') over food. Remember, beer *always* improves the flavour.

11. Keep women well away. Barbie tucker requires a minimum of four males to advise on when to turn the snags.

12. Take bets on which tongsman first gets the squits.

SYDNEY OLYMPICS: THE FACTS

- Sydney 2000 set a new Olympic record for ticket sales. Even so, it wasn't a sell-out. Ultimately, more than 87 per cent of available tickets were bought, comparing well to previous record tickets sales notched up in Atlanta, where the figure was 82 per cent.

- Before the Olympics ended ticket sales were worth A$775 million (£326 million) in gross revenue.

- About 3,768,000 people travelled to Sydney for the Games. On one day alone, Sydney Olympic Park was filled with 400,345 spectators.

- As for souvenirs and memorabilia, sales of retail products amounted to an astonishing A$420 million (£177 million).

- It wasn't all about money, though. More than five million man hours were given up by 47,000 volunteers during the games.

- Technological advances in the Third World meant that the Games were broadcast in more homes in different parts of the world than ever before. It reached 220 countries, while the Atlanta Games were broadcast in only 214 countries.

- Technology also contributed to a thriving Internet site. The official Olympic site fielded a deluge of nine billion hits during the competition.

- Athletes in the Olympic Village consumed more than a million meals, with chargrilled Tasmanian salmon steaks being the hot favourite.

- Staff working in the Sydney Olympic Park ate one billion lollies during the Games, averaging out at six lollies per person per day.

- More countries competed than ever before, with more than 200 represented at Sydney. The USA returned home with the most medals – 39 golds, 25 silvers and 33 bronzes, a total of 97 medals. Russia was in second place, with 88 medals and China was third with 59. In fourth place came the host country, Australia, bagging 16 gold medals, 25 silver and 17 bronze, a total of 58.

GOOD BREEDING STOCK

Australia's most eccentric earl is almost certainly Keith Rous, the 6th Earl of Stradbroke, who left his family's enormous Suffolk estate in the mid-1950s to emigrate and become a sheep farmer. The earl now runs a 6-hectare (15,000-acre) sheep and cattle station in Victoria, but in the past has dabbled in unusual entrepreneurial projects such as offering his sperm for sale at A$240,000 (£100,000) per sample. He never much liked the wishy-washy family motto – *Je vive en espoir* ('I Live In Hope') – and eventually changed it to the steelier 'We fight like lions; breed like rabbits.'

ELLE'S TEETH!

Aussie fashion icon Elle 'The Body' Macpherson can Pommie-bash with the best of them. In a New Zealand TV documentary screened in 2003, the 39-year-old supermodel said, 'It has taken me quite some time to re-educate the English. They are not renowned for their lingerie bravado. They are not really a country that has a reputation for changing their underwear very often. We have had to educate the English woman into really enjoying lingerie.'

CULTURE VULTURES

Ten million adult Aussies went to the movies at least once during 2002 – around 70 per cent of the over-18s population. Of this group, almost a quarter went more than ten times. Figures released by the Australian Bureau of Statistics in October 2003 show that cinema is the clear leader in adult cultural venues followed by libraries (42 per cent of over-18s), botanic gardens (42 per cent), zoos and aquariums (40 per cent), pop concerts (26 per cent), museums (25 per cent), art galleries (25 per cent) musical and operas (19 per cent) theatre (18 per cent), dance (11 per cent) and classical music (9 per cent). In most cases, women visit more than men.

FIRST FLEETERS

The ships that initially arrived in Australia with convict cargo were called the First Fleet. Those aboard were consequently the First Fleeters. Although there remain some historical discrepancies at source, the following gives a potted pen portrait about the voyage to, and subsequent settlement of, Australia.

- The First Fleet comprising 11 ships departed Portsmouth on 13 May 1787. The six convict ships were the *Alexander*, the *Charlotte*, the *Lady Penrhyn*,

the *Friendship*, the *Prince Of Wales* and the *Scarborough*. The other ships were HMS *Sirius*, HMS *Supply*, the *Fishburn*, the *Borrowdale* and the *Golden Grove*.

- Following three stops, the ships arrived in Botany Bay on or shortly after 20 January 1788. Although chained below decks, just 23 convicts died on the voyage.

- Just days after the First Fleet dropped anchor, a French contingent led by Count Jean-Francois de la Perouse hove into view. Thus, Australia was only hours away from being the property of the French rather than the English.

- About 750 male and female convicts were transported on that occasion. The youngest was a boy of 9, the eldest a woman of 82.

- One convict was being sent overseas for taking a dozen cucumber plants. Another stole a book, a third took a greatcoat.

- Among them there were no farmers, gardeners or medics who could have used their talents to help the colony survive. There was just one fisherman and only five men with rudimentary knowledge of building.

- Items aboard included 1,364l (300 gal) of brandy, 13.6 tonnes (15 tons) of drinking water, 4 mares, 32 hogs, 250 women's handkerchiefs, 29 geese, 40 tonnes (44 tons) of tallow, five rabbits, a piano and prickly pear seeds.

- In addition to convicts there were several hundred seamen and marines, many of whom begun relationships with the convicted women.

- After finding a grand natural harbour, Captain-General Arthur Phillip, who was in charge of the expedition, rejected the notion of naming it Albion and plumped for Sydney Cove, after Thomas Townshend, Baron Sydney, the Home and Colonial Secretary of the day.

- Although conciliatory towards the Aborigines, Phillip was himself speared during one confrontation.

- When relief ships were delayed in Britain and a supply ship, the *Guardian*, was wrecked off the Cape of Good Hope, everyone in Australia was under threat from starvation, except for the bemused Aborigines.

- The first ship to reach Australia among those in the Second Fleet was the *Lady Juliana* in 1790, carrying a substantial number of women convicts.

- The Third Fleet arrived in 1791. The first free settlers came in 1793.

LATE TRAIN

The age of train travel came somewhat late to Australia. It wasn't until 1970 that passengers could travel from Sydney to Perth in one journey using the luxurious Indian Pacific Railway. Of course, Australia had numerous railways before this late date. Problem was, back in the 19th century, none of the states could agree on a suitable gauge size for the tracks during construction. As a result, lines were built in narrow, standard and broad gauges. Passengers were forced to hop from one to the next when they traversed the continent, and it was impossible to get anywhere fast. Then came the Indian Pacific, scything across country for 4,352km (2,704 miles) in some considerable style. Its emblem is the magnificent wedge-tailed eagle that can sometimes be spotted from the train windows. The Indian Pacific has another extraordinary claim to fame. It runs along one piece of track that stretches for 478km (295 miles) without deviating. That's the longest section of dead straight track in the world.

GRAPE FARMERS SQUEEZED

A persistent drought played havoc with the 2003 grape harvest according to the government's Vineyard Survey. Overall production fell by 16 per cent to 1.4 million tonnes (1.54 million tons) and overall yield dropped to 10.2 tonnes (11.3 tons) per hectare from 12.2 tonnes (13.5 tons) the previous year.

The three biggest grape-producing states were all badly hit. Victoria's harvest of 392,000 tonnes (432,000 tons) was down by almost a quarter, while in New South Wales it fell 17 per cent to 374,000 tonnes (412,000 tons). The really big player, South Australia, escaped lightly in comparison – down 10 per cent to 627,000 tonnes (691,000 tons). And this in a year when Australia's total vineyard area increased slightly to 159,000 hectares (393,000 acres).

CRIME ON THE UP

Crime figures remain on a rising trend in Australia with, perplexingly, the biggest 2000/01 increase attributed to blackmail (37 per cent more victims than the previous year). The percentage of robberies involving a weapon was 42 per cent, roughly the same as 1993, but the use of firearms fell from 16 per cent to 6 per cent. Figures from *Recorded Crime, Australia 2001* show another worrying new development in an AIDS-conscious society – the use of syringes as weapons (3.5 per cent of all armed robberies).

THE CITY PREVIOUSLY KNOWN AS PALMERSTON

When the city of Darwin was first established in 1869 it was known as Palmerston, after the British Prime Minister of the era.

AUSTRALIAN DINOSAURS

According to the Australian Museum online, 'Dinosaurs lived in Australia, although only a few have been found so far.' The museum explains the scarcity of finds compared to those in other countries by adding that 'More dinosaurs have been found in North America and Asia because people have spent more time looking for them and a great deal of money has been invested in the search.'

RUGBY WORLD CUP FINAL 2003

The 2003 World Cup was a hugely successful tournament for the game of Rugby Union, with Australia hosting a festival of sport to rival anything that had gone before. The only downside down under was, of course, that England won, beating their Aussie hosts in the final, with a dramatic kick from Jonny Wilkinson in the dying seconds of extra time.

Random RWC Factfile

- Wilkinson's joy at kicking the World Cup-winning points was matched only by the elation of a canny punter who put A$5,000 (£2,100) on the full-time draw at 26–1. The unnamed gambler walked away with a cool A$130,000 (£54,600).

- The tournament saw 20 teams use more than 600 players to contest 48 games.

- The victorious English egg-chasers celebrated hard after their victory. Twenty-four hours after lifting the cup, several English players, including Jason Leonard, decided to return to their hotel. No taxis were available so they flagged down a police car and were courteously given a lift back to base.

- Prince Harry (remember – he was down under as part of his gap-year frolics) celebrated with the England team, joining them along with his cousin Zara Phillips at a city-centre bar.

- England fans who missed Wilkinson's winning kick might have to wait a while to see it again. The IRB is charging A$15,420 (£6,500) a minute for footage of the final.

INDEX

EVERYTHING YOU DIDN'T NEED TO KNOW ABOUT THE UK

Nick Brownlee

How did Big Ben get its name? Why do 51 per cent of Brits sleep naked? Was the Queen really sending emails in the 1970s? And just how do you make the perfect cup of tea?

Packed with inane anecdotes and useless trivia, *Everything You didn't Need To Know About The UK* is a compilation of weird and intriguing facts concerning all things British and the ultimate guide to understanding the minutiae of life in the Mother Country.

UK | 1-86074-562-8 | £9.99
US | 1-86074-597-0 | $13.95

Everything You Didn't Need To Know About The

U.S.A

ALASKA

SEATTLE

IDAHO

HOLLYWOOD

66

BANGOR

NEW YORK

DAYTO

Karen Farrington